Botanicum Medicinale

First published 2020

Published by arrangement with
UniPress Books Limited,
by The MIT Press.

The MIT Press

Massachusetts Institute of Technology

Cambridge, Massachusetts 02142

http://mitpress.mit.edu

ISBN: 9780262044479

Library of Congress Control Number: 2020932878

Printed in China.

Conceived, designed, and produced by
UniPress Books Limited.

www.unipressbooks.com

Design, image research, and diagrams by
Lindsey Johns

Project managed by
Kathleen Steeden

Illustrations on pp. 54, 104,
148, 154, 182, 184, and 188
by Julie Spyropoulos

Botanicum Medicinale

A MODERN HERBAL OF MEDICINAL PLANTS

Catherine Whitlock

The MIT Press | Cambridge, Massachusetts

CONTENTS

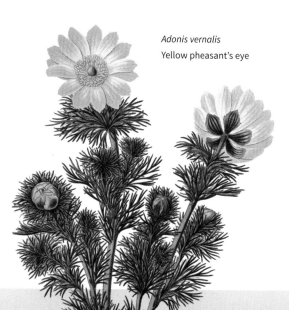

Adonis vernalis
Yellow pheasant's eye

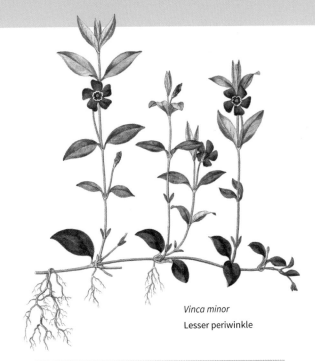

Vinca minor
Lesser periwinkle

INTRODUCTION

Remedies derived from plants are the oldest form of medicine. Along with the rest of life on our planet, human beings have evolved alongside plants, using them as fuel, food, shelter, and, most importantly for this book, medicines.

In China and India in particular, traditional medicine is as popular as its modern counterpart. Many of the most commonly used remedies are herbal, although acute and life-threatening illnesses are usually treated with pharmaceutical drugs. In African countries like Ghana, at least 80 percent of the population rely on herbal medicines, often prepared from native West African plants.

In much of Europe in the 20th century, herbal medicines fell out of favor, as the burgeoning pharmaceutical industry produced new drugs, including antibiotics, anticancer treatments, and immunosuppressants. Now that the rate of drug discovery and production has tailed off, and issues such as antibiotic resistance have become more pressing, herbal medicine has grown in popularity, alongside other holistic and alternative therapies.

The plant world is a rich source of remedies that can be used to maintain good health. When used carefully, and with medical advice, many herbal remedies have a good safety record and they can be self-administered, often for prolonged periods of time for those with chronic conditions. Today, it is possible to combine the insights of traditional medicine with the clarity and quality control that scientific research can provide.

In 2017, it was reported that approximately 35 percent of the U.S. population use herbal remedies each year. In Europe, Germany leads the way in herbal medicine use and research, although worldwide research into herbal medicines is expanding rapidly.

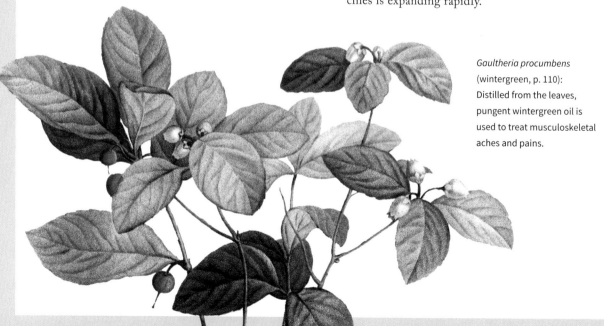

Gaultheria procumbens (wintergreen, p. 110): Distilled from the leaves, pungent wintergreen oil is used to treat musculoskeletal aches and pains.

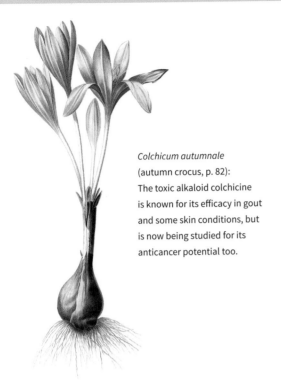

Colchicum autumnale
(autumn crocus, p. 82):
The toxic alkaloid colchicine
is known for its efficacy in gout
and some skin conditions, but
is now being studied for its
anticancer potential too.

It's not just herbs...

The term "herbal medicine" is a bit of a misnomer. It's not just herbs that are used to prevent, treat, or alleviate disease symptoms. Herbal medicine uses any plant or plant material, such as flowers, roots, fruits, leaves, or bark. Each part of the plant may have different medicinal uses. Gaining a university degree in herbal medicine is now the norm for medical herbalists. This enables them to make use of plants whose traditional uses are often backed up by scientific research and clinical trials.

A modern herbal

Herbals—from the Latin *liber herbalis*, meaning "book of herbs"—were some of the first books produced in medieval times, first as manuscripts and later by woodblock printing and movable metal type. This book contains an up-to-date presentation and appreciation of the world of botany and the medical treatments that can be harnessed from the plants around us. The illustrations provide a feast for your eyes, alongside descriptions of the historical use of plants and the latest scientific research on both traditional and more recently discovered herbal medicines.

A rich harvest

There are at least 400,000 species of terrestrial plants worldwide. Of these, over 35,000 have been shown to have some medical use. Featured in this book are some of the most significant—those that have a long history of medicinal use and/or are the subject of ongoing or new medical research. These plants are notable for their ability to treat a range of conditions, from aiding sleep, alleviating menopause symptoms, and promoting digestion, to treating cancer, tropical diseases, and heart conditions. Our chosen plants grow in different habitats and reveal the diversity of medical plants; many are beautiful and others are considered weeds. All have value—aesthetically in your garden and as a welcome addition to your medicine cabinet.

DISCLAIMER

Many herbal medicine products are freely available over the counter or on the internet, and most are safe. But care is advised, especially for those who have diagnosed medical conditions, are taking medication (as herbal medicines can modify the actions of some drugs), or are pregnant, breastfeeding, young, or elderly.

This book does not constitute medical advice and therefore does not detail the different forms of herbal medicines, how they are prepared, or, most importantly, precisely how and when they should be used. Medical herbalists and health practitioners are available to provide that advice.

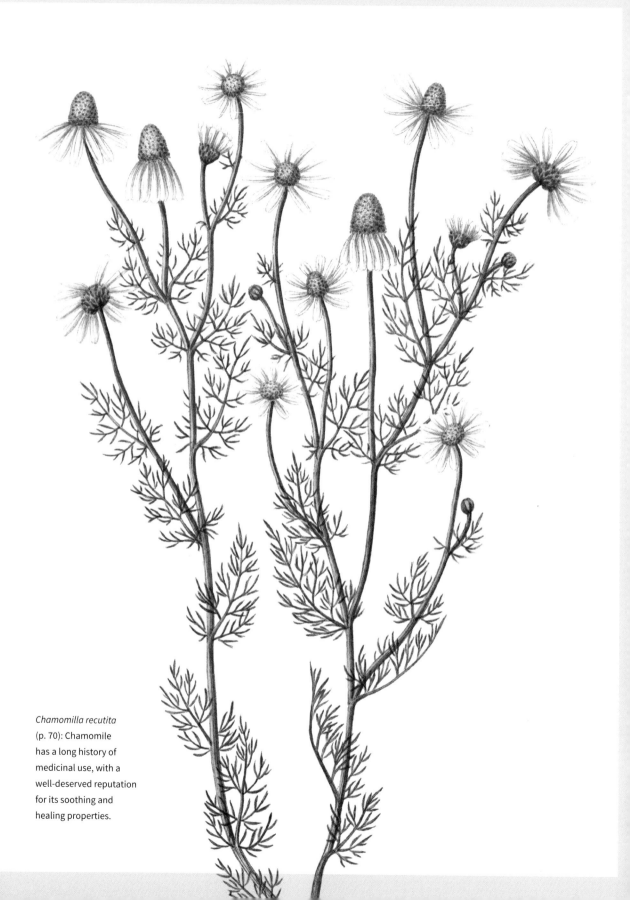

Chamomilla recutita
(p. 70): Chamomile
has a long history of
medicinal use, with a
well-deserved reputation
for its soothing and
healing properties.

The Ancient Roots
of Herbal Medicine

An unbroken tradition of herbalism stretches back centuries in India and China, while other cultures have increasingly incorporated the herbal approach alongside Western medicine. Over the past 30 years, around 80 percent of people worldwide have come to rely on herbal medicinal products and supplements as part of their primary healthcare.

India developed the first system of herbal medicine over 4,000 years ago. From here, knowledge spread across the world to China, with its strong philosophical approach to health and disease, and into the Middle East. Egyptian papyri from 3,500 years ago record several hundred plants used for food and medicine. The expansion of the ancient Greek and Roman empires carried herbal medicine further into Europe and Britain.

In Britain, monasteries were the centers of herbal medicine—growing and prescribing medicinal plants, as well as making translations of the Latin herbals. From the 16th century, herbals were published by the famous English herbalists, including John Gerard (1545–1612) and Nicholas Culpeper (1616–1654). In America, the early settlers spread herbs across the country, often assimilating the knowledge of the indigenous American peoples. Until the early 1900s, herbalism was the primary health system in the USA.

Ayurveda

Ayurvedic medicine is ancient and well documented. One of the earliest herbals appeared in classical Sanskrit literature, around 4,000–5,000 years ago. The Charaka Samhita text, which dates back to 300 BCE, still guides the modern practice of Ayurvedic medicine. Approximately 500 plants are commonly used. *Ayurveda* comes from the Sanskrit words *ayur* (life) and *veda* (knowledge). It focuses on the forces of life, their interaction with the elements (earth, water, fire, air, and

ether), and the belief that health is dependent on a balance of mind, body, and spirit. As such, it incorporates herbal medicine with activities such as massage, yoga, and meditation. Many of the herbs in this book are used in Ayurvedic medicine, like Indian ginseng (*Withania somnifera*, p. 208) which is one of the *rasayanas*—those herbs associated with longevity.

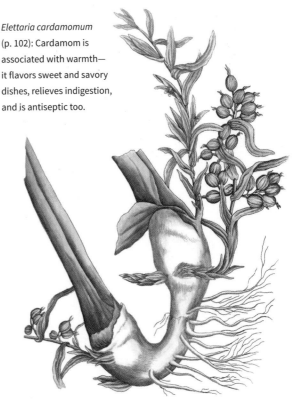

Elettaria cardamomum (p. 102): Cardamom is associated with warmth—it flavors sweet and savory dishes, relieves indigestion, and is antiseptic too.

Chinese herbal medicine

Like India, China's primary source of medicines is plants, with around 450 plants in use in today's Chinese herbal culture. The vast majority of doctors in China (98 percent) are trained in traditional Chinese medicine (TCM). This has an emphasis on prevention and, combined with herbal medicine, encompasses other therapies, such as acupuncture and movement practices (*qigong*). Chinese medicine is similar to Ayurveda in its focus on energy and balance. In TCM, the activity of *qi*, or energy flow, determines physical and mental wellbeing. Creating a balance between the *yin* (passive force) and *yang* (active force) will restore harmony and good health. Chinese herbal medicine crops up a number of times in this book as it is applied to a wide range of health disorders, although many people use it as part of TCM to maintain good health or to prevent ill health.

The pioneers

Two of the best-known early English-language herbals were written by John Gerard and Nicholas Culpeper. As a physician and a gardener, Gerard drew on early writings by, for example, the 1st-century Greek physician Dioscorides (*Materia medica*), and the 16th-century German botanist Leonhart Fuchs and the Swiss Conrad Gessner. His masterful work *The Great Herball* was published in 1597 and an enlarged version in 1633. Gerard was the first noted herbalist to include North American plants in a European herbal.

Gerard's work inspired others, including the botanist and physician Culpeper. In 1652, he published *The English Physician*, later known as *The Compleat Herball*. Culpeper wanted to open up the world of medical plants to the poor who couldn't afford the fees of physicians and apothecaries (those who were skilled in preparing medicines). He linked plants and diseases to the signs of the zodiac—a practice that has not survived the test of time—but Culpeper's herbals, with their detailed descriptions of the medicinal properties of herbs, have never been out of print.

The early American settlers also had Gerard's herbal to hand and, in 1728, the Quaker John Bartram founded North America's first and oldest botanic garden, located on the west bank of the Schuylkill River, Philadelphia, Pennsylvania. In the late 19th and early 20th centuries, the Eclectic approach took off. Based on Native American use of medicinal plants, the Eclectic practitioners lived up to the Greek origins of the name, *eklego*, meaning "to choose from," combining herbal medicine with other components such as physical therapy—whatever was found to benefit their patients.

Section of a page from Culpeper's *English Physician and Complete Herbal* (1789 edition). The title of this tome still stands up to scrutiny: Even with modern printing methods, there are few books that can compete with its definitive treatment and beautiful illustrations of the wealth of medicinal plants.

The yellow bark and flowers of the jaundice tree (*Berberis vulgaris*, p. 46) depicted in a herbal of 1554: In the 17th century the Doctrine of Signatures took hold—the belief that some plants had been "signed" by God to reveal their uses in their appearance.

Finding new drugs—
lessons from nature

Traditional healers often drew inspiration from the ways that animals treat themselves. The Native American healers in America watched wounded elk eat echinacea (*Echinacea purpurea*, p. 100) and tried it out on their human patients.

This trend continues to this day, as a new generation of plants are being discovered, sometimes in surprising ways and often in the depths of the rainforest. In a 2017 study in the journal *Nature*, Morrogh-Bernard et al. revealed how Bornean orangutans chewed on the leaves of the *Dracaena cantleyi* plant to produce a soapy lather, which they spread on aching limbs. The scientists found that the lather had anti-inflammatory properties. This was the first evidence of deliberate external self-medication in great apes and confirmed why local people also used *D. cantleyi* as a pain reliever.

Throughout this book there are many examples of traditional herbal remedies finding new uses, especially in the fields of cancer, obesity, type 2 diabetes, dementia, and mental health.

Conserving stocks

Plant conservation is vital not only for the health of the planet, but for our health, too. Medicinal plants (and the hunt for new ones) are threatened by factors such as forest destruction and changing land use, uncontrolled harvesting in the wild (not all medicinal plants can be cultivated), and climate change. Thankfully, conservation is now a grassroots activity: Gardeners, horticulturalists, botanists, and botanic gardens are saving seeds, propagating plants, creating sustainable hybrids, and exploring genetically engineered plants.

Regulation

Herbal medicines have been used for centuries, but science-based knowledge, registration, and regulation is relatively new. In the USA, the Food and Drug Administration (FDA) regulates herbal remedies. In the UK, it is the Medicines and Healthcare products Regulatory Agency (MHRA), and in Europe, the European Medicines Agency (EMA). However, not all herbal medicines or products are regulated, especially those that are sold online and/or as food supplements.

Safety is a paramount concern and one that is centered on knowledge of plants—nutritional and medicinal—experience of prescribing, and research. Though a multitude of herbal products can be bought over the counter, consultation is recommended. The increase in university-trained herbal practitioners and naturopaths mirrors the rise in popularity of herbal medicine. It is recommended that these should be members of a professional body such as the American Herbalists Guild, the National Institute of Medical Herbalists (UK), or the European Herbal & Traditional Medicine Practitioners Association.

IN THE LABORATORY

Science is still revealing how herbal remedies work and their potential for future applications, but understanding a plant's chemistry is essential to many of the current research studies.

Herbal medicine often relies on using whole plants and combinations of plants, with the synergistic effects that result. It is not always possible to narrow down the precise compounds involved but chemists have lots of fun delving into plant metabolism, studying chemical structures and how they all relate. For us lesser mortals, it's probably enough to say, it is complex!

Secondary metabolism is important here. A plant's primary metabolism describes all the basic processes that take place to produce molecules like proteins and carbohydrates—the essentials of life. Primary metabolism is what allows a plant to grow and reproduce. On top of this, secondary metabolism produces something in the region of 200,000 specialized compounds. It wasn't until the 1970s that it was understood that these secondary metabolites, although seemingly of lesser importance, actually play a vital role in allowing the plant to survive in a hostile world (see "Plant Health," opposite). It is these compounds that are primarily responsible for the health benefits of plants.

Three types of plant compounds crop up regularly in this book: the flavonoids, the alkaloids, and the glycosides.

Flavonoids

The in vivo bioavailability of plant compounds like the flavonoids is a major factor in their ability to influence disease processes. Many of these flavonoids have an "anti-" characteristic to their name: anti-inflammatory, antioxidant, and so on. Antioxidants are essential for optimal health. They work by decreasing the free radicals—highly reactive and unstable molecules that are naturally produced

Present at the birth of chemistry

In the 19th century, chemists developed the techniques to separate and purify pure compounds from complex mixtures. These advances meant that the ancient herbal remedies could be separated into their constituent active principles—the chemical compounds that are chiefly responsible for the biological or pharmacological effect of a plant or herbal extract. Atropine (p. 45), quinine (p. 73), caffeine (p. 81), cocaine (p. 107), and morphine (p. 145), were all isolated at this time. Not surprisingly, these compounds had greater activity than in their diluted natural state and the commercial potential of these powerful drugs was quickly realized. The success of today's multinational pharmaceutical companies dates back to these heady early days of chemical investigations.

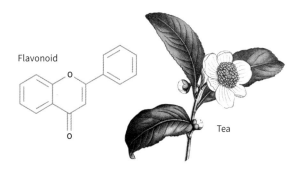

Flavonoid

Tea

The flavonoid backbone (2-phenyl-1, 4-benzopyrone): Flavonoids have the same basic carbon ring structure (C_6-C_3-C_6), with modifications to this producing six different subgroups. For example, the catechin EPG (found in *Camellia sinensis*, tea, p. 52) is in one of these subgroups and quercetin (*Aesculus hippocastanum*, buckeye tree, p. 22) in another.

Plant health

Plants contain a complex mixture of compounds (secondary metabolites) that perform numerous functions within the plants—many to do with survival. This also helps explain why any single plant may be used for a number of ailments. Plants can't escape danger and don't have a sophisticated immune system, so these compounds form part of their defense mechanisms against hungry predators, microbes, parasites, and insects. Some of the alkaloids are highly toxic. Other compounds, like those essential oils found in lavender (p. 126) and thyme (p. 196), have antimicrobial properties. The flavonoids attract pollinators and many have antioxidant properties. Just as in humans, these protect the plant against damage caused by oxygen free radicals.

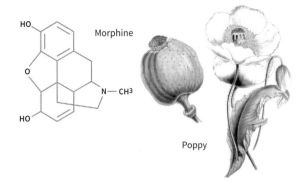

Morphine

Poppy

Alkaloids are alkaline (hence their name), contain nitrogen (N), and, as bases, can combine with acids to form salts. They are especially common in certain families of flowering plants, like morphine from the Papaveraceae, or poppy, family. Quite often alkaloids, like quinine, have a bitter taste, a warning of their potent, sometimes toxic, effects.

as a byproduct of metabolism—which damage cells and are implicated in many common diseases. Flavonoids often announce their presence by their bright colors. Beta carotene, for example, gives carrots their vibrant orange appearance. Flavonoids are the largest group of antioxidants, with at least 6,000 varieties. They are sometimes referred to as polyphenols.

Alkaloids

Most alkaloids are found in plants, with 10–15 percent of plant species containing some alkaloids. The majority of the approximately 5,000 alkaloids that have been studied are biologically active or, put more strongly, induce a marked physiological and sometimes toxic reaction. Many of the active principles isolated in this book are alkaloids and are frequently named by adding the suffix "–ine" to the genus or species name. The list includes: atropine, berberine, caffeine, cocaine, colchicine, ephedrine, ergometrine, galantamine, morphine, pilocarpine, piperine, quinine, reserpine, rotundine, sanguinarine, tetrandrine, vinblastine, vincristine, and yohimbine.

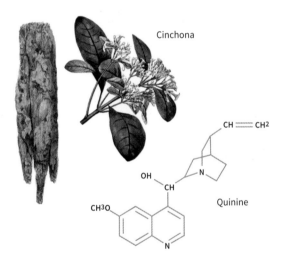

Cinchona

Quinine

Glycosides

Glycosides occur in both animals and plants, where they're often flower or fruit pigments and, in the context of this book, have therapeutic applications. There are at least 30 different classes of glycosides, with varying structures, but common features are a carbohydrate (sugar) portion combined with a non-sugar molecule. The heart-stimulating glycosides of *Digitalis* (foxglove, p. 96) and others belong to the group of cardiac glycosides (p. 14). Others have much milder effects on the body, like stevioside from *Stevia rebaudiana* (p. 184).

∞ 13 ∞

Revolutionizing the Treatment of Common Conditions

For some plants, not only have the active components (the active principles) been isolated, but the pathway has extended to the development of important new drugs. About 40 percent of pharmaceutical drugs come from plants. These drugs have revolutionized many areas of medicine, including in the fields of cardiology, oncology, and pain control.

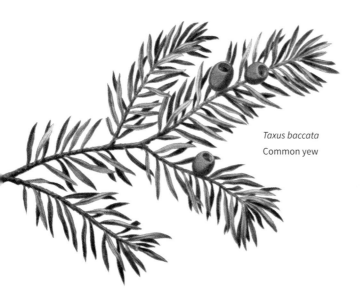

Taxus baccata
Common yew

flavonoids, tannins, curcumin, and gallocatechins—are all considered to be anticancer compounds. Prevention is key here. Including a wide range of plants in your diet provides antioxidants that are thought not only to improve health generally but to reduce the risk of developing cancer.

Throughout this book, several cancer drugs derived from plants are featured: camptothecin, from the appropriately named cancer tree (*Camptotheca acuminata*, p. 54); vinblastine and vincristine, from the Madagascan periwinkle (*Catharanthus roseus*, p. 66); etoposide and teniposide, from the American mandrake (*Podophyllum peltatum*, p. 162); and Taxol, from the Common Yew (*Taxus baccata*, p. 190).

Heart disease and cancer are two of the biggest causes of mortality in many countries and controlling pain is an overriding concern too. A large proportion of the world's population is regularly using vital drugs that are derived from plants.

Cancer

Cancer and plants have always had a close relationship. Many of the 100 plants in this book have anticancer effects, some of which are newly discovered and the subject of intense research. The plants featured here weren't chosen for their anticancer activity alone, but the high number that display such activity reveals the anticancer potential of plants. The polyphenolic compounds—those secondary metabolites that include alkaloids,

Cardiology

Cardiologists, who study the heart, its major blood vessels, and how they work, have used plant-derived medicines for centuries. Treatment of heart failure uses cardiac glycosides derived from *Digitalis lanata* (p. 96), *D. purpurea* (p. 96), and *Cytisus scoparius* (p. 92). These plants and others like *Adonis vernalis* (p. 20) and *Cinchona ledgeriana* (p. 72) can regulate irregular or rapid heartbeats. *Adonis vernalis* also acts as a heart sedative, easing palpitations, while *Ammi majus* (p. 30) and *Convallaria majalis* (p. 84) are active against angina—the chest pain caused by reduced blood flow to the heart.

The cardiac glycosides are at the heart of these actions—quite literally! Digoxin, for example, acts

on an important cellular mechanism, which regulates the amount of sodium and potassium in cells, and increases the rate of contraction of heart muscle cells. Some of the heart glycosides have been superseded by modern, less toxic, alternatives, but there is significant research interest in new uses for these workhorse heart drugs, particularly as anticancer therapies.

Pain

Management of pain—both acute and chronic—is a perennial concern in medicine, such that there are even physicians that specialize in it. Globally, it is estimated that 20 percent of adults regularly suffer from some type of pain. That is reflected by the figures for the plants here. Approximately one third of the 100 plants featured can be used to treat pain, whether it be headaches or migraines, toothache or sore throat, rheumatic, muscular, fibromyalgia, or neuralgia.

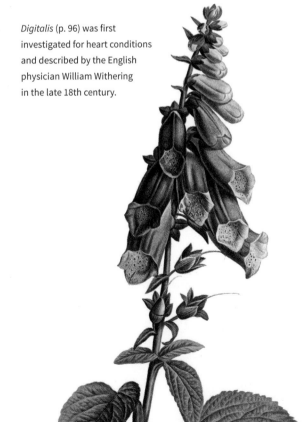

Digitalis (p. 96) was first investigated for heart conditions and described by the English physician William Withering in the late 18th century.

Pharmacology is just toxicology at another dose!

It's not all good news. Drug resistance and toxicity are challenges that pharmacologists are still trying to overcome. Toxicity is an issue with any drug, as there's frequently a fine line between beneficial and detrimental effect. Plant-derived cancer drugs are often highly effective in killing cancerous cells, but that frequently comes with unpleasant side effects, so the search is on for less toxic but equally effective analogs.

The other danger is a reliance on herbal supplements as anticancer treatments. A cursory search online will reveal plants that promise the earth but are not backed up by scientific evidence, and which may even be dangerous. Choosing these instead of conventional medicine is not recommended, although, with medical advice, they might be helpful as an adjunct therapy, particularly to help with the side effects of chemotherapy and radiation therapy.

It is a complex area and one that's difficult to get right, but the world of plants has generated some powerful painkillers. Two of the key ones are featured in this book. Opium, from the poppy *Papaver somniferum* (p. 144) has been known for centuries to relieve pain. In the 1800s, morphine was isolated from opium and founded the area of alkaloid research, which continues to this day. Like its derivative, heroin, morphine is addictive, so several morphine-like drugs have been synthesized to minimize adverse effects and the potential for abuse.

The willow tree (*Salix alba*, p. 168) contains salicylate, which is used to make aspirin. Aspirin was one of the first drugs to be regularly used globally: in the 1950s it was recorded in the *Guinness Book of Records* as the most frequently used painkiller—and that is still true.

NATURE'S PHARMACY

Herbal medicines have many attractive features that draw people to them: They can often be taken long-term (which is useful in chronic conditions) and sometimes in conjunction with prescription medicines; they are frequently gentle and mainly safe. With care, they are a renewable resource.

Medical herbal practitioners take a holistic approach. Over the last 30 years or so the rise in popularity of herbal medicines has mirrored the rise in all alternative therapies. Looking at the person as a whole—as an individual with both physical and mental needs, and taking the time to focus on that person—is a cornerstone of alternative therapies.

Herbal medicines treat many conditions, some of which are featured here (see the table beginning on p. 212 for an overview) and discussed under individual plants. It is not an exhaustive list. This book covers 100 plants, to give a snapshot of this fascinating field, but herbal practitioners regularly use many more than these. And they often combine plants to create a specific treatment package. Medical herbalists don't only treat existing conditions. Preventing illness and enhancing health—for example, by encouraging a healthy gut flora—is all part of their remit.

Herbalists use whole plants or purified extracts of plant parts. For many plants, the active components are known; for others, they are not or it's not possible to isolate them without losing the plant's efficacy. In contrast, chemists and pharmacologists have spent decades isolating and refining several active principles from plants to produce drugs that have revolutionized some areas of medicine, for example, cancer, cardiology, and pain (see p. 14).

From poultice to pill

Herbal medicines come in a bewildering array of concoctions, which vary hugely in the concentration and standardization of the active principles. This is one area where consulting an expert could make all the difference to your health. Generally speaking, herbal preparations range from infusions and poultices—relatively unprocessed plant parts—to tablets and capsules containing purified and often highly concentrated extracts.

"Clinical trials"

"Trial" is an apt word here. In ancient times, finding the best remedies sometimes meant trial by death. These early "trials" were nothing like the rigorously designed clinical studies of today's modern medicine, but the evidence gleaned from long-term anecdotal use and current scientific, pharmacological, and medical knowledge informs the modern use of herbal medicines.

Herbal medicines come from a range of different plant parts, from the glossy purple berries of elderberry (*Sambucus nigra*, p. 172) to the knobbly rhizomes of ginger (*Zingiber officinale*, p. 210).

Narrowing down

This book follows the tradition of ancient herbals, with a modern slant of evidence-based science and medicine. Choosing just 100 plants can be a cherry-picking exercise, but some key factors drove the selection, to achieve as much balance and breadth as possible:

- Type of plant (from tiny perennials to tall trees)
- Edible—or most definitely not!
- Varying worldwide habitats
- The range of medical conditions (see the table beginning on p. 212)
- Historical and traditional uses
- Current bestselling herbs
- More recent discoveries, or new uses for old plants
- Important drugs derived from plants (cardiology, cancer, pain control)
- Available scientific and clinical data (www.ncbi.nlm.nih.gov/pubmed)

Each entry gives the plant's Scientific and common names, along with a detailed botanical illustration and sections detailing key information about the plant

Classification and habitat—following the Linnaean system of plant nomenclature (*Genus* followed by *species*), type of plant, derivation of common name, how it grows and where, preferred growing conditions

Harvesting—time of year, which plant parts, and how plants are prepared for use (tinctures, extracts, etc.)

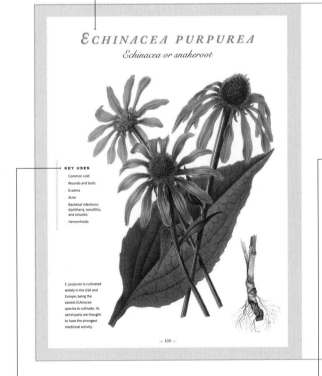

ECHINACEA PURPUREA
Echinacea or snakeroot

KEY USES

Common cold
Wounds and boils
Eczema
Acne
Bacterial infections: diphtheria, tonsillitis, and sinusitis
Hemorrhoids

E. purpurea is cultivated widely in the USA and Europe, being the easiest Echinacea species to cultivate. Its aerial parts are thought to have the strongest medicinal activity.

Classification and habitat

Eleven species of hardy, herbaceous perennials make up this genus, which is native to the eastern USA. Echinacea is a popular garden plant, making a colorful border display from midsummer to early fall. It does need full sun and fertile, well-drained soil. *E. purpurea* grows to a height of 4ft (1.2m) and produces numerous daisy-like, honey-scented pink-purple flowers, with conical orange-brown centers, for cutting.

The genus name *Echinacea* comes from *echinos*, the Greek word for "hedgehog," describing the prickly scales of the plant's seed head.

Harvesting

Aerial parts, rhizomes, and roots are harvested in the fall. Echinacea extracts are widely available either in a liquid form or as powders or tablets.

Living up to its name?

It's fair to say that, despite centuries of traditional use and a regular slot in the top 10 selling herbs list, there is some disagreement as to whether echinacea really boosts the immune system and helps cure the common cold. This is partly down to variable preparations, or poorly designed or over-hyped experiments, and partly because, in the wake of a wealth of anecdotal evidence, there is a lack of financial incentive to investigate echinacea's properties fully. This is a common issue in the field of herbal medicine, unless there is even a hint that a plant might cure cancer—and that's not currently on the horizon for echinacea!

CAUTIONARY NOTES

High doses can cause nausea. Long-term use is not recommended.

Medical use

E. purpurea, together with *E. angustifolia* and *E. pallida*, has been used throughout history to treat all manner of ailments, from the everyday cold, respiratory symptoms caused by bacterial infections, to wounds, snake bites, and blood poisoning.

Echinacea is most commonly used nowadays as a short-term treatment for common colds and sore throats and to boost the immune system. The jury is still out as to how it works—or if it really does—but even a cursory glance at the scientific literature will reveal studies showing how it purportedly enhances the activity of white blood cells, in various ways.

The most sensible, and possibly the most accurate, advice seems to be to take it at the onset of a cold, which may decrease its duration and severity. Even a weak effect is worth it and short-term use of the recommended dose is unlikely to do you any harm.

Scientists have tried to isolate the active ingredient in echinacea and have identified at least three different classes of compounds. In isolation, they may show some activity but it seems to be the sum of these parts that has the most effect. The hunt continues. One group, which were first discovered approximately 10 years ago, the phylloxanthobilins (natural products that arise from the degradation of chlorophyll) are attracting attention as possible candidates for the active principle accolade.

Echinacea angustifolia
Narrow-leaf coneflower

In its cultivated form, this plant joins *E. purpurea* as one of the main medicinal sources of echinacea.

Key uses—actions and conditions treated

Medicinal use—historical/ modern day use and scientific/ medical research

Cautionary notes—specific things to watch out for with this plant

ACTAEA RACEMOSA
Black cohosh

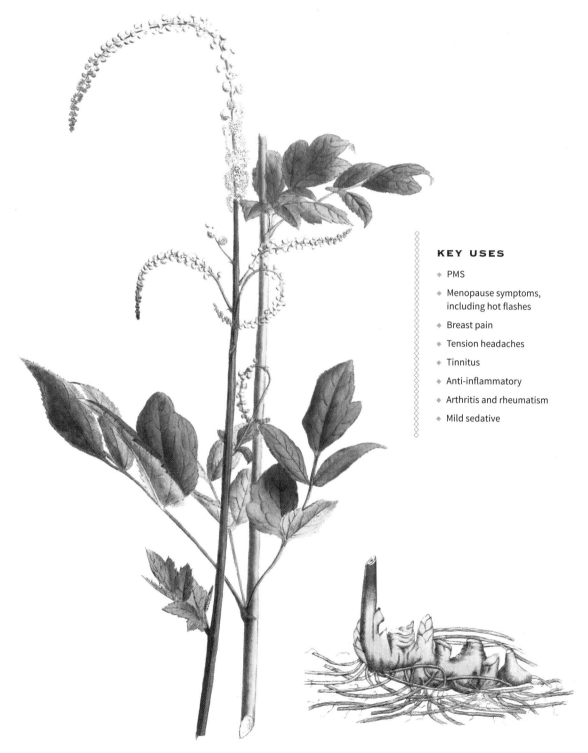

KEY USES

- PMS
- Menopause symptoms, including hot flashes
- Breast pain
- Tension headaches
- Tinnitus
- Anti-inflammatory
- Arthritis and rheumatism
- Mild sedative

Classification and habitat

Black cohosh is a North American species of *Actaea*, the hardy herbaceous perennials that are found in northern temperate regions. This tall woodland plant grows to around 5ft (1.5m) and produces slender, bottle-brush spikes of small white flowers in midsummer. Black cohosh grows easily in rich, moist soil in light shade.

The name of this plant, which was introduced to early settlers by Native Americans, comes from the Algonquin word *cohosh*, meaning "knobby, rough roots." Another name, "bugbane," describes the insect-repelling quality of its flowers.

Harvesting

The rhizome and roots are harvested in fall and used fresh in tinctures or dried for use in liquid extracts or capsules.

Medical use

Native American women traditionally relied on black cohosh, or squaw root, for female-specific ailments, particularly for menstrual pain and difficult childbirth, but also more generally for arthritic and rheumatic pain. Studies show that it is a mild sedative and has an anti-inflammatory action.

By the 1800s, herbal healers became convinced that black cohosh was a panacea and its uses ranged from snakebite to smallpox to hypochondria. Nowadays, black cohosh regularly features in lists of top 10 selling herbs.

Black cohosh supplies estrogenic sterols and glycosides (chemicals that help the body produce and use a variety of hormones) and has become the herb of choice for treating menopausal symptoms. Although a 2012 Cochrane Review by Leach et al. found evidence that black cohosh may be as effective as hormone replacement therapy (HRT) for relieving hot flashes, night sweats, and headaches, results from some studies were inconclusive. This finding is likely to be due to the difficulty in standardizing and taking the correct quantities of the active components of the herb. In addition, combining black cohosh with sage (*Salvia officinalis*, p. 170) and St. John's wort (*Hypericum perforatum*, p. 124) may be the best way forward in treating menopause difficulties.

A healing wand

In the spring, black cohosh resembles an arthritic limb, curled in on itself. As it grows, it opens and straightens, brandishing its magic wand of elegant white flowers, an analogy for its traditional use in oils to soothe painful limbs.

CAUTIONARY NOTES

Although black cohosh may take up to three weeks to have an effect, long-term use (greater than six months) is not recommended, as this may result in liver disorders.

Pregnant women should avoid this herb as it can stimulate premature uterine contractions.

ADONIS VERNALIS
Yellow pheasant's eye

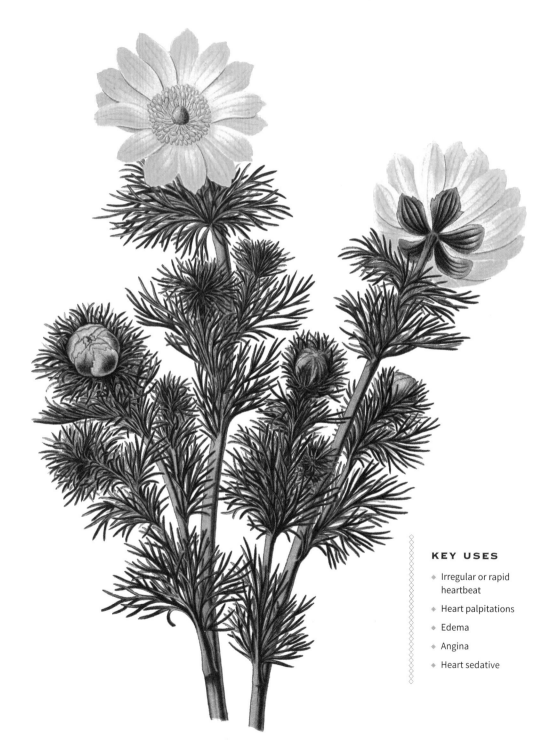

KEY USES

- Irregular or rapid heartbeat
- Heart palpitations
- Edema
- Angina
- Heart sedative

Classification and habitat

Adonis vernalis is one of about 20 species of annuals and herbaceous perennials that make up this genus, which grows in temperate Europe in a variety of habitats. *A. vernalis* is rare and protected in many areas. Most flowering plants are hermaphrodites, although the male and female sex organs are not always contained within the same flower; when they are, as for *A. vernalis*, they are sometimes referred to as "perfect flowers."

The genus is named after Adonis, the beautiful boy of Greek mythology who was killed by a boar. The solitary yellow flowers resemble large buttercups. Adonis' return to life, as his blood touched the earth, is represented by these striking flowers, heralding the arrival of spring.

This ornamental plant (height 6–16in, 15–40cm) grows in light, well-drained gritty or rocky garden soils, enriched with leaf mold. Full sun suits its showy nature.

Harvesting

The whole plant is used. Plants are cut when in full flower, then dried for use in liquid extracts and tinctures. It should be harvested every year, as the dried herb does not keep well.

Medical use

A. vernalis contains glycosides that have both tonic and sedative effects on the heart. It is an ingredient of several proprietary German preparations for heart complaints and low blood pressure; it is also found in Bekhterev's Mixture, a Russian formulation for heart conditions. *A. vernalis* is used for cardiac insufficiency,

Watch this space!

In 2019, a review of *A. vernalis* by Shang et al. highlighted that, since the first compound was isolated from *Adonis* plants in the early 19th century, more than 120 compounds have been isolated and identified. Fifty-four cardiac glycoside compounds were identified as active components and, in 1918, a method for the preparation of an active digitalis-like glucoside from *A. vernalis* was developed. Alongside these cardiac glycosides, a flurry of research studies since 2000 has revealed a whole host of further compounds with potential antimicrobial, anti-inflammatory, neuroprotective, and anti-allergic properties.

irregular or rapid heartbeat, mitral stenosis (a narrowing of the mitral valve), and edema (swelling) caused by heart failure. The cardiac glycosides are similar in effect to those found in foxglove species (*Digitalis,* p. 96) but the effects are not cumulative, hence its popularity in proprietary preparations. The glycosides improve the heart's efficiency, increasing its output at the same time as slowing its rate. *A. vernalis* can also be used when *Digitalis*-derived compounds have failed to treat heart problems, particularly in cases where there is coexisting kidney disease.

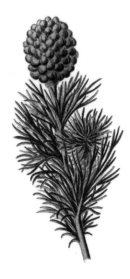

CAUTIONARY Notes

The cardiac glycosides in A. vernalis *are poisonous, so the use of this plant is heavily regulated, requiring a one-to-one consultation with a medical or herbal practitioner.*

A. vernalis can be grown from seed but, once established, it does not take kindly to being moved or transplanted elsewhere.

Aesculus Hippocastanum

Horse chestnut or buckeye tree

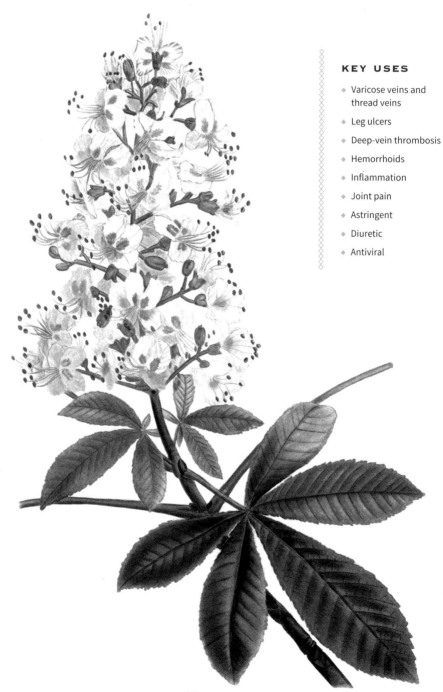

KEY USES

- Varicose veins and thread veins
- Leg ulcers
- Deep-vein thrombosis
- Hemorrhoids
- Inflammation
- Joint pain
- Astringent
- Diuretic
- Antiviral

Classification and habitat

One of a genus of 13 species of deciduous trees and shrubs, and native to the Balkan Peninsular, *A. hippocastanum* is now found growing in woodlands in many parts of Europe. In the USA and Europe it is often planted as an ornamental tree in towns and parks. *A. hippocastanum* chestnut extracts are used in herbal medicine. Four other *Aesculus* species grow in the USA: *A. glabra*, *A. octandra*, *A. pavia*, and *A. californica*. They are called buckeyes because their large seeds resemble the eye of a buck, or male deer.

Horse chestnuts are large trees, regularly growing to a height of 130ft (40m). Erect spikes of white, pink, or yellow flowers (depending on the species) appear in late spring, giving way to the spiny green fruit with shiny brown seeds in late summer and fall.

Harvesting

Horse chestnuts are ripe in the fall and can be harvested from the ground as they drop from the trees.

The seeds are hard to cut but can easily be ground in a coffee grinder and steeped in alcohol for two weeks to extract the active compounds. Adding this extract to base oils or creams creates a skin ointment, for external use only.

CAUTIONARY NOTES

*Horse chestnuts—or conkers, as they're known in the UK—have a poisonous outer shell. They should not be confused with the edible sweet chestnuts that are delicious when roasted and come from the sweet or Spanish chestnut tree (**Castanea sativa**).*

People on blood-thinning medication such as warfarin or aspirin should avoid horse chestnut-derived treatments, as their ability to reduce blood clotting enhances the action of these drugs.

Horsey business

There are several explanations for the name *hippocastanum*. It may describe horse chestnuts' use as fodder, the small horseshoe-like markings on the branches—the scars left where leaves previously grew—or horse chestnuts' traditional use as a treatment for equine respiratory conditions. Regardless, the chestnut-coated horse is an accurate comparison for the seeds' rich color.

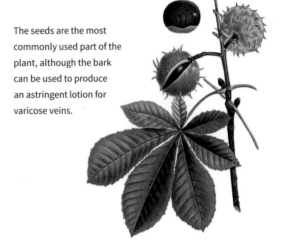

The seeds are the most commonly used part of the plant, although the bark can be used to produce an astringent lotion for varicose veins.

Medical use

Horse chestnut seeds, bark, twigs, and leaves are all used in traditional Chinese medicine: to treat blood circulation problems; as an astringent, a diuretic, an anti-inflammatory, or an expectorant in respiratory disorders; and to fight viruses.

Horse chestnuts contain aescin, which acts on the elasticity of blood vessels, helping to restore their strength and hence improve the flow of blood through them. A 2019 scientific review by Gallelli concluded that aescin can treat bruises, sprains, crush injuries, varicose veins, thread veins, and piles; aescin is now extracted from horse chestnuts and added to locally applied creams and oral capsules for these conditions. Horse chestnuts are also rich in the natural anti-inflammatory quercetin, which is good for swollen, painful joints and hemorrhoids or piles.

ALLIUM SATIVUM
Garlic

KEY USES

- Antibacterial
- Antiviral
- Antifungal
- Antioxidant
- Reduces blood pressure, cholesterol, and blood sugar levels
- Expectorant
- Acne
- Supports beneficial gut bacteria

Classification and habitat

Allium sativum belongs to the onion family of Amaryllidaceae and is one of the 700-plus species of the *Allium* genus. Garlic is an ancient medicinal plant and, with its superhero status, is one of the most heavily researched plants today. It was used by the Babylonians (c. 3000 BCE), found in the tomb of Tutankhamun (14th century BCE), and consumed in large amounts by the Greeks and Romans. Garlic was first mentioned in traditional Chinese medicine c. 500 CE.

A. sativum is a perennial, growing to a height of 36in (1m) and producing a bulb of 5–15 cloves encased in a papery white or mauve-tinged skin. Garlic will grow from bulbs or individual cloves planted in fall or winter. In rich, well-drained soils in full sun, these will produce many bulbs of garlic the following summer.

Harvesting

Garlic bulbs are harvested in late summer and early fall and left to dry in the sun before being stored at 37–41°F (3–5°C). The cloves of garlic can be crushed and eaten both raw and cooked, or processed for a tincture or oil capsules.

Each bulb of garlic comprises up to 12 cloves. Eating four cloves a day may be as effective as prescription drugs in lowering high blood pressure, but this quantity of garlic is probably best taken in capsule form!

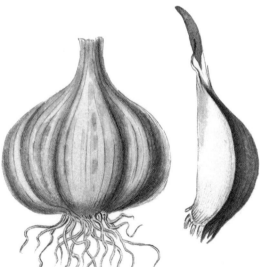

Kitchen medicine

Combining a crushed garlic clove with the juice of a freshly squeezed lemon (*Citrus limon*, p. 76), chopped ginger root (*Zingiber officinale*, p. 210) and a teaspoon or two of honey produces a comforting and effective home remedy for colds, coughs, and sore throats.

Medical use

Before the advent of modern antibiotics, garlic was used to ward off and treat bacterial infections. The Egyptian pharaoh Khufu ordered his workers building the Great Pyramid to have a daily ration of garlic, to give them strength and protect them against epidemic infections. More recently, garlic was used in, for example, World War I wound dressings. Nowadays, it still plays a role in treating all type of infections, both viral and bacterial, either alongside antibiotics or as a preventative and a boost to the immune system.

Based on fresh weight, garlic contains 1.1–3.5 percent sulfur-containing glycosides, which is significantly higher than other plant foods. These compounds, including allicin, are thought to be responsible for the numerous health benefits of garlic, especially its broad-spectrum antibacterial activity. For example, a 2017 study by Reiter et al. showed that allicin inhibited the growth of three bacteria that cause lung infections: *Streptococcus pneumoniae*, *Pseudomonas aeruginosa*, and *Staphylococcus aureus*. In the battle against bacterial antibiotic resistance, finding antibiotic candidates from the plant world may be one way to win the fight.

CAUTIONARY NOTES

Garlic thins the blood, so those on blood-thinning medication like warfarin should avoid eating large quantities of raw garlic.

PACKING A PUNCH

Thanks to its potent flavor, garlic is indispensible in the kitchen, but it is the plant's medical benefits—from helping to prevent cardiovascular disease to decreasing the risk of cancer—that make this one mighty bulb.

Taken long term, garlic can help to prevent heart attacks and strokes by decreasing atherosclerosis (narrowing of the arteries), thinning the blood, and lowering cholesterol levels. Allicin facilitates nitric oxide release, which improves heart health by reducing blood pressure and preventing blood clots. In the 1st century CE, the Greek physicians said that "garlic clears the arteries and opens the mouths of the veins" (a statement that is often attributed to Dioscorides). This vasodilatory effect and improved blood flow is now well documented in the medical literature.

And while it's impossible to lay the longevity of certain Mediterranean populations at the door of garlic, it no doubt contributes to their health and wellbeing.

An ode to odor

Garlic's characteristic smell is caused by sulfur-containing glycosides like allicin, which have the greatest benefit on the circulatory, digestive, and respiratory systems. Garlic is the most pungent of alliums, and this correlates with its strong therapeutic potential. To harness garlic's healing power, it is best eaten raw or taken in capsules containing pure garlic oil; the active compound allicin, released when a garlic clove is crushed, is unstable and quantities diminish as it is cooked.

The slightly yellow and oily allicin is one of the chemicals behind garlic's powerhouse of activity. Allicin is antibacterial (including showing activity against antibiotic-resistant bacteria), antifungal, antioxidant, antiparasitic, and antiviral.

Allicin in garlic is thought to be one natural way of inhibiting the formation of fatty deposits (plaque) that impede the flow of blood through blood vessels.

Unimpeded
blood flow

Fatty deposits form
inside blood vessels

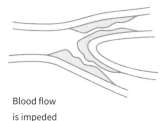

Blood flow
is impeded

The breakdown products of allicin circulate throughout the body—into our blood, sweat, and urine. Since humans and animals are exquisitely sensitive to the tiniest amounts of sulfur compounds, garlic can be smelled several days after a heavy night on the stuff. Eating raw garlic may not win you many friends, but parsley (*Petroselinum crispum*, p. 150) will counteract some of the odor and odorless garlic capsules are available.

Flavorsome fuel for all

Garlic enhances the flavor of most meats, seafood, and many vegetables. It is an essential ingredient in cooking around the world, especially in the Mediterranean, the Middle East, Asia, the West Indies, Mexico, and South America. Raw garlic is the main flavor in sauces such as aioli (Southern France and Spain), skordalia (Greece), persillade (France), gremolata and pesto (Italy), and is added as a condiment to butter, oil, vinegar, and salt.

Alongside its many therapeutic effects, dietary garlic has attracted more interest recently for its ability to manipulate our gut microbiome, for the better. Like other vegetables that are prebiotics (such as onions, leeks, fennel, asparagus, Jerusalem artichokes, and chicory), garlic contains high quantities of inulin. This fiber may be indigestible for humans but it is manna from heaven for our gut flora, encouraging the growth and function of the "good" bacteria, and damping down those "bad" ones.

A stake through the heart of cancer

There are many superstitions about garlic: It wards off the devil and vampires, causes moles to leap out of the earth, and, if chewed, prevents competitors getting ahead in races. Folklore aside, these myths really attest to garlic's medical power, especially in countering infections, improving heart health, and decreasing cancer risk. Eating garlic lowers the risk of getting several cancers including colorectal cancer. Research shows that the active compounds in garlic help with the repair of damaged DNA, decrease inflammation, and slow cancer cell growth.

Garlic contains antioxidants, like allicin, that are essential for optimal health. These compounds help decrease free radicals, which damage cells and lead to disease, including cancer.

ALOE VERA

Aloe vera

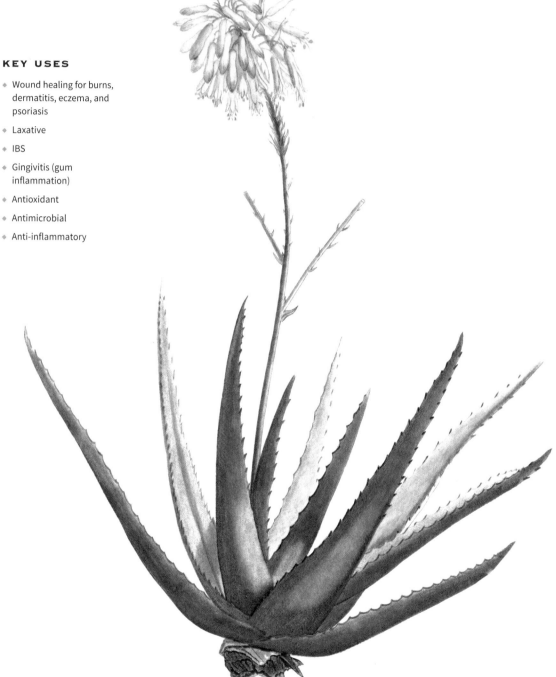

KEY USES

- Wound healing for burns, dermatitis, eczema, and psoriasis
- Laxative
- IBS
- Gingivitis (gum inflammation)
- Antioxidant
- Antimicrobial
- Anti-inflammatory

Classification and habitat

Aloe is a genus that contains more than 500 species of succulent flowering plants, many of which are native to North Africa. *A. vera*, although originally from the Arabian Peninsula, is now grown commercially worldwide. Even in northern climes, it can be cultivated as a house plant. It grows in light, sandy soil, under warm conditions, to a height of 2ft (60cm). The fleshy, tapering leaves form a dense rosette and, when mature, *A. vera* has yellow or orange bell-shaped flowers.

Aloe is derived from the Arabic word *alloeh*, meaning "bitter and shiny substance," and *vera* from the Latin word for "true." *Aloe vera* is often known as a "first aid plant."

Harvesting

The glutinous gel is harvested from the succulent leaves of two- or three-year-old plants. It is used not only for medical purposes but also for food flavoring and supplements, as well as in cosmetics.

Medical use

A. vera has been used therapeutically for centuries in many countries. The ancient Egyptians recorded its use in a papyrus dated to the 16th century BCE and described it as the "plant of immortality." When a Pharaoh died, a mix of aloe and myrrh was used for embalming. Similarly, in the New Testament, St. John describes how the body of Jesus was wrapped in linen impregnated with myrrh and aloes.

Forging a path

Recent research is focused on the strength of the *A. vera* polysaccharides as carrier molecules that improve the absorption of oral drugs across the gut wall and into the bloodstream. A 2019 study by Haasbroek et al. describes how these polysaccharides open up the so-called tight junctions between the epithelial cells that line the gut, making it more permeable.

The clear gel that oozes from a cut leaf can be applied directly to the skin to soothe itchy, hot sunburn, nettle rash, insect bites, and minor burns.

Fingernail "friend"

One of the plant's historical uses is for gum and throat irritations. *A. vera* in the mouth can be an unpleasant experience—as any nail biter who had bitter aloes painted on their fingernails as a child will attest!

The medical literature is right behind the traditional use of *A. vera* in wound healing. The gel can be applied neat to inflamed skin, where it acts as a protective barrier and has antibacterial and anti-inflammatory properties. *A. vera* is also thought to minimize scar formation. But the jury is still out on many of its other uses, such as in the treatment of irritable bowel syndrome (IBS) or as a laxative. Leaf extracts contain about 200 active chemical compounds. Many of the health benefits associated with *A. vera* have been attributed to the polysaccharides, or complex carbohydrates, contained in the leaf gel.

CAUTIONARY NOTES

Applying aloe to open wounds is not recommended. It is advisable to test on a small patch of skin before applying A. vera, to check for allergic reactions. Take internally only after medical advice.

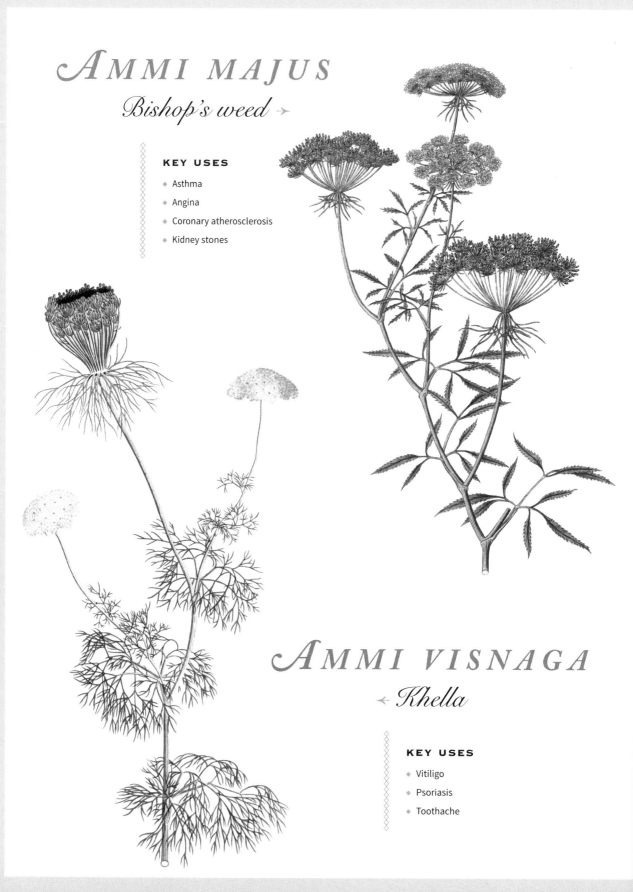

AMMI MAJUS
Bishop's weed →

KEY USES

- ◆ Asthma
- ◆ Angina
- ◆ Coronary atherosclerosis
- ◆ Kidney stones

AMMI VISNAGA
← *Khella*

KEY USES

- ◆ Vitiligo
- ◆ Psoriasis
- ◆ Toothache

Classification and habitat

This genus is made up of 10 species of annuals and biennials distributed throughout southwestern Asia to southern Europe and neighboring Atlantic islands. *A. majus* is an attractive, white-flowered ornamental, grown for the cut flower market. Its delicate, lacy appearance combines well with tall, more colorful annuals. *A. visnaga* has yellow-white flowers that grow on stalks that thicken and remain erect after flowering. It is native to the eastern Mediterranean, particularly Egypt. Both species grow to heights of 18–30in (45–75cm).

A. majus is a hardy plant and *A. visnaga* half-hardy. They both grow in well-drained soil in full sun.

Harvesting

For both *Ammi* species, the seeds are used and gathered when ripe. They are dried for powders, tinctures, and liquid extracts.

Medical use

Both of these *Ammi* species have powerful therapeutic actions and have long been used in the Middle East.

A. majus is used for the treatment of the autoimmune skin condition vitiligo, where the body destroys the cells that produce melanin. The active ingredient in *A. majus* is psoralen, which stimulates melanin production in skin when it's exposed to ultraviolet from a special lamp. This treatment is sometimes called PUVA (psoralen and UVA light). In Morocco, *A. majus* is called *cure-dents du Prophète* ("Prophet's toothpick"), as it's used as a gargle for toothache.

A. visnaga is one of those plants that have changed the world, as it provided one of the first drugs to target asthma. The ancient Egyptians used this fruit, which is now known to contain a molecule called khellin that relaxes smooth muscle. It was first isolated in 1879, but it was in 1946 that an Egyptian scientist discovered that extracts of the fruit had a powerful effect on the coronary arteries and the bronchioles of the lungs, where it relieved the symptoms of asthma. The

Sew directly outdoors from early spring onward and *Ammi majus* will flower from late spring to early summer, producing heads of tiny white flowers.

Adding to the list

Cancer researchers are always on the lookout for new drugs and *A. majus* has yielded some exciting molecules. Research in 2017 and 2018 by Mohammed and El-Sharkawy has added at least five newly identified molecules to the list, all of which show strong cytotoxic potential against cancer cells in laboratory conditions.

dilation of bronchial, urinary, and blood vessels occurs without affecting blood pressure.

In the 1950s, researchers synthesized and modified khellin, trying out over 200 compounds before finding one in 1965 that met the criterion of providing more than six hours of protection. This drug, disodium cromoglycate, is still used in inhalers to prevent asthma attacks.

Adding *A. visnaga* fruits to your diet is thought to prevent and manage kidney stones, due to the actions of two of its major constituents, khellin and visnagin.

CAUTIONARY NOTES

Care is needed when handling any plants from the Ammi genus, as the sap may irritate the skin. Its photoactive compounds can cause blistering to normal skin on sun exposure.

ANANAS COMOSUS
Pineapple

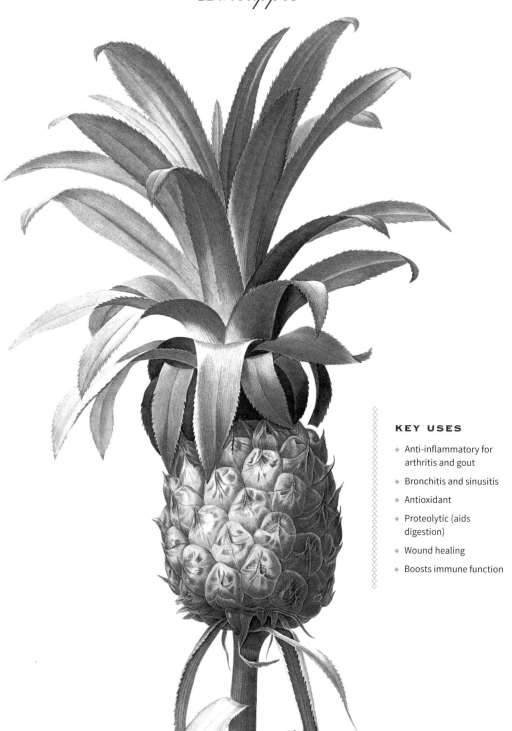

KEY USES

- Anti-inflammatory for arthritis and gout
- Bronchitis and sinusitis
- Antioxidant
- Proteolytic (aids digestion)
- Wound healing
- Boosts immune function

Classification and habitat

Ananas is a plant genus in the family Bromeliaceae. It is native to South America and includes the species *A. comosus*, the pineapple. This is a spectacular plant (maximum height 6ft, 1.8m) that is now grown commercially in many warm regions worldwide. In temperate regions, pineapples can be grown in hothouses. The pineapple is a large tropical fruit with spiny leaves, whose common name is derived from its resemblance to a pine cone.

The Latin genus name *Ananas* comes from the Amazonian Tupi word *nanas*, meaning "excellent fruit." *Comosus*, or "tufted," refers to the arrangement of the leaves.

Harvesting

Several parts of the pineapple plant are harvested, including the stem, fruit, leaves, and peel. As well as the need to grow pineapples for food, high demand for bromelain in the pharmaceutical, clinical, and industrial fields has resulted in gradual increases in bromelain production. To cope with this, recombinant DNA technology has emerged as an alternative route for producing large amounts of ultra-pure bromelain enzymes.

Medical use

Historically, pineapple was used in Central and South America for a variety of ailments, including digestive disorders. Bromelain is a crude extract of pineapple that contains, among other components, various closely related proteases—prote-olytic enzymes that break down proteins and help with digestion. Although these enzymes are produced in the pancreas, certain foods also contain proteolytic enzymes.

Papaya (papain) and pineapple (bromelain) are two of the richest plant sources, explaining their traditional use as natural tenderizers for meat. These enzymes act as an aid to protein digestion, and their internal absorption may go beyond the gut, with a whole host of benefits attributed to bromelain. For example, as a dietary supplement, it may reduce inflammation and

Hothousing

John Evelyn (1620–1706), an English garden writer, developed a method of growing exotic plants in cold climates by planting them in deep pits filled with steaming dung. Pineapples grown in these "stoves" thrived and the newfound passion for such plants initiated the "greenhouse" revolution. One of the first to be built was commissioned by Queen Anne in 1704, at the Royal Palace, Kensington Gardens in London.

pain, particularly in rheumatic diseases and sports injuries; alleviate bronchitis and sinusitis; and aid digestion. Bromelain is applied to the skin to promote the healing of wounds and burns.

Several studies in 2019 (Chang et al.; Lee et al.) have highlighted bromelain's potential as an anti-cancer agent, by inhibiting cancer cell growth in laboratory experiments on, for example, oral carcinoma and colorectal cancer cells. Scientists are still working out bromelain's mode of action, but it's not all down to the proteolytic enzymes. Other factors are at work. This is also true for bromelain's ability to modulate the immune system, and its potential to eliminate burn debris and accelerate wound healing. Like *Aloe vera* (p. 28), bromelain may also aid the absorption of drugs, especially antibiotics.

Fresh is best

The proteolytic enzymes in bromelain are destroyed by canning, so fresh pineapple fruit is best for medicinal purposes. Bromelain is also present in the leaves and stem but these sources have much lower proteolytic activity than the fruit-derived bromelain.

CAUTIONARY NOTES

Bromelain should only be taken under medical supervision.

ANDROGRAPHIS PANICULATA

Green chiretta

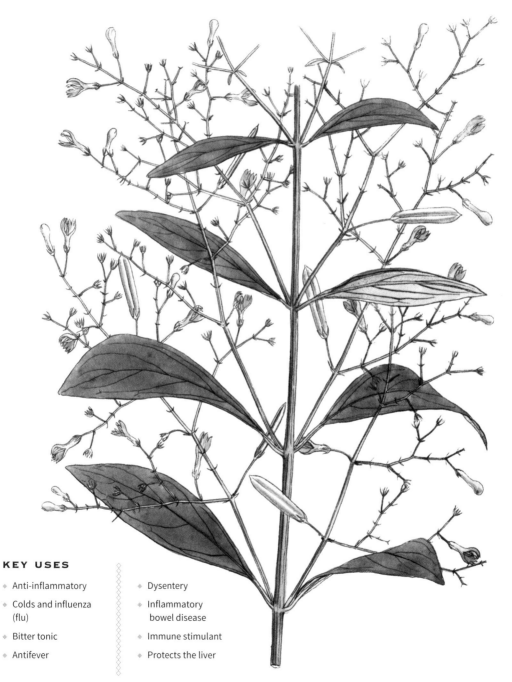

KEY USES

- Anti-inflammatory
- Colds and influenza (flu)
- Bitter tonic
- Antifever
- Dysentery
- Inflammatory bowel disease
- Immune stimulant
- Protects the liver

Classification and habitat

Andrographis paniculata, commonly known as creat or green chiretta, belongs to the family Acanthaceae. It is an annual herbaceous plant that grows best in sunny locations. It is native to India and Sri Lanka but is now found in other Asian countries, including Malaysia, Indonesia, and the Philippines. In India, where it occurs commonly in most regions, including the plains and hilly areas up to 1,600ft (500m), its use is widespread. *A. paniculata* grows as an erect herb to a height of 12–42in (30–110cm), with small, pink solitary flowers appearing from early fall to early winter.

Harvesting

The leaves and fresh shoots of *A. paniculata* are harvested from wild or cultivated plants, to make infusions, tinctures, or tablets.

Biological control

A. paniculata leaves may be a flavorsome addition to the human diet, but they leave a bitter taste—and more—in the mouths of predators. Insect pests cause significant damage to crops and reduce crop yields. Biological control methods are increasingly recognized as one way to avoid using agrochemicals that damage the environment and enter the food chain. Crude extracts of A. paniculata have been shown to control a number of pests, including one that infects cotton (*Gossypium hirsutum*, p. 116)—the spiny bollworm, *Earias vittella*.

CAUTIONARY NOTES

Like many herbs, chiretta should not be taken during pregnancy or when breastfeeding. People with liver disorders should also avoid it.

Medical use

Chiretta has a powerful bitter taste that stimulates digestive and liver activity and counters infection. Highly prized in both Chinese and Ayurvedic medicine, where it is particularly valued as a digestive remedy, it has traditionally also been used to treat diabetes, malaria, dysentery, and intestinal worms.

In the West, it is used mainly as an immune-enhancing herb, making it a key remedy for protecting against upper respiratory infections, including cold, flu (influenza), and tonsillitis. A meta-analysis in 2017 by Hu et al. suggested that for both the common cold and, to a lesser extent, flu infections, taking *A. paniculata* can reduce both the severity of symptoms and how long they last.

Chiretta is also being investigated for its potential ability to treat cancer. For example, a 2019 research paper by Khan et al. demonstrated how andrographolide, a bioactive compound extracted from *A. paniculata*, can inhibit the growth of colon cancer cells in vitro.

In addition, initial studies suggest that taking extracts of *A. paniculata* daily for eight weeks reduces the symptoms of inflammatory bowel disease, to a similar extent as prescription drugs (Holleran et al., 2020). Other research suggests that taking *A. paniculata* for 14 weeks reduces the symptoms of rheumatoid arthritis compared to a placebo (Burgos et al., 2009).

Chiretta combines well with milk thistle (*Silybum marianum*, p. 178), for the liver, and echinacea (*Echinacea purpurea*, p. 100), for colds and flu.

Foiling flu?

Chiretta is renowned for its ability to stimulate the immune system, making it better able to fight off infections, especially viral infections. It is frequently used to prevent and treat the common cold and flu, and chiretta reportedly stopped the Indian onslaught of the worldwide 1918 flu epidemic, although this is an unproven claim.

ARECA CATECHU
Betel nut palm

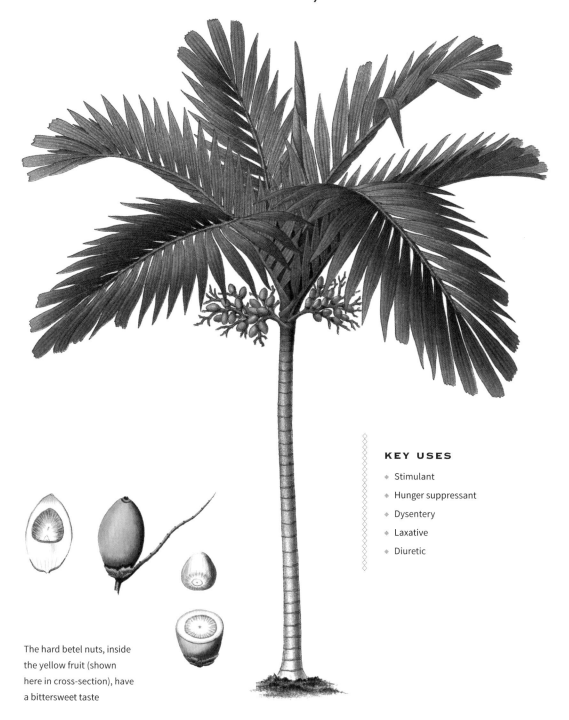

KEY USES

- Stimulant
- Hunger suppressant
- Dysentery
- Laxative
- Diuretic

The hard betel nuts, inside the yellow fruit (shown here in cross-section), have a bittersweet taste

Classification and habitat

The *Areca* genus consists of 50–60 species of tall, evergreen palms, which occur in coastal regions of India, Pakistan, Malaysia, Australia, and the Solomon Islands. *A. catechu* is a slender palm tree growing to a height of 70ft (20m). It has a grey-green trunk and pinnate leaves up to 6ft (2m) long. Trees that are older than six years produce pale yellow flowers, followed by yellow, orange, or scarlet egg-shaped fruits, each with an acorn-sized seed—the betel nut. *A. catechu* grows well in moist, well-drained soil in the sun, with high humidity and a minimum temperature of 61°F (16°C).

Harvesting

Mature nuts are usually harvested approximately nine months after flowering. The entire kernel becomes hard and firm, in contrast to the soft, jelly-like consistency of the immature kernel.

Medical use

Betel nuts have been chewed as a stimulant in India, Pakistan, and Southeast Asia since ancient times, with recorded use dated to 504 BCE. In traditional Chinese medicine, *A. catechu* is used to destroy intestinal parasites and to treat dysentery and malaria. The rind is used as a laxative and as a diuretic for edema.

The hard seed is sliced, mixed with a piece of lime and spices, wrapped in a leaf of betel pepper (*Piper betle*)—hence its name—and chewed. These so-called betel quids, or *paan*, are prepared with

Curing addiction

In 2015, Papke et al. found that arecoline from *A. catechu* works on the same receptors in the brain as another addictive drug, nicotine, raising the possibility that the drugs used for nicotine addiction could help betel nut addicts too.

and stored in elaborately decorated cutters and repositories, respectively. Betel nut is the fourth most addictive substance in the world, behind alcohol, nicotine, and caffeine, with its chewers making up at least 10 percent of the world's population (mostly in Asia and South Asia).

Betel nuts stimulate saliva flow and accelerate heart rate and perspiration. Excessive salivation means that areas where betel nut chewing is prevalent bear the evidence in the form of red-stained roads—from betel spitters! One of the main uses is to suppress hunger, while offering protection against intestinal worms. The active alkaloids in *A. catechu* are arecoline, arecaidine, guvacine, and guvacoline. These stimulants produce feelings of wellbeing and heightened heart activity, by speeding up the messages traveling between the brain and the body.

A scientific review conducted by Liu et al. in 2016 highlights the potential for arecoline in treating disorders of, for example, the nervous and digestive systems, and parasitic diseases, providing arecoline's toxic and carcinogenic effects can be minimized.

Dental records

Betel nuts are highly pigmented, turning the saliva, teeth, and gums a reddish-black color. It's a characteristic look, and archaeologists have used betel nut stains as evidence when dating human skulls.

CAUTIONARY NOTES

Betel nut use is associated with an increased risk of heart attacks and various cancers—particularly oral cancer—and behavioral and psychological disturbances.

ARNICA MONTANA
Arnica

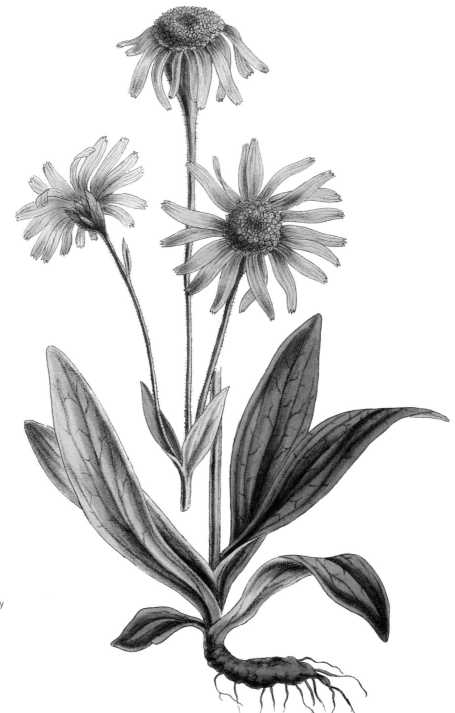

KEY USES

- Pain relief
- Wound healing
- Anti-inflammatory
- Bruises
- Sprains
- Chilblains
- Heart conditions

Classification and habitat

Arnica montana is one of the traditional European herbs, an inhabitant of acidic alpine soils in the northern hemisphere. In the genus *Arnica*, there are about 30 species of perennials with rhizomes. Growing in domestic gardens or rockeries, and being an alpine, *A. montana* needs a cool climate and dislikes wet winters: Ridges or raised beds will encourage drainage and aid its growth.

The long creeping rhizomes produce upright stems and heart-shaped leaves. Clusters of vivid yellow-green flowers appear throughout the summer. Arnica is also readily identifiable by its aromatic and pungent odor.

Arnica is an ancient Greek name, derived from *arnakis*, meaning "lamb's skin," an allusion to the soft texture of the plant's leaves. Its old English name, *fallherb*, describes its most common use.

Harvesting

The flowers are picked when fully open and dried for use in creams, gels, infusions, and tinctures.

Medical use

This healing herb was popular in Germany for short-term treatment of heart conditions, such as heart failure and coronary artery disease. The writer Johann Wolfgang von Goethe (1749–1832) reputedly drank arnica tea for his angina. Taken internally, arnica is highly toxic, so its use is now tightly regulated and restricted, but a 2016 research paper by Fiorenelli et al. showed that low doses can reduce the incidence of heart problems in patients with stable coronary artery disease.

Homeopathic versus herbal

Arnica comes in both herbal and homeopathic preparations. The latter are highly diluted, so negligible or infinitesimal amounts of active compounds remain. For this reason, homeopathic remedies are very safe but it's debatable how marked their effects are. Herbal creams and gels made with extracts of fresh arnica flowers can contain up to 64,000 times as much arnica as homeopathic remedies and hence have a much greater potential to hit the spot.

In most of Europe and the USA, arnica is most commonly applied externally for bruises, sprains, and chilblains. Native Americans rubbed mashed-up arnica flowers on bruises. A substance in arnica called helenalin relieves pain and inflammation, but its toxic nature means that finding molecular analogs is a research priority. These almost identical molecules would have the same anti-inflammatory function but be chemically altered to remove all or most of the toxicity.

Arnica's pain-relieving properties can enhance wound healing following surgery. Cumulative evidence reported in a 2016 scientific review by Iannitti et al. suggests that *A. montana* may represent a valid alternative to nonsteroidal anti-inflammatory drugs.

Arnica, like other ancient herbs, is still revealing its compounds and how they may be used as new therapies for intractable diseases like malaria (Llurba Montesino et al., 2015).

CAUTIONARY NOTES

Arnica is toxic so should only be used externally (unless recommended by a medical practitioner) or in homeopathic preparations, and should not be applied to open wounds or used by people with sensitive skin.

ARTEMISIA ABSINTHIUM

Bitter wormwood

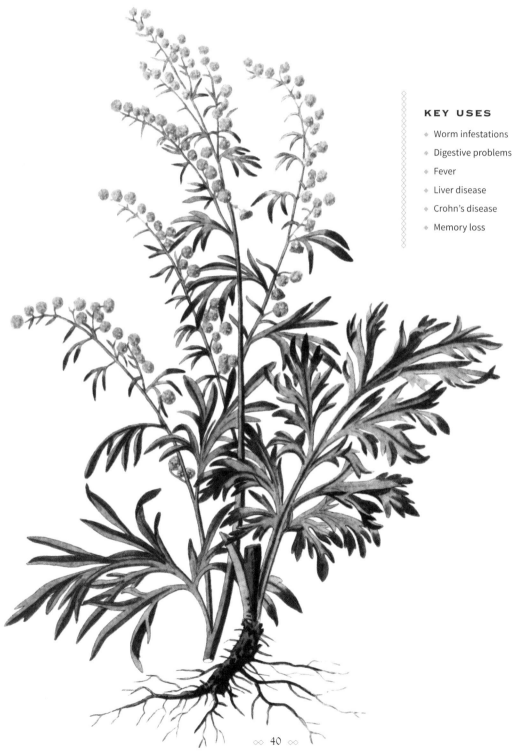

KEY USES

- Worm infestations
- Digestive problems
- Fever
- Liver disease
- Crohn's disease
- Memory loss

Classification and habitat

Artemisia is a genus of about 300 species of hardy annuals, biennials, and perennials. Many artemisias are grown as ornamentals for their finely cut, often silvery foliage and interesting aromas. They are easily cultivated, even on poor, dry soils. The cultivar "Lambrook Silver" grows to a height of 18-32in (45-80cm) and can be used to create an informal hedge, although the species grows wild on wasteland in parts of Europe, Africa, and North America.

The species name *absinthium* means "without sweetness" and refers to the plant's intensely bitter taste. The common name "wormwood" comes from the German *Wermut*, meaning "preserver of the mind," as the herb was thought to enhance mental functions.

Harvesting

Whole plants are cut when flowering; leaves are picked before flowering. All parts of the plant are dried for infusions, powders, tablets and tinctures, or oil extraction.

Medical use

As its name suggests, wormwood is a powerful worming agent (anthelmintic) that has been used for centuries to expel tapeworms, threadworms, and especially roundworms from both animals and humans. The Roman naturalist and philosopher Pliny the Elder described its use as an anthelmintic in his *Natural History,* compiled in the 1st century CE. Wormwood is one of the bitterest herbs in general use. In biblical times, its use, and in particular its bitterness, became a simile for the consequences of sin: "For the lips of a strange woman drop as an honeycomb. And her mouth is smoother than oil: But her end is bitter as wormwood" (Proverbs 5: 3–4).

In traditional Chinese medicine, *A. absinthium* is used to restore mental functions and treat stomach and throat infections, as well as being used to treat fevers.

A green spirit

Absinthe—the highly alcoholic, vivid green beverage—was traditionally flavoured with bitter wormwood. Nicknamed the "green fairy," this fatally addictive spirit was the downfall of many a 19th-century European artist. The French novelist Émile Zola wrote about the hoarse "absinthe voice," glazed eye and "clammy" hand experienced after imbibing the drink, and under its influence, the painter Henri de Toulouse-Lautrec took to shooting spiders he believed were about to attack him.

Friendly relations

Related plants include southernwood (A. abrotanum), which is, like A. absinthium, a good moth and fly repellent, characterized by its delicately scented leaves; and mugwort (A. vulgaris), from the Anglo-Saxon mucgwyrt, which is also an insect repellent.

In 1972 the compound artemisinin was isolated from another relation, sweet wormwood—A. annua (p. 42)—and shown to have potent antimalarial properties. Artemisinin was developed into an antimalarial drug and several of its derivatives are still used to treat the disease today.

CAUTIONARY NOTES

This bitter-tasting plant contains thujone, a poisonous chemical that is highly addictive and can cause seizures, hallucinations, vomiting, or even paralysis. The Swiss were the first to ban the use of wormwood oil as a flavoring in 1908 and today's successors to absinthe—anisette and vermouth—do not contain thujone, although it is said that illicit absinthe liqueurs can still be found in southern France, Italy, and Spain.

ARTEMISIA ANNUA

Sweet wormwood

KEY USES

- Fever
- Malaria
- Checks bleeding, including nosebleeds

Classification and habitat

Like *Artemisia absinthium* (p. 40), *A.annua* is often grown as an ornamental plant. It is native to temperate Asia but now also grows in many other countries, including parts of North America. *A. annua* is a large plant (height 5–10ft, 1.5–3m) that, although fast-growing, is tidy in nature and useful for filling gaps behind other plants in a border or providing contrast to smaller, more colorful plants.

The upright stems are often red and the fragrant leaves are bright green with a sawtooth appearance. Tiny yellow flowers appear in the summer months. *A. annua* is frost-hardy and grows well in sun, in neutral to slightly alkaline soil.

Harvesting

The whole plant is harvested when flowering, while leaves are picked before flowering. All parts of the plant are dried for infusions, tablets, tinctures, or oil extraction.

Medical use

Like *A. absinthium* (p. 40) this plant has a long history of traditional use. Known as *qing hao* in China, it is a major herb of this region. *A. annua* was first described (during the Eastern Jin dynasty, around 317–420 CE) as possessing powerful fever-reducing properties. The fever described is now thought to have been malarial fever: the infectious disease caused by the *Plasmodium* parasite. As this parasite became increasingly resistant to chloroquine (see p. 73) and other antimalarial drugs, Dr. Tu Youyou was commissioned by the Chinese government to find an alternative cure for malaria. This is definitely one of those cases where the records of an ancient civilization have led to a useful new drug...

In 1972, Dr. Tu isolated the compound artemisinin from *A. annua* and 30 patients with malaria were cured with the extract, showing no signs of fever or parasites in the blood. Artemisinin was developed into an antimalarial drug and, in 2015, Dr. Tu was one of three people awarded the Nobel Prize in Physiology or Medicine. In her case, it was for her lifelong study of sweet wormwood. Today, there are several derivatives of artemisinin, including artesunate and artemether, which are used in the treatment of malaria.

Artesunate can be administered intravenously, with immediate effect, making it a unique type of artemisinin-derived drug. This means it is especially suitable for the treatment of cerebral malaria, where the parasite spreads to the brain, often leading to rapid death.

Annua advances against cancer

In the 1980s researchers started investigating synthetic derivatives of artemisinin as potential anticancer agents. A 2018 review by Konstat-Korzenny et al. reported that several of these show low toxicity but high specific cytotoxic (cell-killing) activity against a range of cancers, including breast, prostate, ovary, colon, kidney, and melanoma cells.

CAUTIONARY NOTES

Artemisinin and its derivatives work for short periods of time and only against a specific stage of the malaria parasite, so the drugs are usually used in combination with other antimalarial agents. In parts of the world where artemisinin is used in isolation, the malaria parasite can develop resistance. This gift from Chinese medicine cannot be taken for granted.

ATROPA BELLADONNA

Deadly nightshade

KEY USES

- Dilates pupils
- Narcotic
- Sedative
- Rheumatic and muscular pain
- Parkinson's disease
- Motion sickness

Classification and habitat

Atropa belladonna is one of four species of tall perennials in this genus, occurring from Western Europe to North Africa and the Himalayas. It grows to a height of 3–5ft (1–1.5m) and has long, oval leaves, which grow from erect and branched stems. The purple-brown, bell-shaped flowers appear during summer, followed by shiny black berries in the fall.

The plant's name originates from the Italian *bella donna*, or "beautiful lady," as women historically indulged in the risky practice of dropping the juice of this herb into their eyes to create a much-desired wide-eyed appearance. The Latin genus name refers to one of the Greek Fates, Atropos, who held the blade that cut the thread of human life, reflecting the poisonous nature of this plant.

A. belladonna grows in well-drained, alkaline soil in sun or partial shade.

Harvesting

The whole plant is cut when flowering and dried for processing into dry and liquid extracts, tinctures, and skin preparations. The roots of two- to three-year-old plants are lifted in the fall and similarly harvested.

Medical use

Deadly nightshade has always had a mystical aura associated with it. Legends tell of the use of deadly nightshade to subdue invaders, notably in 11th-century Scotland by the last Gaelic king, Macbeth, who's said to have used it to vanquish

CAUTIONARY NOTES

Deadly nightshade ranks as one of the most poisonous plants in Europe and other parts of the world. All parts of the plant are toxic and even small doses can cause cramps, delirium, hallucinations, coma, and eventually death.

Witchcraft

Deadly nightshade is one of those plants that feature in tales of witchcraft and sorcery. The image of the witch on a broomstick has origins in the use of these plants which, when inhaled or rubbed into the skin, cause intoxicating flying sensations. Outbreaks of lycanthropy (the supposed transformation of a human into a wolf) have also been associated with ointments made from nightshades and narcotic herbs such as cannabis (*Cannabis sativa*, p. 56) and the opium poppy (*Papaver somniferum*, p. 144).

the Danish army. Before the use of modern anesthetics, *A. belladonna* was applied to the skin as "sorcerer's pomade" to make the patient unconscious before surgery.

Though widely regarded as unsafe—and certainly falling into the category of "consult a medical health practitioner before using"—*A. belladonna* is used by herbalists. The emphasis is on the clinical utility of low doses. Its use extends from controlling bronchial spasms in asthma and whooping cough to Parkinson's disease and motion sickness. In skin ointments, it's purported to ease joint and nerve pain and reduce excessive sweating.

A. belladonna contains several tropane alkaloids. Ophthalmologists use one of these, atropine, to dilate the pupils of the eye to allow them to visualize the retina. This effect is reversed by physostigmine (eserine) from *Physostigma venenosum* (Calabar bean, p. 152). A 2018 scientific review by Schittkowski and Sturm concluded that the 100-year-old practice of using atropine to arrest myopia (short-sightedness) progression is justified by the latest medical research.

Atropine can block the function of key areas of the body's nervous system, explaining *A. belladonna*'s effects on salivation, sweating, pupil size, bronchial spasms, motion sickness, Parkinson's, nerve pain, and so on.

BERBERIS VULGARIS
Common barberry

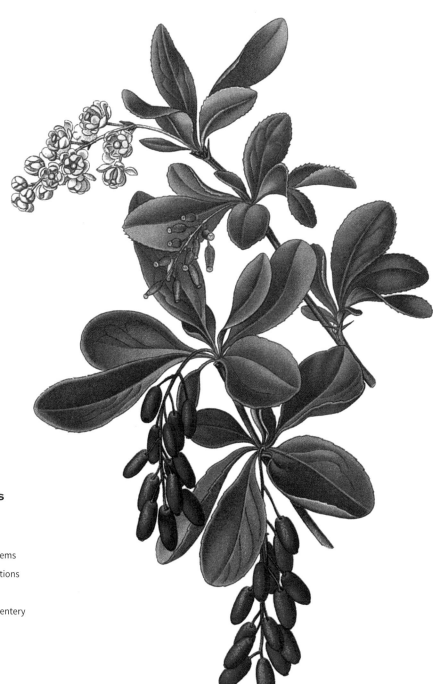

KEY USES

- Jaundice
- Gallstones
- Kidney problems
- Urinary infections
- Sinusitis
- Bacterial dysentery
- Indigestion
- Hair growth
- Tonic
- Astringent

Classification and habitat

Some 450 species of shrub make up this genus. Native to Central and Southern Europe, *B. vulgaris* is a perennial deciduous shrub with gray, woody stems and dark green leaves, bearing clusters of red berries. *B. vulgaris* grows well in most soils, providing they're not waterlogged, up to a height of 10ft (3m). The dense, spiny growth makes it a garden favorite for hedging or on steep banks.

The plant's generic name may come from the Phoenician word *barbar*, which means "glossy," referring to the shiny leaves.

Harvesting

Parts of the plant are harvested in the fall: The fruits and bark are used fresh, although both the bark and roots can be dried and powdered or used in liquid extracts.

The ripe berries are very sour, containing high quantities of acids such as citric acid and ascorbic acid (or vitamin C).

Medical use

This extremely bitter herb is highly effective against many disease-causing microbes and is also anti-inflammatory—in ancient Egypt the berry juice was taken as a remedy for fever. Traditionally, the bark was cooked with alcoholic beverages such as white wine or ale, while an infusion of berries was taken as a tonic.

B. vulgaris is one of those plants that fall under the Doctrine of Signatures, the 16th-century idea that plants that resemble parts, or organs, of the body could be used to treat those organs. In areas of the UK such as Cornwall, *B. vulgaris* was named the "jaundice tree," as its yellow bark was used to treat this condition. Jaundice is typically caused by a malfunctioning liver, in which the buildup of a yellow substance called bilirubin turns the skin and the whites of your eyes that color.

Banishing the blight

As an intermediate host plant to the fungus black rust, common barberry was blamed for the devastating effect that this blight had on wheat yields. European settlers brought common barberry to the USA in the 17th century but 20th-century eradication programs significantly reduced its distribution and spread.

The bark and twigs were also used to treat gallstones and indigestion (the bitterness stimulates the production of digestive juices), and to promote hair growth, while the berries were utilized for kidney problems.

Barberry contains the antibacterial alkaloid berberine, also found in other plants, including *Hydrastis canadensis* (goldenseal, p. 122). Berberine inhibits the adherence of bacteria to cells, thus preventing infections taking hold and explaining its traditional and ongoing use (particularly in Japan, Southeast Asia, and the Middle East) in treating bacterial urinary infections, tropical diarrhea, and certain eye diseases.

A 2017 scientific review by Tabeshpour et al. concluded that berberine lowers lipid levels and decreases insulin resistance, thus playing a role in managing metabolic syndrome: the combination of factors such as obesity, high blood pressure, and insulin resistance that predisposes people to type 2 diabetes and cardiovascular disease.

CAUTIONARY NOTES

All parts of the plant are harmful if eaten, with the exception of the ripe, although exceedingly sour, berries. B. vulgaris should not be given to pregnant women.

BETULA PENDULA
Silver birch

KEY USES

- Anti-inflammatory
- Skin diseases
- Kidney infections
- Cystitis
- Gout
- Fibromyalgia
- Rheumatism and arthritis
- Cancer
- Tonic

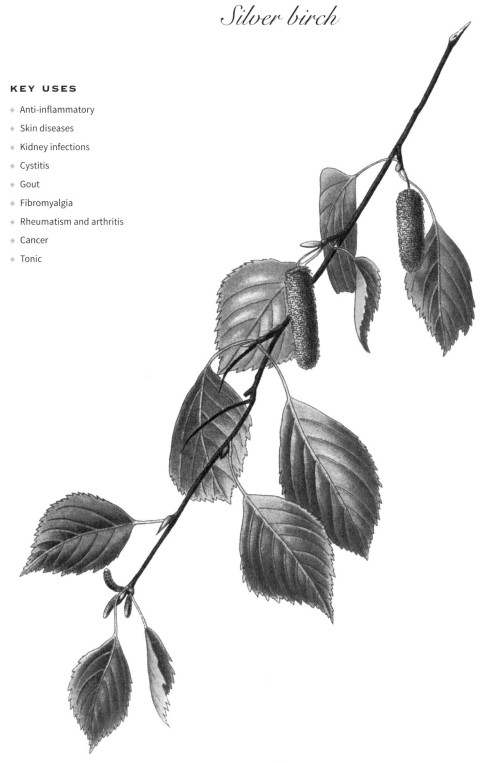

Classification and habitat

B. pendula comes from a genus of about 60 species of deciduous trees and shrubs, distributed across northern temperate regions. Birches are one of the most common trees in these regions, as they grow well in most soils. *B. pendula* is a fast-growing, elegant tree, which reaches a height of 30–40ft (9–12m). The branches droop, bearing catkins in spring, and have a characteristic silver-white peeling bark.

Like the horse chestnut (*Aesculus*, p. 22), birch trees are best pruned in midsummer, as these species "bleed" sap if they are pruned in the fall or early winter.

Harvesting

The bark is harvested for distillation into a birch tar oil. The leaves and sap are also used for tinctures or extracts.

Medical use

Trees and shrubs account for a high proportion of the traditional plants used in Native American medicine; the birch tree, *Betula pendula*, is one such example. Its bark is used externally for chronic skin diseases like psoriasis and eczema, and the leaves internally for kidney and rheumatic disorders—they contain aspirin-like substances that control inflammation and joint and muscle pain. *B. pendula* is often used with willow bark (*Salix alba*, p. 168), to boost this activity.

CAUTIONARY NOTES

It can be easy to get confused between the external and internal uses of herbs, so check with a medical herbalist first. B. pendula is used for both applications: internally for kidney and rheumatic complaints and externally for skin conditions.

Nothing beats birch

In Scandinavia, birch twig bundles are used in saunas to beat the skin and muscles. This eases tender and aching muscles, while at the same time stimulating sweating and having an invigorating effect. The slender, flexible twigs also make great brooms. A less popular use, at least with offenders, was "the birch"—a whip of birch twigs commonly used in Europe until the mid-19th century as an educational and judicial punishment.

Silver birch's actions also extend to enhancing kidney function, increasing the body's ability to remove waste products from joints and muscles. The sap is thought to be a diuretic.

There are many active components in birch bark and leaves, including betulinic acid. A 2015 scientific review by Al-Snafi highlighted its ability to kill cancer cells in vitro and to decrease their motility, an important way of preventing cancer metastasis. Betulinic acid boosts the production of T cells, which are a crucial component of the immune system. New pharmacological opportunities for betulinic acid may arise from exciting advances in nanoscale drug delivery systems: engineered technologies that use tiny particles for the targeted delivery and controlled release of drugs, thus minimizing side effects and reducing doses.

Male and female flowers (catkins) appear on the same tree. The male ones (shown here) form in the fall but don't open until the spring, when the female catkins (shown opposite) appear.

BRASSICA NIGRA
Black mustard

KEY USES

- Chilblains
- Poor circulation
- Upper respiratory mucus and coughs
- Sore throats
- Arthritis
- Obesity

Classification and habitat

Brassica nigra comes from the Cruciferae, or cabbage, family. Brassicas are a genus of about 30 species of hardy, mainly annual or biennial herbs, distributed throughout Eurasia.

Brassica nigra can grow to a height of 6ft (1.8m). In summer, it has small, bright yellow flowers, which gradually fade and are followed by the appearance of narrow four-sided seed pods. The plant grows well in rich, well-drained soil in full sun.

The name "mustard" derives from the Romans' habit of mixing the ground seeds with grape juice: *mustum*, meaning "grape must," was combined with the word *ardens*, or "burning."

Harvesting

The seeds are harvested for both culinary and medicinal purposes.

Medical use

The ancient Greek physicians certainly put mustard on a pedestal, so much so that they believed it had been discovered by Asclepius, the demigod of medicine and healing. The seeds have been ground to make into condiments since this time, and their leaves used in bandages, poultices, or foot baths for chilblains, poor circulation, and arthritis.

Here's the rub

One of the active chemicals in mustard is allyl isothiocyanate, a rubefacient: Rubbing of such chemicals into the skin causes it to redden. This gentle and localized increase in blood flow ameliorates inflammation and provides pain relief

The seeds of *B. nigra* (black mustard) are hotter than those of *B. juncea* (brown mustard) and *B. alba* (white mustard), which is the mildest.

at the same time. The difficulty lies in working out how, but other herbs, such as *Capsicum* species (chili pepper, p. 60) have a similar effect.

Stubborn chest congestion will yield to the steam produced when hot water is poured onto bruised mustard seeds and sore throats can be eased by gargling with mustard. Allyl isothiocyanate is just one of the mustard molecules behind these effects.

Interest in some novel properties of this molecule is growing, at least in the field of obesity and insulin resistance. A 2018 study by Lo et al. showed that this molecule could reduce weight gain in mice fed high-fat diets. And attention is also being drawn to some enticing early data on its antimicrobial and anticancer properties.

Mustering mustard

Mustard contains mustard oil glycosides. These give the characteristic tangy flavor and endow the oil with medicinal properties. The chemistry is now well understood and explains something of the assembly of mustards available. As the ground seed is mixed with cold water, an enzyme (myosin) acts on a glycoside (sinigrin) to produce the sulfur compound allyl isothiocyanate. The flavor of the condiment depends on the type of seeds used and whether water or vinegar is added. American mustard is made from white mustard (*B. alba*) seeds, while these are mixed with *B. nigra* to make English mustard.

CAMELLIA SINENSIS
Tea

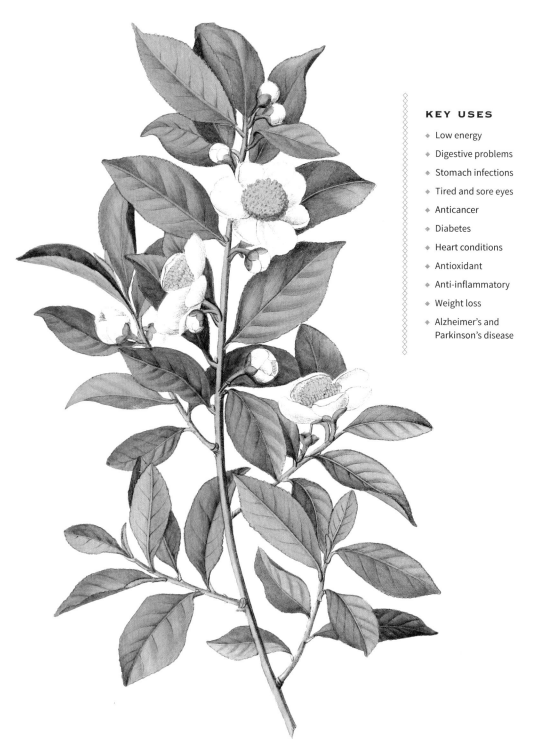

KEY USES

- Low energy
- Digestive problems
- Stomach infections
- Tired and sore eyes
- Anticancer
- Diabetes
- Heart conditions
- Antioxidant
- Anti-inflammatory
- Weight loss
- Alzheimer's and Parkinson's disease

Classification and habitat

Camellia is named after Georg Josef Kamel, a Jesuit who traveled through Asia collecting plants at the end of the 17th century. There are at least 150 shrubs and trees in this genus, many of which are grown as ornamentals for their fine foliage and flowers. *C. sinensis* is an evergreen shrub, usually cut back to about 6ft (2m), native to Asia and the Indian Subcontinent. It may not stand out for its looks but is highly important commercially.

Harvesting

The young leaves are picked by hand: The spring harvest is most prized for its therapeutic potential.

Medical use

Tea has been drunk for millennia—according to legend, since 2737 BCE, when the Chinese emperor Shen Nung allegedly enjoyed the taste after tea leaves blew into his pot of boiling water. Regardless of the veracity of this tale, tea is now one of the most widely consumed beverages worldwide, enjoyed for its fragrant taste, stimulant properties, and health benefits.

Tea doesn't contain as much caffeine as coffee (p. 80) but it still acts as a warming pick-you-up and increases alertness. In traditional Chinese and Ayruvedic medicine, tea is also used to treat diarrhea, dysentery, asthma, and heart disease.

An increasing number of medical benefits are being attributed to tea, particularly green tea, which is highest in the antioxidant polyphenols called catechins. A 2020 review (Musial et al.) described the relationship between their increasingly complex structure and the strength of their antioxidant activity. By neutralizing damaging oxygen free radicals, the most potent of these—epigallocatechin gallate (EPG)—has significant anti-inflammatory and anticancer potential. Green tea can't replace chemotherapy but it can support the fight against cancer and possibly other diseases such as type 2 diabetes, cardiovascular conditions, and neurodegenerative disorders.

Color-coded tea

All tea comes from the same plant, *Camellia sinensis*: The different colors and names boil down to which leaves are picked and the way they are processed. There are five main types: black, green, oolong, white, and pu-erh, with black and green tea turning up most in the world's teacups.

Black tea represents up to 85 percent of the tea drunk in the West. It is fully oxidized and typically has a higher caffeine content than other teas but only about half that found in coffee. Green tea is unoxidized: Heating the leaves just after they're picked destroys the enzymes that cause oxidation, thus preserving the antioxidant polyphenols associated with tea's health benefits.

Soothing eye bags

Soaking cotton wool in green tea or gently placing a teabag on tired or sore eyes will ease inflammation and help counter infections.

Non-tea teas

Other "teas" are really herbal infusions or tisanes. These may be flower-derived (e.g. chamomile, p. 70), fruit or spice-derived (e.g. lemon, p. 76, ginger, p. 210), or made from the leaves of plants other than *C. sinensis*. *Yerba mate* is made from the South American holly tree, *Ilex paraguariensis*, and almost matches arabica coffee (p. 80) in its caffeine content. In contrast, South African rooibos, or red bush, made from *Aspalathus linearis*, is caffeine-free.

CAUTIONARY NOTES

Tea impairs the absorption of iron, so those who are anemic should avoid drinking it with meals.

CAMPTOTHECA ACUMINATA

Cancer tree

KEY USES

- Cancer
- Psoriasis
- Liver and stomach conditions
- Common cold

Classification and habitat

Native to the warm, humid banks of rivers in southern China and Tibet, this deciduous tropical tree grows to heights of 65ft (20m). The small, white, inconspicuous flowers appear from December to February.

Another common name is the "happy tree," a direct translation of the Chinese name *xǐ shù*. The origins of this name are somewhat shady—but therein may lie the answer! The tree grows upward, and the leaves are a cheering light, bright green, forming a huge canopy up to 40ft (12m) wide at the top.

C. acuminata will grow in many types of soil, from light and sandy to heavier clay soils, although it prefers moist soil. It does not tolerate strong winds and is most suitable for light woodland areas. The tree grows very fast during the first 10 years, with slower subsequent growth. This can be useful if coppicing is required, as the tree can be pruned back without damaging it.

It's said that all the *C. acuminata* trees in the USA come from the seed of two trees imported by the United States Department of Agriculture in the 1900s.

Harvesting

The stem and root bark contain only trace amounts of the active compound camptothecin; the tender young leaves yield the highest concentration in pharmaceutical extractions.

Medical use

The happy tree has been used for centuries in traditional Chinese medicine for psoriasis, liver and stomach complaints, and the common cold. It was also used to treat leukemia.

Cancer treatments became a key focus in the 1940s and '50s, and in 1958, medical researchers revealed that the compound camptothecin was responsible for *C. acuminata*'s cancer-fighting properties. However, scientists found that camptothecin is not water-soluble and can be highly toxic, and this makes it difficult to administer as a medicine.

Endangered

The population of Chinese *C. acuminata* has been decimated, such is the demand for its powerful anticancer compounds. Export is now severely restricted, as it's estimated that fewer than 4,000 of the trees remain in the wild in China.

After decades of extensive research, several relatively safe and effective water-soluble analogs, or derivatives, of camptothecin have been developed, including irinotecan, topotecan, and rubitecan. Topotecan, for example, treats metastatic ovarian, cervical, or small-cell lung cancer. It works by blocking an enzyme, topoisomerase 1, which helps DNA to repair when cells divide. Blocking the action of this enzyme damages the DNA and so the cancer cells die.

The raw material for these new compounds is still only available from *C. acuminata*. Worldwide sales of drugs such as topotecan have reached in excess of $1 billion annually. And the story doesn't end there. Camptothecin is such a powerful chemotherapeutic drug that researchers are still exploring new analogs in the fight against cancer.

Other chemical compounds have been isolated from *C. acuminata*, such as hyperoside, a potential new antibacterial therapy. A 2017 study by Sun et al. showed that this could prevent the formation of biofilms by a common pathogen in hospital-acquired infection: the antibiotic-resistant *Pseudomonas aeruginosa*.

CAUTIONARY NOTES

Irinotecan, topotecan, and rubitecan are much less toxic than the parent molecule camptothecin but, like many cancer treatments, they do still cause significant side effects in some patients, such as an increased susceptibility to infections, nausea, and weight loss.

CANNABIS SATIVA
Marijuana

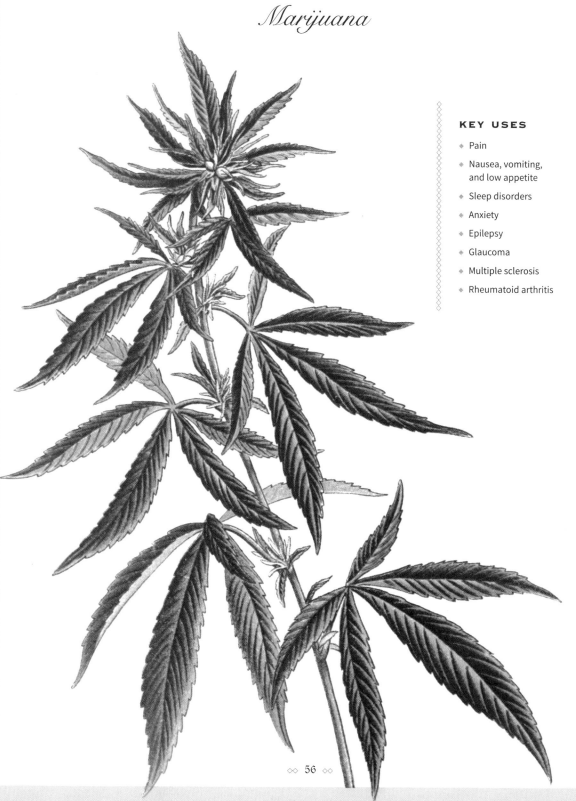

KEY USES

- Pain
- Nausea, vomiting, and low appetite
- Sleep disorders
- Anxiety
- Epilepsy
- Glaucoma
- Multiple sclerosis
- Rheumatoid arthritis

Classification and habitat

Cannabis is a genus of flowering plants in the Cannabaceae family, which consists of three species or subspecies: *C. sativa*, *C. indica*, and *C. ruderalis*. The genus name *Cannabis* is also one of its common names. Others include marijuana, pot, hash, weed, and hemp.

C. sativa generally grows as an annual and up to a height of about 8ft (2.5m). It is a short-day plant and only starts flowering as the day length shortens and nights grow longer in late summer. The plant has characteristic finger-like serrated leaves. In many parts of the world it is illegal to grow cannabis without a license.

Harvest

C. sativa is a fast-growing plant: harvesting can take place as little as three months after germination. The plant is ripe when the buds turn from milky white to reddish orange. Flower buds, leaves, and resin are all harvested to extract the key active compounds, the cannabinoids.

Medical use

Cannabis has a long history as a recreational drug. Some of the earliest records describe the Chinese using it for its mind-altering properties, now known to be caused by the compound tetrahydrocannabinol (THC). As it arrived in the Middle East, the famous Muslim sect who attacked the Crusaders in the 11th and 12th centuries derived their name *Hashashin* (Assassins) from their hashish-using habits. From there, the drug spread worldwide. Dr. William Brooke O'Shaughnessy, an army surgeon who had served in India, introduced cannabis into British medicine in 1842. The Victorians found that it alleviated muscle spasms and the convulsions of tetanus, rabies, and epilepsy; treated rheumatic pain; promoted uterine contractions in childbirth; and aided sleep. It's even said that Queen Victoria used cannabis for menstrual pain.

Cannabis really made its presence felt in America when its use spread from the Beatniks of the 1950s to the student culture of the 1960s.

CAUTIONARY NOTES

Traditional herbal cannabis and cannabis resin (hashish) have a THC level of less than 10 percent. In some parts of the world, including American states like Colorado and California (where recreational use of cannabis has been legal since 2012 and 2016, respectively), concentrated cannabis—or, as it is called in the UK, skunk—is more frequently available. This high-strength cannabis can have a THC level of up to 67 percent and its use is increasingly associated with mental health problems. Studies in Europe and America have suggested a relationship between skunk use and an increase in the incidence of psychosis.

MARIJUANA MATTERS

Cannabis is at a pivotal moment in its long history. As one of the world's oldest drugs, frequently associated with recreational use, it is now being extensively researched for the potential medical benefits of CBD in a range of conditions from anxiety and chronic pain relief, to autoimmune diseases, cancer, and epilepsy.

The two cannabinoids that are most strongly associated with the effects of cannabis are THC and CBD. The structure of these two molecules is remarkably similar (see diagrams opposite) but that's where the similarity ends. THC is the main psychoactive substance found in cannabis, while CBD has significant therapeutic properties.

Medical products from the cannabis plant are now legal in many countries, including some American states, following the example of Israel where it has been used as a medicine for over 20 years. The strongest scientific evidence to date concerns the use of CBD in treating childhood epilepsy that does not respond to standard medications.

Seeing through the smoke: Hemp vs. marijuana

These two varieties of *C. sativa* can appear indistinguishable from each other. Indeed, perfectly legal hemp has occasionally been seized because it looks like marijuana. The key difference between the two is hidden within and lies in their chemical composition. Both hemp and marijuana can produce high amounts of CBD, the medicinal and non-intoxicating cannabinoid. However, by dry weight, hemp only contains approximately 0.3 percent of the intoxicating cannabinoid THC; the THC level in marijuana, meanwhile, can be up to 30 percent.

Levels of legality

THC levels lie behind the varying legality of hemp and marijuana. In the USA, in 2018, hemp growth, processing, and sale was legalized providing the products (building materials, cooking oil, and medicinal products) contain no more than 0.3 percent THC. Marijuana is still treated as a controlled substance in many areas of the world, particularly in some states of the USA and some

Tetrahydrocannabinol (THC)

European countries, but it is legal to grow and smoke it in much of Central and South America and Canada. Recreational use is one thing, but the medicinal use of CBD is set to drive a change in the law. In the USA, at least 33 states have legalized the medical use of cannabis, with around one third of those allowing recreational use.

A shifting picture

Across the world, governments are struggling to keep a distinct line between recreational and medical use of cannabis. In the USA, although the federal government continues to retain the 1970 classification of cannabis as a Schedule I substance, many states have developed a regulatory framework to improve access to marijuana for medicinal purposes. The Medical Marijuana Laws (MMLs), particularly those amendments passed since the 1990s, allow for use, possession,

and supply of cannabis and purified CBD, for patients with proven medical need. Keeping up with demand is not always a smooth process, however, as those in the UK have also found. Worldwide there are concerns about CBD marketed as a supplement and not a medication: Safety, purity, and the effects of long-term use are perennial issues.

Mind-blowing

The cannabinoid receptors that bind THC are found throughout the brain and the body, so the effects of smoking or ingesting THC-containing cannabis are wide-ranging. It affects the part of the brain that makes a person feel good—hence the well-described "high"—but it can also slow a person's reaction time (impairing skills like driving), disrupt memory formation, cause anxiety, and affect judgment.

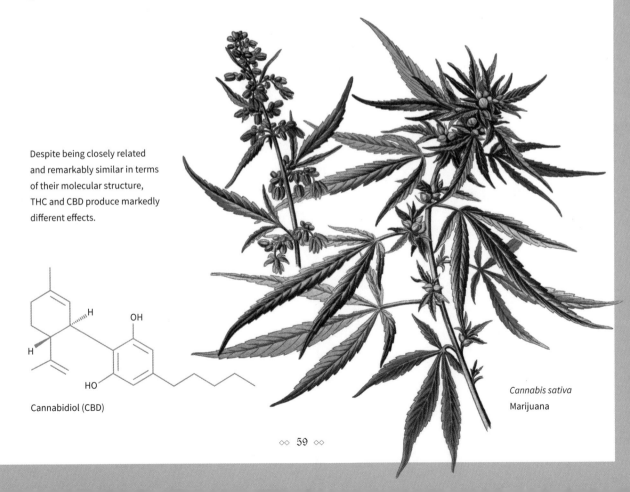

Despite being closely related and remarkably similar in terms of their molecular structure, THC and CBD produce markedly different effects.

Cannabidiol (CBD)

Cannabis sativa
Marijuana

CAPSICUM
Chili pepper

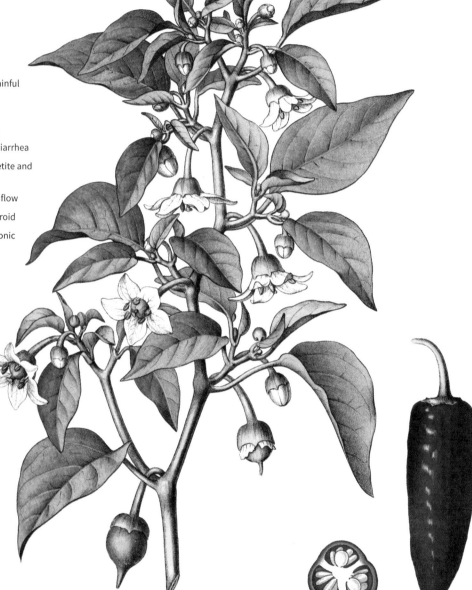

KEY USES

- Antiseptic
- Local painkiller
- Toothache
- Inflamed and painful joints
- Chilblains
- Gastrointestinal infections and diarrhea
- Stimulates appetite and digestion
- Improves blood flow
- Underactive thyroid
- Stimulant and tonic

Capsicum annuum
Chili pepper

Classification and habitat

Capsicum comes from the Greek *kopto*, meaning "I bite." *Capsicum* plants are annual or short-lived perennial shrubs (maximum height 5ft or 1.5m) whose white flowers become green, yellow, or bright red peppers. These come in a number of varieties, ranging from the sweet and mild to the hot and pungent. All derived from the same wild species, *C. annuum*, the cultivars are variously called sweet peppers, bell peppers, chili peppers, cayenne peppers, red peppers, pimento, and tabasco. What follows describes the chili pepper variety, *C. frutescens*.

Chili peppers are cultivated throughout the tropics, particularly Africa and India, and in temperate regions under cover. They are fantastic domestic greenhouse plants, with dwarf cultivars growing well in pots providing the compost gets neither too wet nor too dry.

Harvesting

Chili peppers can be cut when green in the summer or left on the plant to ripen into yellow or red versions. Chilies can be used fresh or dried and ground into chili powder.

Medical use

Archaeologists have estimated that the cultivation of the chili pepper in South America began around 5200–3400 BCE, making it one of the oldest domesticated plants. It was introduced to Europe by Christopher Columbus in the 15th century. Capsaicin is the key active ingredient: The levels of capsaicin directly relate to the level of "heat" when eaten, and it has numerous therapeutic applications.

Applied locally to the skin, capsaicin initially heightens the pain but then leads to a desensitizing of the nerve endings and a reduction in pain. Creams for shingles, diabetic nerve pain, and itchiness often contain capsaicin. Another effect on the skin is increased blood flow, so lotions containing chili can clear waste products from the circulation and ease muscular aches and arthritic joints.

Speeding things along

Capsaicin accelerates gut transit time; hence that familiar feeling after a spicy curry. So, it might come as a bit of a surprise that a 2014 study by Aniwan and Gonlachanvit, among irritable bowel syndrome patients, reported that those given chili capsules described a decrease in gastrointestinal symptoms, possibly due to the desensitization of capsaicin receptors in the gut.

Capsaicin is also attracting attention for its potential role in combating obesity by decreasing appetite, increasing satiety, stimulating a higher metabolic rate, and decreasing deposition of fat.

Adding chili to other herbal preparations acts as a general stimulant. It can stimulate an underactive thyroid and, combined with echinacea (p. 100) and licorice (p. 114), for example, chili can treat throat infections.

Research is also emerging that suggests that chili can enhance the action of other herbal medicines and even the anticancer activity of antioxidant remedies.

Chili has antiseptic properties too, so its use in tropical countries is not only about adding flavor but reducing the risk of food poisoning. Using chili as flavoring is not all good news: Consuming a strong curry too close to bedtime can make for a restless night as capsaicin not only affects your gut but inhibits sleep, via an increased body temperature.

Cautionary Notes

A little goes a long way. Too much chili, either internally or externally, can cause intense pain and burning.

CARICA PAPAYA
Papaya

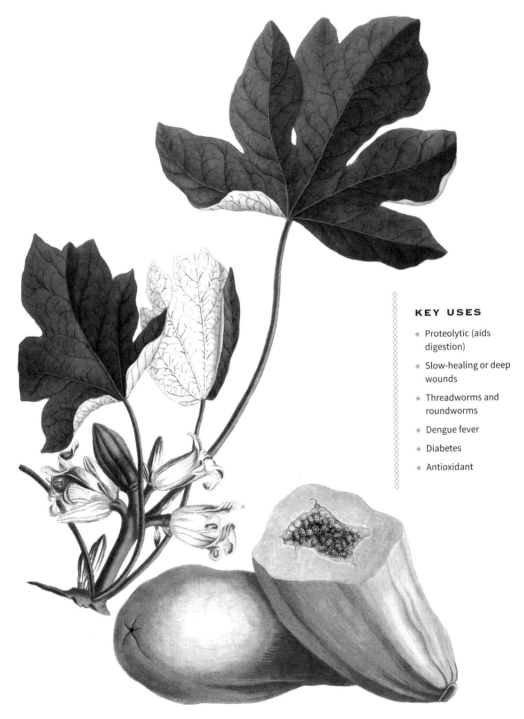

KEY USES

- Proteolytic (aids digestion)
- Slow-healing or deep wounds
- Threadworms and roundworms
- Dengue fever
- Diabetes
- Antioxidant

Classification and habitat

The lowland tropical forests of Central and South America are home to some of the world's most important edible and medicinal plants, such as *Carica papaya* and the *Capsicum* species (p. 60). The *Carica* genus contains 22 trees and shrubs, which have characteristic thick, unbranched trunks. This evergreen tree grows to a height of 10ft (3m) and produces large (28in/70cm across) seven-lobed leaves. The fruits are approximately 18in (45cm) long, with leathery yellow-green skin.

Papaya grows best in rich, moist soil in sun and with high humidity. It requires minimum temperatures of 55–59°F (13–15°C).

Harvesting

The enzyme papain is processed from unripe fruit into tablets or capsules.

Medical use

C. papaya has been cultivated in tropical America since pre-Columbian times, with some of the earliest descriptions of its growth in North America dating from the mid-16th century.

The pulp of ripe papaya fruit is cooked or eaten as is, while the unripe fruit, or the leaves, are used as a food tenderizer (particularly in the fast-food industry) or utilized for medicinal purposes. When the unripe fruit is cut, a thick white juice of latex seeps out. This contains the digestive enzyme papain.

This enzyme, like bromelain (pineapple, p. 32), breaks down proteins. Papain is particularly efficient in an alkaline environment such as the small intestine. This enzyme can complement the body's own digestive juices or enhance digestion where there is a deficiency in normal digestive juices.

Rugby ball versus soccer ball

It's easy to confuse yellow-skinned papayas and pawpaws but there are some subtle differences, aside from the fact they're different species—American pawpaw (or custard apple) is the fruit of the *Asimina triloba* tree. Shape and color are key in telling the two apart. Papayas have red flesh and are oval, like a rugby ball, whereas the pawpaw has yellow flesh, and is slightly larger and rounder, like a soccer ball. To complicate things further, Australians sometimes refer to *C. papaya* as pawpaw and there's also green papaya, eaten in Asian countries as a vegetable. Green papaya is either red-fleshed papaya or yellow-fleshed pawpaw picked green!

Ripe papayas are high in antioxidants, and also have laxative properties. The round, black papaya seeds are taken internally in the countries of origin to expel threadworms and roundworms.

Recent research is finding new uses for papaya. In 2015, the *British Medical Journal* published guidelines by Kularatne Senanayake for treating patients with the viral disease dengue fever, after studies by Subenthiran et al. found that drinking *C. papaya* leaf juice decreased fever and increased blood platelet (cells that stop bleeding) counts in these patients. And *C. papaya* fruit extracts may not only help wound healing in diabetic patients, but papaya leaves have been shown to lower blood sugar levels too.

CAUTIONARY NOTES

Concentrated forms of papain should be used with caution during pregnancy.

C. papaya is probably the most exotic tree you can grow at home from a pip. Temperatures of 72–82°F (22–28°C) are needed to achieve germination. Using biodegradable pots for seeds and young papayas will ensure the seedlings can be potted on without root disturbance.

CASSIA
Senna

Senna alexandrina
Alexandrian senna

KEY USES

- Laxative
- Tapeworm and roundworm
- Antibacterial

Classification and habitat

Senna grows across North Africa, the Middle East, and India. The genus name *Cassia* is thought to originate from the Hebrew word *ketziah*, which means "peeled back"—a possible reference to senna's easily peeled bark.

Alexandrian senna is a shrubby perennial (height 3ft, 1m), with thin, hairy leaves. In spring and summer, small sandy-colored flowers appear, followed by straight seed pods up to 3in (7cm) long.

Grown as an ornamental, Alexandrian senna requires well-drained soil in sun, with a minimum temperature of 41°F (5°C).

Harvesting

The leaves (which have milder effects than the pods) are picked before and during flowering, while the pods are harvested when ripe in the fall. Both are dried for use in infusions, powders, tablets, and tinctures.

Medical use

Senna is used worldwide as a laxative and is an effective short-term treatment for constipation. It was first used by the Arabs in the 9th century CE and introduced to Europe shortly thereafter. Nowadays, senna is a key ingredient in many over-the-counter laxative preparations. It is also used to clear the bowel before diagnostic tests such as colonoscopies.

Senna contains chemicals called sennosides. These irritate the lining of the bowel, which causes a laxative effect. Senna's action normally takes six to eight hours to kick in, so it's best to take it in the evening, resulting in a bowel movement the next morning.

In traditional medicine, Alexandrian senna is sometimes combined with pumpkin to expel tapeworms and roundworms. And research in 2019 by Silva et al. revealed that extracts from Senna species such as *S. macranthera* had sufficient antibacterial activity against *Staphylococcus aureus* infections that administering the plant extract, in combination with antibiotics, meant a lower antibiotic dose could be used.

A word about names

As genetic methods of classifying species have overtaken simple visual identification methods, some species have been reclassified to reflect more accurate evolutionary relationships. Consequently, the common name "senna" can now apply to more than one genus. There were originally about 330 *Cassia* species, of which 300 are now more accurately placed in the genus *Senna*, with about 30 retained in the genus *Cassia*. In the USA, "senna" refers to *Senna alexandrina* Mill, although names used in Europe and elsewhere —*Cassia angustifolia* and *C. senna*—remain accepted alternatives, particularly among medical herbalists.

The bottom line here (no pun intended!) is that senna is derived from different species but the active sennoside components and laxative actions are very similar.

CAUTIONARY NOTES

Senna may sometimes cause abdominal cramping, especially if the recommended dose is exceeded. A relaxing remedy such as chamomile (Chamomilla recutita, p. 70) or ginger (Zingiber officinale, p. 210) can ease stomach cramps.

CATHARANTHUS ROSEUS

FORMERLY KNOWN AS VINCA ROSEA

Madagascan periwinkle

KEY USES

- Diabetes
- Digestive ailments
- Fluid retention
- Cancer

Classification and habitat

There are eight species of Madagascan annuals and perennials in this genus. *Catharanthus roseus* is a small, upright perennial (height 2ft, 60cm) with shiny oval leaves and striking pink flowers.

In the tropics, Madagascan periwinkle is now commonly found as a weed but in temperate regions its compact growth makes it ideal for containers or as a summer bedding plant. This tender ornamental prefers moist soil in full sun, with a minimum temperature of 55°F (13°C).

Harvesting

The leaves are picked before or during flowering and dried for liquid extracts or tinctures.

The pharmaceutical industry extracts alkaloids from the leaves, although the yield is low and costly. Synthetic methods of producing the active compounds are now being fine-tuned, particularly as there is scope in the steps involved in these synthetic pathways to produce efficacious drugs with less toxicity or fewer side effects.

Medical use

Across tropical Africa and the West Indies, *C. roseus* was traditionally used for high blood pressure, chronic constipation, indigestion, fluid retention, lung congestion, and menstrual regulation. In Ayurvedic medicine, it is used for treating diabetes. Medical research has focused on the isolation and application of the plant's active alkaloids.

Two of these, vinblastine and vincristine, have transformed the treatment of certain cancers. In

CAUTIONARY NOTES

C. roseus can be toxic and the drugs derived from it certainly are. In common with other chemotherapies, vinblastine and vincristine's side effects include nausea, hair loss, and a depleted immune system.

Rainforest drug hauls

The Madagascan periwinkle is one of those plants that highlight the importance of screening tropical plants for active principles. Starting in the 1920s, research on Madagascan periwinkle has revealed over 130 different alkaloids. It wasn't until the 1950s that researchers, looking for new drugs for diabetes, were surprised to find that *C. roseus* extracts were not particularly effective at reducing blood sugar levels in mice but they dramatically reduced the number of white blood cells in the blood: Vinblastine and vincristine had been discovered.

fact, they represent two of the most important contributions that plants have made to cancer therapies. Since the 1950s, vincristine has increased the survival rate of children with leukemia from about 10 percent to 95 percent. It is also now used in the treatment of other cancers, such as neuroblastoma (a childhood cancer that affects certain nerve cells) and soft-tissue tumors. Vinblastine is effective against Hodgkin's lymphoma and, for example, advanced testicular and breast cancers.

A make or break situation

Cells contain microtubules, highly active polymers of the protein tubulin that form hollow fibrous shafts, or microtubules. They have several functions, including maintaining the shape and structure of the cell. Microtubules are dynamically unstable, helping to control the process of cell division by rapidly growing (polymerization) or shrinking (depolymerization) as required. Several key cancer drugs target these processes, thus killing rapidly dividing cancer cells, such as white blood cells in leukemia. Vincristine and vinblastine inhibit polymerization while Taxol (*Taxus brevifolia*, Pacific yew, p. 190) inhibits depolymerization.

CENTELLA ASIATICA
Gotu kola

KEY USES

- Concentration and memory aid
- Tonic
- Adaptogen (see opposite)
- Wound healing

- Anti-inflammatory
- Leg ulcers
- Hemorrhoids (piles)
- Varicose veins

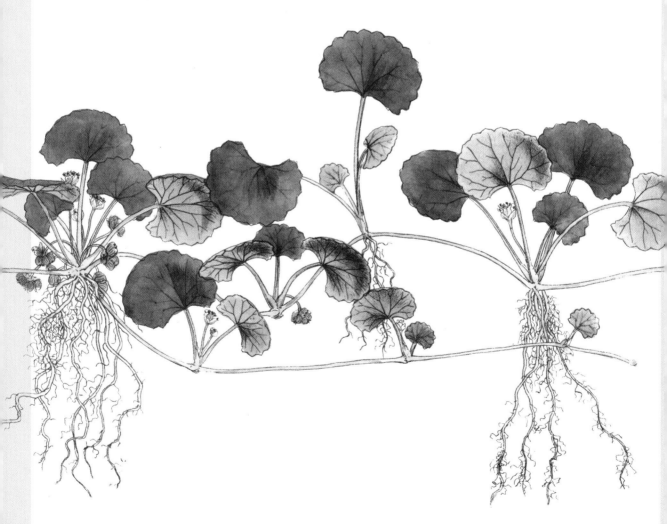

Classification and habitat

The *Centella* genus contains about 20 species of low-growing perennials, which occur in southern Africa and most parts of the tropics. Best known is *C. asiatica*, or gotu kola, a creeping plant from Asia and Australia. It grows wild in India, where it's known as *brahmi*. There it thrives in wet, sunny places, such as rice paddies, although as an ornamental it will grow in partial shade, in rocky areas, and on walls.

The plant grows to a height of 6–8in (15–20cm), producing kidney-shaped leaves and, in the summer, tiny pink-red flowers beneath the foliage.

Mental fitness into old age

The name *brahmi* means "bringing knowledge of Brahman, the Supreme Reality," alluding to one of the plant's uses in India: aiding meditation. In Sinhalese, a Sri Lankan language, *gotu kola* means "cup-shaped leaf." Here the local people follow the elephants' dietary habits, believing that the famed memory and longevity of elephants is related to eating gotu kola leaves daily.

Harvesting

The whole plant is harvested. This, or just the leaves, is used fresh or dried for infusions, powder, milk drinks, or medicated oil or ghee (highly clarified butter). The leaves are eaten in salads and curries in Southeast Asia.

CAUTIONARY NOTES

Gastric irritation, although rare, can occur with internal use. Externally, gotu kola can occasionally cause allergic reactions and skin irritation.

Medical use

Gotu kola has been used in Indian medicine for over 2,000 years. As one of the most important rejuvenative herbs in Ayurvedic medicine, it is used as a tonic and adaptogen (see below) for chronic health problems, for promoting longevity, and for enhancing concentration and memory.

Scientific studies have revealed that gotu kola's active components—the triterpenoid saponins—protect and repair damaged nerve cells, supporting the traditional neuroprotective role of gotu kola. A 2017 meta-analysis by Puttarak et al., of gotu kola in humans, suggested that while alertness was improved and anger symptoms reduced, the data was inconclusive on memory loss. Further clinical trials, which use suitable doses of standardised *C. asiatica*, are necessary.

Another common application of gotu kola is for wound healing and chronic skin disorders. Again, it's thought to be the triterpenoids that are at work here. In conditions such as minor burns and psoriasis, these compounds promote effective tissue repair by increasing skin cell (fibroblast) proliferation and collagen synthesis, and reduce the risk of scar formation.

Gotu kola can also be taken internally for leg ulcers and varicose veins, as it appears to tone and strengthen veins.

Adaptogens: Leveling the seesaw

Adaptogens are the latest buzzword in alternative medicine. These are nontoxic plants that are marketed as helping the body deal with stress: physical, biological, or chemical. They have their roots in Chinese and Ayurvedic medicine, but scientists are still trying to understand how they work. More research is needed, but adaptogens may do for our adrenal glands what exercise does for our muscles, training the body to handle the effects of stress and putting its physiological processes back on an even keel.

CHAMOMILLA RECUTITA

SYN *MATRICARIA CHAMOMILLA*

Common or German chamomile

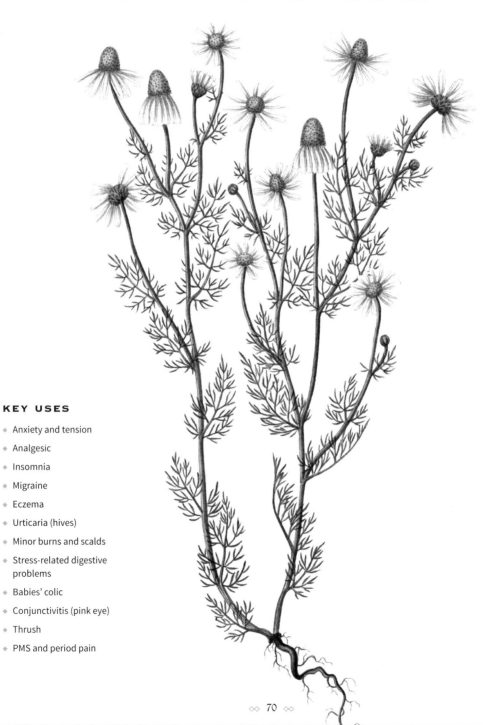

KEY USES

- Anxiety and tension
- Analgesic
- Insomnia
- Migraine
- Eczema
- Urticaria (hives)
- Minor burns and scalds
- Stress-related digestive problems
- Babies' colic
- Conjunctivitis (pink eye)
- Thrush
- PMS and period pain

Classification and habitat

Chamomile's Greek name *chamaimelon* means "earth-apple," referring to the strong apple-like scent released when the plant is walked upon.

German chamomile is an annual plant that grows best in full sun in well-drained, preferably chalky soil. It can reach 2ft (60cm) in height and flowers throughout the summer, with flowers that are daisy-like in appearance. *C. recutita* self-seeds freely.

For a chamomile lawn, plant seedlings about 4–6 in (10–15 cm) apart.

Harvesting

The flowers are picked when they are fully open and used fresh, frozen, dried, or in liquid extracts (containing the essential oils).

Medical use

Native to Europe, but now used worldwide, chamomile is sometimes thought of as the European equivalent of the Chinese herb ginseng (*Panax ginseng*, p. 142)—life-enhancing and soothing. There are two types of chamomile used medicinally: the annual German chamomile featured here and the creeping perennial *Chamaemelum nobile*. Their medicinal properties

Steamy success

It's estimated that worldwide over 1 million cups of chamomile tea are drunk each day. Making a chamomile infusion is best done in a teapot or a mug with a saucer on top, as most of the active constituents are present in the steam.

CAUTIONARY NOTES

On rare occasions, chamomile can cause allergic reactions.

Chamomile canon

Chamomile appears in various forms in English literature. The horticultural habit of growing chamomile lawns, with their evocative scent, was immortalized in Shakespeare's *Henry IV Part I*—"Though the camomile, the more it is trodden upon, the faster it grows"—and more recently, in Mary Wesley's 1984 novel *The Camomile Lawn*. In Beatrix Potter's 1901 children's story *The Tale of Peter Rabbit*, "Peter was not very well during the evening. His mother put him to bed, and made some chamomile tea, and she gave a dose of it to Peter."

are very similar but German chamomile is usually preferred because it has a less bitter taste.

Chamomile is best known as a relaxing herb. Taken internally, as an infusion, it helps to reduce tension and anxiety, relieve insomnia, and soothe colicky, fractious children. Chamomile aids digestion, as its anti-inflammatory and antispasmodic properties relax the smooth muscles located in the gut. Chamomile's analgesic action also helps reduce pain in teething, earache, migraine, period pain, neuralgia, and arthritis. Its antiseptic properties guide its use in respiratory infections and fevers, in both adults and children.

Externally, a 2018 scientific review by Lin et al. confirmed that the anti-inflammatory action of chamomile speeds tissue repair in eczema, urticaria, and minor wounds and burns. Massaging with chamomile essential oil is said to relieve the pain of arthritic limbs, while chamomile tea is a good antiseptic lotion for the skin, a mouthwash for throat infection, and an eyewash for conjunctivitis. Added to bathwater, it will help cystitis and thrush.

The principal constituent of chamomile flowers is a blue volatile oil containing compounds called azulenes. These are what produce the plant's distinctive apple-like fragrance.

CINCHONA LEDGERIANA

Quinine tree

KEY USES

- ◆ Malaria
- ◆ Pain
- ◆ Fever
- ◆ Cold and flu (influenza)
- ◆ Cardiac arrhythmia
- ◆ Hemorrhoids
- ◆ Varicose veins
- ◆ Cancer

Classification and habitat

Cinchona is native to Northern Bolivia and Peru but is now grown worldwide, where environmental conditions permit. Growing to a height of up to 50ft (15m), this evergreen tree produces clusters of flowers called panicles. It grows in well-drained, moist soil, with high humidity and a minimum temperature of 59–64°F (15–18°C).

Harvesting

The bark is harvested from young saplings between six and twelve years old, from late spring to early fall. Sometimes the trees are coppiced—cut almost to the base to harvest the bark—and allowed to regenerate from the root. Before quinine was isolated, the bark was ground up and drunk with milk or water.

Medical use

When the Quechua people of Peru were conquered by the Spanish, they shared their centuries-old knowledge of the powerful antimalaria tree, known to them as *quina*, or "bark." Ironically, this allowed the Europeans to conquer the people who'd given them the wherewithal to survive attacks of malaria. By the end of the 17th century, the bark was in demand worldwide, and vast quantities were shipped from Peru and Bolivia. Carl Linnaeus renamed the tree *Cinchona* in 1742 and, in 1820, two French chemists isolated the active principle (see p. 12), namely, the quinine molecule. This remained the only treatment for malaria until the 1930s.

CAUTIONARY NOTES

An excess of quinine (significantly above therapeutic doses) causes cinchonism: headache, rash, nausea and vomiting, and decreased hearing and tinnitus.

Some medications, including antidepressants and blood thinners such as warfarin, can interact with quinine.

A tonic

Quinine is responsible for the taste of tonic water but it is present only at low concentrations, so is unlikely to have any therapeutic effects.

Malaria has killed more people throughout history than any other disease and it still affects millions of people worldwide. The *Plasmodium* parasite that causes malaria has a complicated and evasive life cycle in humans and its other host, the *Anopheles* mosquito. This means that it has been notoriously difficult to develop a vaccine for malaria.

Various antimalarial drugs are available, including the other important one derived from a plant, artemisinin (see p. 42). However, quinine, or its synthetic substitute, chloroquine, remain important and effective treatments for malaria today, despite outbreaks of drug resistance, which are commonly seen in all antimalarial drugs with prolonged use.

Another alkaloid, quinidine, is used to prevent or relieve certain types of cardiac arrhythmia (abnormal heart rhythm). And the latest scientific research suggests that newly isolated alkaloids from *C. ledgeriana* have anticancer activity.

Getting the conditions right

Environmental factors—such as sunlight, water, and soil conditions—will influence a plant's metabolism and what chemicals it produces. In the 1800s, early attempts to cultivate the cinchona tree in Asia, using seedlings from South America, failed. Botanists grew the cinchona tree in the wrong environmental conditions: The plants grew but the bark didn't contain any of the antimalarial quinine. In cultivated plants, pesticide use can lead to a decrease in medicinal compound production if the plant no longer needs to defend itself to the same extent with toxic compounds (see p. 13).

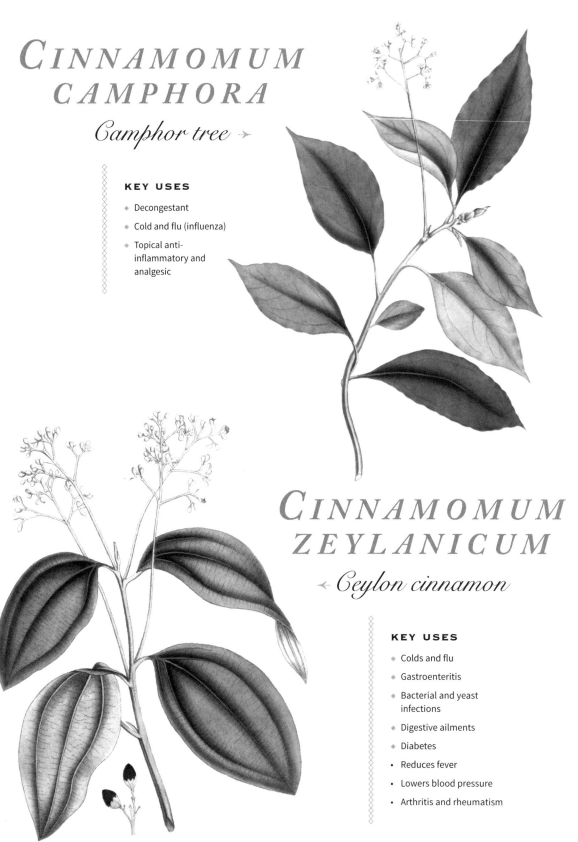

CINNAMOMUM CAMPHORA
Camphor tree →

KEY USES

- Decongestant
- Cold and flu (influenza)
- Topical anti-inflammatory and analgesic

CINNAMOMUM ZEYLANICUM
← *Ceylon cinnamon*

KEY USES

- Colds and flu
- Gastroenteritis
- Bacterial and yeast infections
- Digestive ailments
- Diabetes
- Reduces fever
- Lowers blood pressure
- Arthritis and rheumatism

Catching a lift

Camphor has a strong odor and is easily absorbed through the skin. A 2016 study by Xie et al. suggested that camphor might be a safe and effective carrier for enhancing the delivery of drugs across the skin.

Classification and habitat

This genus contains over 250 species of evergreen trees and shrubs, occurring in Asia and Australia. The *C. camphora* tree has shiny, aromatic, pointed leaves, which are red when young, with clusters of pale yellow-green flowers in spring and summer, followed by black fruits. It grows to a height of 40–100ft (12–30m) in the forests of China, Japan, and Taiwan.

Cinnamomum species include cassia (*C. cassia*) and the slightly sweeter Ceylon cinnamon (*C. zeylanicum*). *C. zeylanicum* is, as the name suggests, native to Sri Lanka (formerly Ceylon), although the tree is commercially grown in Brazil, the Caribbean, and India. It has light-brown, papery bark, with leathery leaves up to 7in (18cm) long. Small, yellow-white flowers appear in clusters in the summer, followed by oval purple berries.

Cinnamon trees are coppiced down to the ground and covered with soil when they are around two years old. This effectively turns the tree into a bush, with new shoots emerging from the sides the following year.

Harvesting

Camphor oil is extracted from the wood of camphor trees and processed by steam distillation.

With cinnamon bushes, the bark is stripped from the branches and left to dry in the sun. As this happens, the bark curls into the familiar cinnamon quills, or sticks.

Essential oil and powdered cinnamon are produced from cinnamon quills. Cinnamon is a major culinary spice worldwide.

Medical use

Both of these *Cinnamomum* species have powerful therapeutic actions. They have long been used in East and Southeast Asia, and are now employed worldwide. In 1875, the camphor tree was introduced to Florida, and today it grows in many countries around the world.

Camphor is a type of organic compound called a terpene that was traditionally used to combat colds and flu, and as a safe, natural moth repellent. Camphor was also thought to calm the nerves. Nowadays, it is found in some nasal decongestants and chest rubs, where it relieves inflammation and congestion.

Camphor can be used as a topical cream, which is applied to the skin to relieve pain, irritation, and itching. A study in 2015 by Tran et al. found that camphor increased elastin and collagen production in the skin, making it a potentially beneficial ingredient in anti-wrinkle and anti-aging cosmetics.

Alongside cinnamon's sweet taste and pungent aroma, it also has medicinal effects, particularly associated with its warming and stimulant properties.

Cinnamon was traditionally used in Asian medicine to improve digestion and peripheral circulation, to treat colds and flu, and to relieve spasms. Recent research indicates that not only is cinnamon high in antioxidants, it has other effects, such as stabilizing blood sugar levels and helping to prevent or slow down the onset of diabetes. The compounds cinnamaldehyde and cinnamic acid have been shown to be responsible for some of the antibacterial properties of the plant, for example, against *Helicobacter pylori*, the bacterium that causes stomach ulcers.

CAUTIONARY NOTES

Camphor can have an irritant effect, so care should be taken with the dosage. It is not advisable to use it on open wounds.

CITRUS LIMON
Lemon

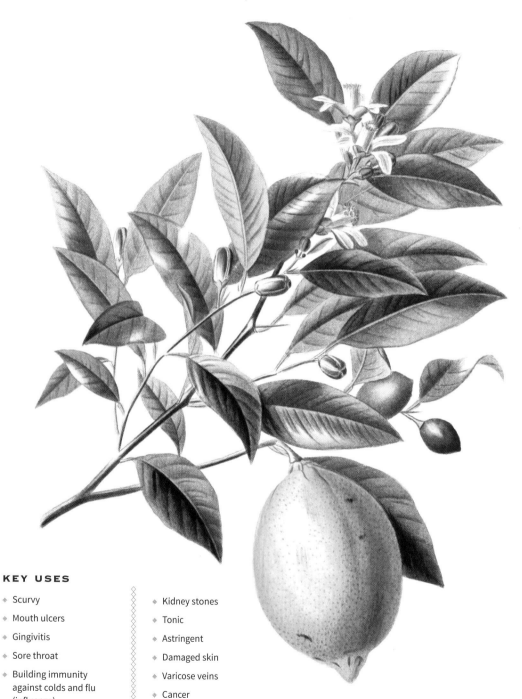

KEY USES

- Scurvy
- Mouth ulcers
- Gingivitis
- Sore throat
- Building immunity against colds and flu (influenza)
- Kidney stones
- Tonic
- Astringent
- Damaged skin
- Varicose veins
- Cancer

Classification and habitat

Lemons are just one of a large number of citrus fruits. Most citruses have been cultivated for so long that their origins are obscure, but the species are closely related, with numerous hybrids and cultivars.

C. limon trees grow to 12–15 ft (4–4.5m) tall. They have glossy green leaves and fragrant white flowers. The fruits appear during spring and summer, and grow underneath the flowers, so flowers and ripe fruits often coexist.

Citrus trees are not hardy, requiring rich, well-drained soil in sun and ample moisture during the growing season, with a minimum temperature of 40°F (5°C) for *C. limon*.

Harvesting

The leaves and fruits (including peel and juice) are harvested to extract the essential oil and juice.

Medical use

Long before vitamin C (also called ascorbic acid) was identified, lemons and oranges were used as a remedy for scurvy. Lemon juice is rich in vitamin C and antioxidant bioflavonoids. Drinking dilute lemon juice stimulates the liver, boosts digestion,

Hot toddy

Lemon juice combined with ginger (*Zingiber officinale*, p. 210) and a teaspoon of honey in a hot toddy (with or without whiskey!) is thought to be as potent a solution for sore throats, colds, coughs, and flu as many over-the-counter remedies.

CAUTIONARY NOTES

Avoid drinking citrus juice neat, particularly that of lemons: It's strongly acidic and can dissolve tooth enamel.

Scurvy at sea

In 1753, the Scottish naval surgeon James Lind proved that citrus fruits, containing vitamin C, prevented scurvy. Most animals can make their own vitamin C, with the exception of humans, monkeys, and guinea pigs. Without vitamin C, the protein collagen, which is found throughout the body, cannot be replaced, and those suffering from scurvy experience symptoms such as bleeding gums, joint pain, slow-healing wounds, and potentially fatal heart problems. Even though it was known that lemons could prevent scurvy, the disease was a major killer of seamen until the early 19th century, when citrus fruits were finally introduced into naval rations.

aids the absorption of iron, and, used sparingly, is an effective mouthwash and gargle.

Applied topically, lemon juice or essential oil helps treat bacterial and fungal skin infections. The peel is particularly rich in bioflavonoids and essential oils containing these are thought to be beneficial for varicose veins and poor circulation.

Consuming citrus fruit also fits with a "prevention is better than cure" approach: They increase resistance to infection by boosting the immune system. A 2018 study by Nair et al. even showed that the peel of *C. reticulata* (mandarin orange), often destined for the trash, should be utilized for its anticancer properties.

The vitamin C hierarchy: Oranges contain the highest concentration of vitamin C, closely followed by lemons and grapefruits, while mandarins and limes contain about half the amount of oranges.

Citrus × sinensis
Orange

CLAVICEPS PURPUREA
Ergot

KEY USES

- Postpartum hemorrhage
- Migraine
- Parkinson's disease

Left: The spindle-shaped sclerotia of *Claviceps purpurea* (ergot) masquerading as grains in ripe wheat ears.

Above: The pink fruiting bodies produce the spores, which are dispersed by the wind to germinate on and colonize a new grass plant.

Classification and habitat

The *Claviceps* genus contains 35 species of parasitic fungi. *C. purpurea* is a poisonous fungus with pale pink to purple, drumstick-shaped fruiting bodies in spring and a *sclerotium* (resting) stage in the summer. The sclerotia, or ergot bodies, are visible on susceptible grasses and small cereal grains, such as rye, wheat, barley, and oats.

Harvesting

C. purpurea (ergot) is harvested mechanically with the ears of rye and other grasses that it grows on, and processed commercially into liquid extracts and its component alkaloids.

Medical use

The sclerotia contain alkaloids that stimulate smooth muscle and act on the central nervous system, blocking the release of adrenalin. Smooth muscle is the type of muscle found mainly in the walls of hollow organs, such as the gut and uterus, and also in the walls of blood vessels. In small amounts, ergot causes uterine and vascular contractions, sometimes resulting in abortion, blocked blood vessels, and a resulting painful, burning gangrene as the blood supply is blocked off. In the Middle Ages, this was called St. Anthony's fire. It was thought to be a punishment for sin that was relieved by a pilgrimage to the shrine of St. Anthony, which was located in an area that was not affected by the fungus.

In larger amounts, ergot causes headache, vertigo, hallucinations, and convulsions; ergot poisoning can be fatal. The fungus may have played a role in the Salem witch trials of 1692–1693. Historians believe that some women developed unusual behaviors after ingesting ergot-contaminated food.

Ergot is evidently toxic but the medically significant alkaloids were isolated in the early 20th century. Two of them—ergometrine (a uterine stimulant) and ergotamine (a vasoconstrictor)—have greatly improved the management of labor, hemorrhage after birth, and migraine. Other derivatives of ergot are also used therapeutically, for example, bromocriptine for Parkinson's disease, and as hallucinogens, for example, lysergic acid diethylamide (LSD).

Fake ID

At a cursory glance, *Claviceps* could be mistaken for a plant—and for years it was. Strictly speaking, though, it isn't, and scientists now classify it in a more suitable kingdom: the fungus kingdom, somewhere between plants and animals. However, *Claviceps'* active molecules have been so sought-after, with such powerful medicinal effects, that the fungus has often been included in botanical medical books. That tradition is continued here. Other examples of fungi, such as magic mushrooms, might also sneak in under the wire but, in a book of only 100 plants, one example of an outlier is probably enough!

CAUTIONARY NOTES

Ergot poisoning is uncommon but outbreaks can still occur when there is a combination of wet weather, cool temperatures, and delayed cereal harvests, or a reliance on poor harvests.

The synthetic ergot derivative LSD is a potent hallucinogen and, although not addictive, it can cause a number of undesirable side effects, including psychosis and depression.

COFFEA ARABICA
Coffee

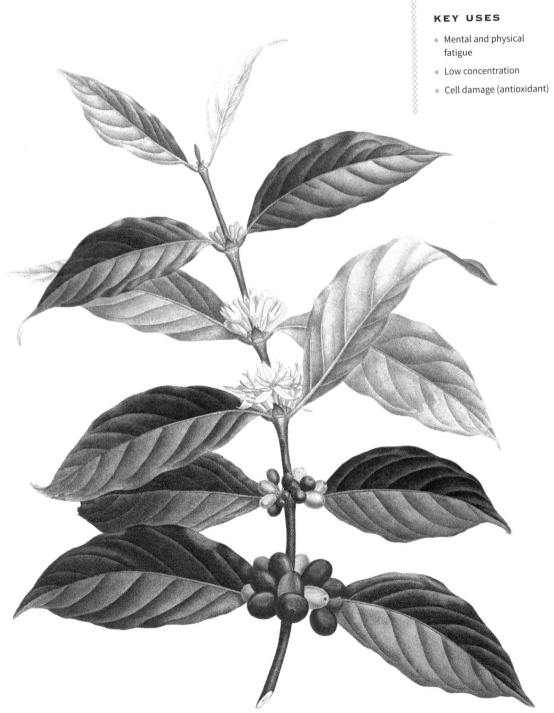

Classification and habitat

This genus contains about 40 species of mainly evergreen shrubs and small trees, which grow in regions of Africa and tropical Asia. *Coffea arabica* is an indigenous plant in and around the Arabian Peninsula (Yemen, Ethiopia, and Sudan); hence its species name. Coffee has been cultivated for over 1,000 years. Brazil is now the world's principal producer of coffee, followed by Vietnam, and then Columbia.

This evergreen shrub (to 22ft, 7m) has broad, glossy leaves. The dense clusters of fragrant white flowers are followed by red fruits, which are called drupes or coffee berries. Inside each drupe are two seeds referred to as beans. *C. arabica* favors well-drained but moist soil in semi-shade, with a minimum temperature of 50°F (10°C).

Harvesting

Coffee beans (more correctly named as the ripe seed) are harvested once a year. The beans are dried and roasted (to varying levels, depending on the desired flavor), before grinding and mixing with hot water to make coffee.

Medical use

Drinking coffee may not feel like taking medicine but the psychoactive properties of caffeine are legendary. Caffeine is a type of alkaloid that is useful to the coffee plant in several ways, including acting as a natural insecticide to protect the plant against insects. For humans, caffeine is a legal psychoactive drug.

Caffeine stimulates the metabolism, blocks the mechanism in the brain that makes you sleepy, and acts on the central nervous system. It reduces both mental and physical fatigue and, when drunk in

Superior supply

Around 75 percent of the world's coffee production comes from *C. arabica*, which has a better flavor and a lower caffeine content than other commercially grown species, such as robusta coffee (*C. canephora*).

Percolating across Europe

A relatively recent drink, in the history of beverages, coffee is now widely drunk, especially in Europe and America, although the British are quite low down the leaderboard, probably because tea is so popular. Coffeehouses spread from the Arabian Peninsula across the Ottoman Empire during the 16th century. As centers of political gatherings, they were sometimes banned, but the drink's popularity ensured their spread first to Europe and then to America in the late 17th century.

moderation, coffee improves concentration and makes you more alert. Caffeine is also included in many painkillers and cold and flu remedies to increase the effect of aspirin or paracetamol.

There are those who think coffee has other health benefits, perhaps not surprisingly, as it contains a complex mixture of 1,000 bioactive compounds. The jury is still out on whether coffee consumption really reduces the risk of developing Alzheimer's or Parkinson's disease, heart disease, type 2 diabetes, colorectal cancer, or gout. But, like tea (*Camellia sinensis*, p. 52), coffee contains antioxidants, which prevent oxygen free radicals from causing cell damage, so there may be some truth behind these claims. The real story probably has several endings, because a 2015 study by Guertin et al. showed that a person's genetic profile and gut microbiome (bacteria) will determine the availability and type of coffee metabolites to which they are exposed.

CAUTIONARY NOTES

If you're drinking four cups or more a day (more than 400mg caffeine), coffee may give you headaches, poor sleep, and heart palpitations. It can exacerbate the hot flashes of menopause, and infertility is also associated with high coffee consumption.

COLCHICUM AUTUMNALE

Autumn crocus

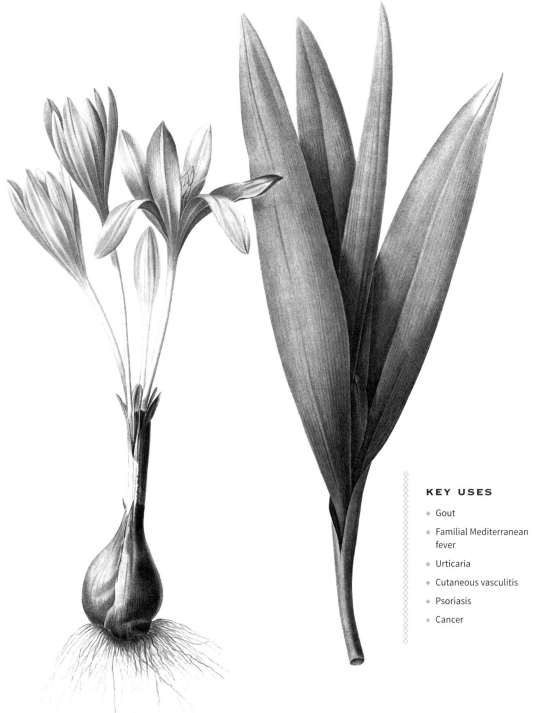

KEY USES

- Gout
- Familial Mediterranean fever
- Urticaria
- Cutaneous vasculitis
- Psoriasis
- Cancer

Classification and habitat

The 45 species in the genus *Colchicum* are native to Europe, North Africa, and from western Asia to western China. They derive their name from an area of Georgia near the Black Sea, called Colchis, where they are very common. One variety, *C. sativus*, produces the yellow spice saffron. Colchicums are popular garden plants, growing in borders, in rock gardens, and under trees. *C. autumnale*, as the name suggests, produces flowers in late summer or early fall. It grows to a height of 12in (30cm).

Harvesting

C. autumnale corms and seeds are collected in the summer and dried for use in liquid and dry extracts or for pharmaceutical preparations.

Medical use

The ancient Egyptians were aware of the poisonous properties of *C. autumnale*. It was also used in ancient Greece as a poison and medicinally to ease the pain of gout.

The active constituent is the toxic alkaloid colchicine. A 2018 scientific review by Pascart and Richette highlighted that data is still being gathered as to its mode of action in gout patients, with particular emphasis on its interactions with other drugs. Side effects and the potential for toxicity are important considerations, but dermatologists have used colchicine for years as an anti-inflammatory agent for skin conditions such as chronic urticaria (hives), cutaneous vasculitis (affecting blood vessels in the skin), and psoriasis (red, inflamed, and raised skin caused by excess skin cells).

CAUTIONARY NOTES

Despite being highly poisonous, Colchicum is commonly grown as an ornamental. Anyone planting it should consider the safety of children and animals.

Colchicine, from *C. autumnale*, is so poisonous that it's sometimes known as "vegetable arsenic."

Ancient to modern

In 2009, the U.S. Food and Drug Administration approved colchicine as a "new" drug. Recent investigations of large cohorts of patients with gout who have been taking colchicine for years have revealed novel uses for this powerful drug, and its derivatives, in the fields of oncology, immunology, cardiology, and dermatology.

Colchicine is also used to treat familial Mediterranean fever, an inherited condition characterized by recurrent episodes of painful inflammation in the abdomen, chest, or joints, often accompanied by fever and sometimes a rash or headache. It primarily affects populations originating in the Mediterranean region, particularly people of Armenian, Arab, Turkish, or Jewish ancestry.

Genetic engineering

Colchicine binds to a structural protein called tubulin, found in both plant and animal cells. Tubulin plays important roles in how cells keep their shape, divide, and move. In a serendipitous finding, tubulin was only discovered in the 1960s because colchicine bound to it! The fact that it disrupts tubulin's function explains colchicine's influence in numerous medicinal fields. And colchicine's effect on plant cells has revolutionized plant breeding. If applied to plant cells when they are dividing, chromosome number can be manipulated, making sterile hybrids fertile and increasing plant size and vigor.

CONVALLARIA MAJALIS
Lily of the valley

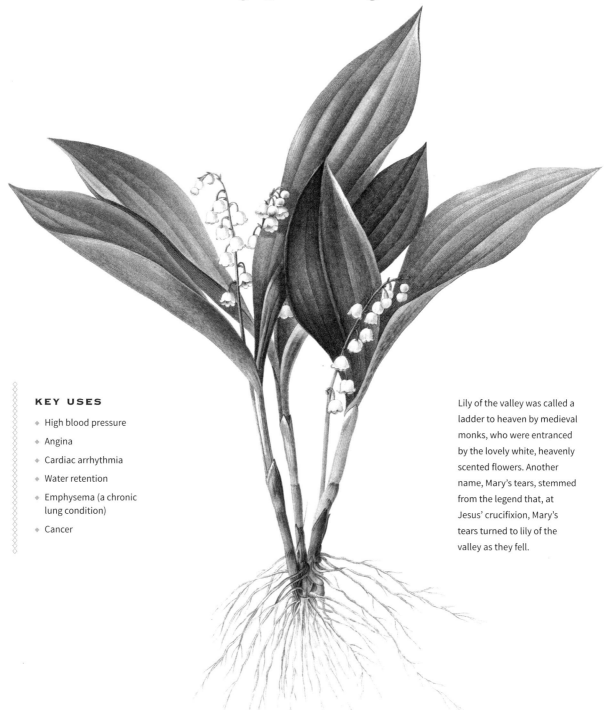

KEY USES

- High blood pressure
- Angina
- Cardiac arrhythmia
- Water retention
- Emphysema (a chronic lung condition)
- Cancer

Lily of the valley was called a ladder to heaven by medieval monks, who were entranced by the lovely white, heavenly scented flowers. Another name, Mary's tears, stemmed from the legend that, at Jesus' crucifixion, Mary's tears turned to lily of the valley as they fell.

Classification and habitat

There are three species of plants in this genus, which are native to northern temperate regions of Europe and North America. The scientific name *Convallaria majalis* comes from the Latin *convallis* (valley) and *majalis* (May-flowering). This small (height 9–12in, 22–30cm) and frost-hardy ornamental plant grows in shady woodland, preferably in deep leaf mold. The scented white, bell-shaped flowers appear in late spring and are followed by red berries. In domestic gardens, this creeping perennial is ideal for growing under roses or shrubs.

Harvesting

The leaves and flowers are harvested in spring and used fresh or dried for liquid extracts, oils, or tinctures. The glycoside content is less in dried leaves.

Medical use

Using lily as a medicinal herb dates back to at least the second century CE, when its flowers were made into a drink that was believed to help boost memory and treat hearts conditions. During World War I, an ointment made from the roots was used to treat the burns caused by mustard gas. The leaves and flowers contain cardiac glycosides (including convallatoxin, convallarin, and convallamarin), which have similar effects to *Digitalis* (foxglove, p. 96). These molecules improve the efficiency of the heart without increasing the need for oxygen, thus lessening the workload on the heart. Lily of the valley's actions are milder than those of *Digitalis*, and are not cumulative, so it is often used as a less toxic substitute for foxglove, particularly for elderly patients. *C. majalis* strengthens the heartbeat while slowing and regulating its rate. For patients with heart failure, *C. majalis* can be combined with *Cytisus scoparius* (Scotch broom, p. 92).

There is less scientific data on *C. majalis* than for *Digitalis*, although recent reports suggest that the cardiac glycosides it contains may have potent anticancer activity. For example, a 2019 study by Badran et al. showed that convallatoxin was the most toxic of a number of small molecules tested in vitro against HER2 positive or triple-negative breast cancer.

Lily lovers

Lily of the valley became Finland's national flower in 1967 because its attractive and sweetly scented flowers are very familiar to Finns. The flower's Finnish name, *kielo*, is also a traditional girl's name, although, for some reason, friendly cows are also called *kielo*!

Bad breaks

The striking but poisonous red berries make this plant a particular hazard in family gardens. Lily of the valley became infamous among *Breaking Bad* aficionados, when the chemistry teacher in the TV drama poisoned a child with its red berries.

CAUTIONARY NOTES

As a toxic plant, C. majalis *should only be taken when prescribed by a herbal or medical practitioner and should not be taken with other cardiac medication. Do not take during pregnancy or while breastfeeding.*

CURCUMA LONGA
Turmeric

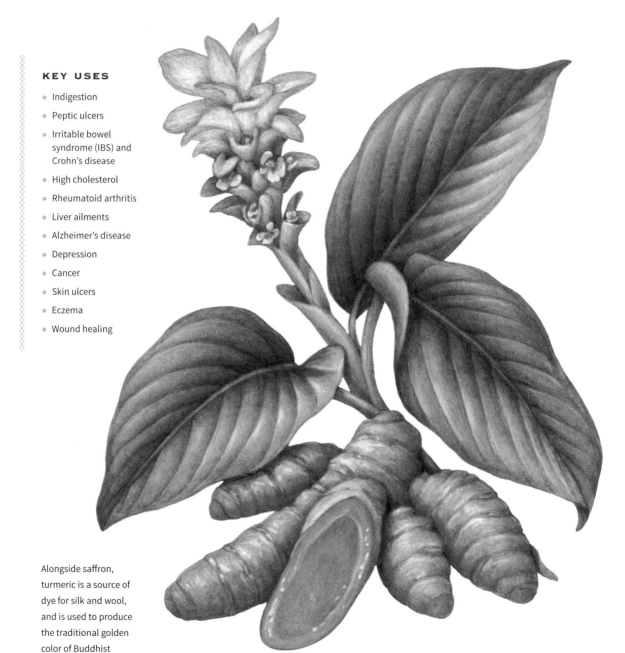

KEY USES

- Indigestion
- Peptic ulcers
- Irritable bowel syndrome (IBS) and Crohn's disease
- High cholesterol
- Rheumatoid arthritis
- Liver ailments
- Alzheimer's disease
- Depression
- Cancer
- Skin ulcers
- Eczema
- Wound healing

Alongside saffron, turmeric is a source of dye for silk and wool, and is used to produce the traditional golden color of Buddhist monks' robes.

Classification and habitat

The *Curcuma* genus belongs to the Zingiberaceae family, of which ginger (*Zingiber officinale*, p. 210) is also a member. *Curcuma longa* is one of 40 species of perennials in this genus, which is native to India and parts of South Asia. The genus name comes from the Arabic name *kurkum*, while "turmeric" is derived from the Latin *terra merita*, which means "worthy" or "deserving earth."

The plant grows to a height of 3ft (1m) and has large rhizomes with long, pointed leaves (up to 20in, 50cm) and yellow flowers in the summer. Like its relative, ginger, turmeric can be grown indoors from fresh rhizomes. It will rapidly sprout new shoots in moist compost above 70°F (21°C).

Harvesting

The rhizomes are harvested from a mature plant (after eight to ten months of growth). They can be stored fresh in the fridge for up to six months, providing they're kept in an airtight bag or container. They'll keep for longer if frozen, or the rhizomes can be dried and powdered for cooking, infusions, or medicinal applications (tablets or capsules).

Turmeric has a rather musky, earthy smell and a pungent flavor. Turmeric's strong taste precludes adding too much to food but it can easily be taken as an extract, in capsules or tablets, for medicinal purposes.

Medical use

Turmeric has had a meteoric rise in recent years to become one of the bestselling herbs in Europe and the UK. That's perhaps not entirely surprising, as turmeric has a long history of use in cooking and in traditional Ayurvedic and Chinese medicine, where it's used to treat digestive and liver ailments, menstrual problems, and rheumatism; to slow aging; and applied to the skin for ulcers, eczema, and to aid wound healing.

Turmeric is used to benefit chronic illnesses from peptic ulcers and liver disorders to high cholesterol and arthritis. Turmeric promotes healthy digestion, working against infection and inflammation in the stomach and small intestine, while protecting the liver from toxins and stimulating the flow of bile. Turmeric is often combined with *Berberis vulgaris* (common barberry, p. 46) for liver complaints and diabetes.

Turmeric is not only used to treat certain conditions, but is often taken as a health prophylactic in keeping with the preventative philosophies of Ayurvedic and traditional Chinese medicine. Turmeric contains curcuminoids, which are highly anti-inflammatory and antioxidant polyphenolic compounds. The polyphenol curcumin makes up 0.3–5.4 percent of raw turmeric and is the active principle that has attracted the most research interest (see next page).

Official approval

Turmeric and its active principles have not escaped the attention of the authorities. In the USA, curcuminoids have been approved by the FDA as GRAS: generally recognized as safe. They are well tolerated and, in clinical trials, they are safe, even at high doses of between 4,000 and 8,000mg/day. Three curcuminoids have been studied: curcumin (see next page), and the related molecules bisdemethoxycurcumin and demethoxycurcumin.

CAUTIONARY NOTES

Turmeric is not associated with any major side effects other than perhaps the risk of people relying too much on its legendary powers, particularly in the case of cancer patients.

CURCUMIN CONUNDRUM

There are thousands of research papers on turmeric and curcumin, but the latest science suggests there is still more to reveal about turmeric's antitumor, antioxidant, and anti-inflammatory properties. Curcumin is part of the picture, but locating its precise position—golden sunset or endless sky— in the turmeric therapeutic jigsaw is still puzzling researchers.

Curcumin has long been heralded as the main active principle of turmeric. Some of the strongest evidence for its therapeutic effects comes from the treatment of arthritis, pain, and depression. From a molecular standpoint, there are some key inflammatory molecules that are influenced by curcumin. Chronic diseases, like Crohn's disease and rheumatoid arthritis, often involve inflammation, and curcumin may block a molecule called NF-κB that turns on genes related to inflammation. Meta-analyses have also supported curcumin's ability to lower the concentration of other inflammatory molecules. These include the C-reactive protein (CRP), TNF-α (the target of a common rheumatoid arthritis therapy), and the cytokine IL-6, one of the many molecules secreted by immune cells.

Take with a pinch of... pepper

There is some doubt as to how much curcumin really contributes to turmeric's actions (see "Pure gold or a PAIN?") but what is known is that curcumin's bio-availability is low. That's because it is not soluble in water, is poorly absorbed in the gut, and, at the same time, when it is absorbed, it is rapidly processed by the liver. If you're buying turmeric capsules, ensure they contain black pepper (*Piper nigrum*, p. 156) or, more specifically, piperine, as this significantly increases curcumin's absorption in the gut. Without it, most turmeric will just go the way of all waste products!

A brainy molecule

Not all molecules can cross the blood–brain barrier, but curcumin can, due in part to its lipophilic nature (meaning it can integrate with and pass through the lipids of cell membranes) and particularly if it is presented in a nanoparticle (tiny) form. Curcumin has been shown to help clear the amyloid plaques that build up in Alzheimer's disease, so the molecule is attracting interest as an Alzheimer's treatment. Curcumin's other effects on the brain include influencing the serotonin and dopamine pathways that are closely linked with depression.

One piece of the puzzle

One of turmeric's more controversial uses is as a supplement for people with cancer. The scientific literature is inconclusive but, in 2018, Lopresti reviewed an increasing body of data supporting the idea that curcumin's myriad medicinal benefits may be related to its positive influence on gastrointestinal health and function. Curcumin may not be well absorbed in the gut but it appears to affect how the gut functions, the composition of the gut microbiome, and levels of inflammation. This is important because scientists are increasingly understanding how the gut influences the body's immune responses and inflammatory status.

Curcumin is part of the turmeric picture but it's just one piece of the puzzle. As one component of a package of health support for cancer patients, and those with other conditions, turmeric may have a role to play, but it's not advisable to rely on its unproven antitumor properties.

The symmetrical molecule curcumin gives turmeric its characteristic yellow color and contributes to some, if not all, of turmeric's medical benefits.

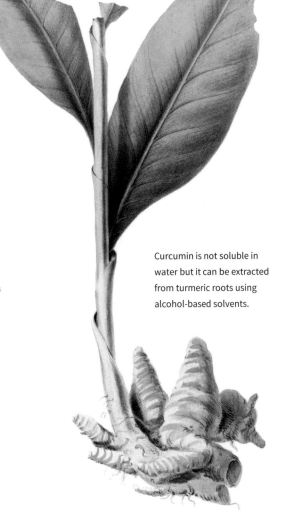

Curcumin is not soluble in water but it can be extracted from turmeric roots using alcohol-based solvents.

Pure gold or a PAIN?

Scientists have recently labeled curcumin as a PAIN (Nelson et al., 2017). Well, in research terms, that's certainly true, because PAIN stands for "pan-assay interference compound." This means that curcumin often gives false positive results in those biochemical tests, or assays, that test its effect on, for example, cancerous cells. Scientists think that curcumin is masquerading as something that is more effective than it actually is. The key difference between PAINs and genuine active principles is specificity. PAINS are excellent actors and can have many personas. In biochemical terms, this means that they interfere with more proteins than the one specific target.

Curcumin is probably not the only plant compound that falls into this category, but scientists are wary of following leads that don't show specificity. It is not the route to a successful drug that can be modified to ensure a safe and targeted action.

CYNARA SCOLYMUS

Globe or French artichoke

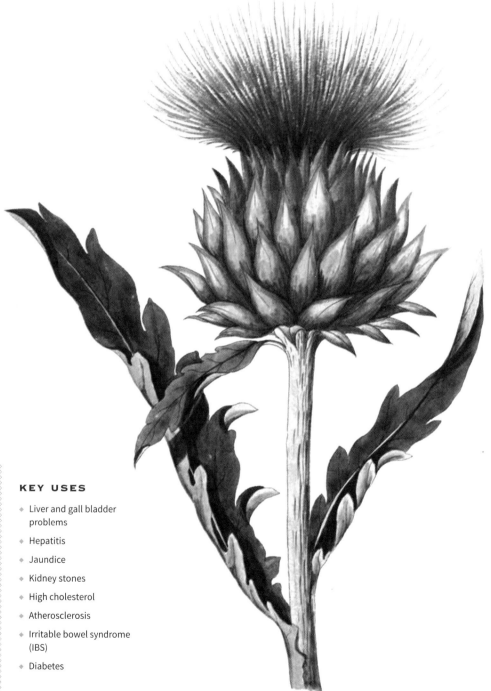

KEY USES

- Liver and gall bladder problems
- Hepatitis
- Jaundice
- Kidney stones
- High cholesterol
- Atherosclerosis
- Irritable bowel syndrome (IBS)
- Diabetes

Classification and habitat

Native to the Mediterranean region and North Africa, the *Cynara* genus includes 10 species of frost-hardy perennials. The name *C. scolymus* comes from the Greek island of Kinaros (*Cynara*) and the word *scolymus*, meaning "pointed stake." *C. scolymus* is not found in the wild but was probably developed from *C. cardunculus* (cardoon) in the distant past.

The plant grows to 4–5ft (1.2–1.5m) and has large, thistlelike, pink-purple flowers. As a striking architectural plant, it's suited to the back of large borders, growing in well-drained soil in sun or partial shade. The heads of the green flower buds are edible.

Harvesting

Before flowering, in early summer, the leaves are harvested for medicinal purposes and dried for use in infusions or pharmaceutical extractions, while the unopened flower heads are cut for food.

Medical use

The artichoke is one food-cum-medicinal plant that definitely sits on the mild end of the poison spectrum. Two of its traditional uses were in what might be viewed by some as a winning combination—it has been used as an aphrodisiac and a contraceptive—although there is no firm scientific evidence for either of these properties!

In recent years, the globe artichoke has become medicinally important, with the discovery of cynarin. This phenol-based compound is isolated from the leaves, where it's at the highest concentration. It stimulates the secretion of

A delicate business

Globe artichokes are not necessarily part of an everyday diet but their delicately flavored leaves are delicious. The unopened flower hearts are boiled and eaten hot. To eat, pull off the outer petals one at a time. You can dip the base of the petal into hollandaise sauce or vinaigrette dressing, then pull it through your teeth to remove the soft pulpy portion. The rest of the petal is discarded.

digestive juices, in particular, bile. And cynarin is responsible for the plant's curious effect on taste: everything else tastes sweet after you've eaten fresh artichoke.

Clinical studies to date have been small-scale in nature but do suggest that *C. scolymus* leaf extract lowers blood lipids, such as the low-density lipoprotein (LDL) form of cholesterol (while HDL, the beneficial high-density form, increases); reduces blood sugar levels; and helps to metabolize fat. Its latter role in helping to combat obesity is of particular interest and the subject of ongoing research.

Restricting consumption

Originally grown by the Greeks and Romans, artichokes became popular in France in the 16th century in monastery gardens. Outside these walls, however, French women were forbidden to eat them, for fear of their supposed aphrodisiac qualities.

CAUTIONARY NOTES

Rarely, artichokes cause an allergic reaction and gastrointestinal pain and bloating. People with gallstones should take medical advice.

CYTISUS SCOPARIUS

Scotch broom

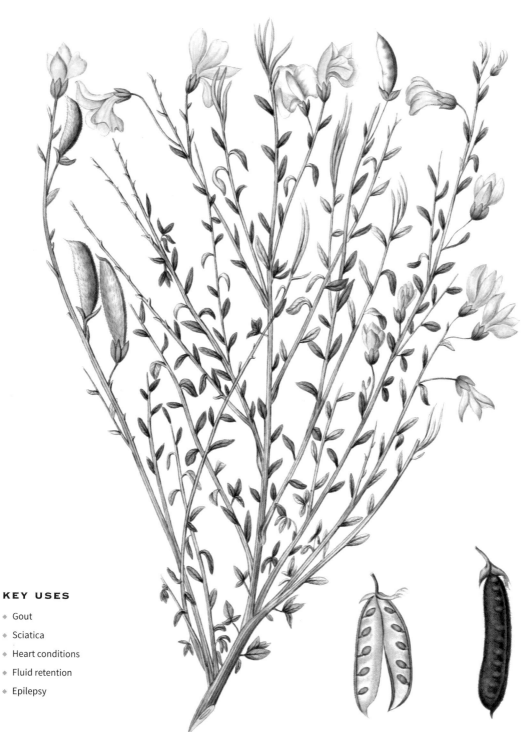

KEY USES

- ◆ Gout
- ◆ Sciatica
- ◆ Heart conditions
- ◆ Fluid retention
- ◆ Epilepsy

Classification and habitat

The genus *Cytisus* contains at least 30 evergreen and deciduous small trees and shrubs, which grow across North Africa, western Asia, and Europe. The perennial shrub *C. scoparius* grows to a height of 9ft (2.75m) and is native to European heaths, waste ground, and woods. It has thin stems, covered with copious bright yellow flowers, which turn into black seed pods.

In domestic gardens, *C. scoparius* grows in well-drained soil in sun. Although the plant does not transplant well, it tolerates hard pruning, back to two-thirds of its growth.

The name *Cytisus* comes from the Greek *kytisos*, an ancient word to describe various wood legumes. The common name "broom" refers to its use as a brush.

Harvesting

The tops of shoots are cut as flowering begins and dried for use in infusions, liquid extracts, and tinctures.

Medical use

Broom features in records of Anglo-Saxon medicine and, in the 13th century, Welsh physicians recommended the unusual combination of broom tops and boys' urine to cure pain caused by a thorn. Broom blossom was also used by the infamous English King Henry VIII, to soothe the effects of his excessive eating and drinking, namely, in a salve to cure gout.

This bitter, narcotic herb depresses respiration, regulates heart action, and has diuretic effects. It has been used particularly in conjunction with

Sparteine is a member of the quinolizidine alkaloids, which have a strong sedative effect on the central nervous system.

Convallaria majalis (p. 84) for heart failure. *C. scoparius* contains alkaloids such as sparteine. This acts upon the electrical conductivity of the heart, slowing and regulating the transmission of the impulses.

Although many of the traditional uses of broom are now historical (see Cautionary Notes below), sparteine research is entering a new phase, with ongoing investigations into exciting new applications of sparteine derivatives. These include new heart failure drugs, long-lasting local anesthetics, and anticonvulsants for epileptic seizures. A 2017 study by Medina et al. also describes in some detail the areas of the brain that are affected by sparteine—all of which relate to its potent effects on the body.

A royal heritage

The medical uses of *C. scoparius* are listed in all the early European herbals under *planta genista*, from which the Plantagenets—the British royal house—took its name.

CAUTIONARY NOTES

The composition of active ingredients in C. scoparius *is highly changeable, so attention is now focused on pharmaceutical extracts of the active ingredients. In addition, many of the hybrids of* C. scoparius *listed in horticultural catalogs are variants and not suitable for medicinal use.*

DATURA STRAMONIUM

Jimsonweed or thorn apple

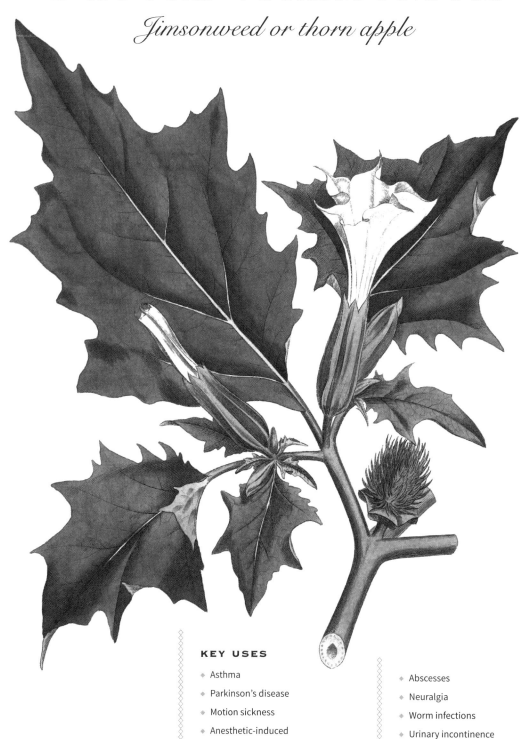

KEY USES

- Asthma
- Parkinson's disease
- Motion sickness
- Anesthetic-induced nausea
- Abscesses
- Neuralgia
- Worm infections
- Urinary incontinence

Classification and habitat

The genus name *Datura* comes from *dhatura*, the Bengali word for the plant, while *stramonium* is a combination of the Greek *strychnos*, for nightshade, and *makinos*, meaning "mad," referring to its narcotic properties.

Thought to have originated in Central and South America, this invasive weed now grows worldwide. It is an annual herb that grows to a maximum height of 6½ft (2m). The stems divide into two branches, both of which divide into two branches as they grow, and so on. The leaves smell rank when they're crushed and the flowers are white and tubular, or trumpet-shaped. *D. stramonium* grows as a weed in rich, light soils in a sunny position.

Harvesting

The leaves and flower tops are collected in summer and the seeds in the fall. Alkaloids are commercially extracted for use in liquid extracts, powders, and tinctures.

Devil's breath
Scopolamine scare stories abound in the backpacking hostels of South America, where the drug was supposedly blown onto travelers, who became drowsy and out of it when they inhaled the dust, at which point their valuables were stolen. It was even supposed to be responsible for similar incidents in Paris in 2015, although there is scant evidence for this.

Competition with crops
D. stramonium grows in dense stands, out-competing other species. Infestations in the USA have led to an up to 60 percent reduction in soybean and cotton yields, while in Spain similar effects have been seen with maize crops.

Medical use

Daturas are extremely poisonous, containing tropane alkaloids—such as hyoscyamine, atropine, and scopolamine—similar to those in *Atropa belladonna* (p. 44). Daturas have a long local history of medicinal and ritual use. *D. stramonium* is a bitter narcotic herb that relaxes spasms, relieves pain, and encourages healing. The Eastern Cherokee used the leaves dried and smoked as a traditional treatment for acute asthma attacks—although this is definitely not a remedy to try at home!

As the plant spread from its southern American origins, it was recorded in 1676 in Virginia, where British soldiers reportedly used its seed as a narcotic.

In modern times, one alkaloid isolated from *D. stramonium*, scopolamine, has found new uses. It causes amnesia and so forms part of the drive to find treatments for the memory loss seen in Alzheimer's patients. And Lee et al. (2020) discovered that, at low doses, applied through a transdermal patch, scopolamine was an effective way of treating motion sickness or anesthesia-induced nausea. It works by decreasing the nerve signals to the stomach that trigger vomiting.

In Indian Hindu temples, worshippers leave offerings of the thorn apple fruits to Shiva, the god who is associated with this plant.

CAUTIONARY NOTES

D. stramonium is highly toxic to livestock and humans. Excess causes giddiness, dry mouth, hallucinations, and coma.

DIGITALIS LANATA

Grecian foxglove →

KEY USES

- Heart failure
- Atrial fibrillation
- Cancer

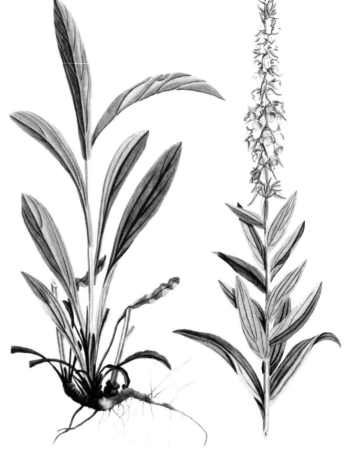

DIGITALIS PURPUREA

← *Common foxglove*

KEY USES

- Heart failure
- Atrial fibrillation

Classification and habitat

The *Digitalis* genus comprises about 20 species of biennials and perennials growing across Europe, North Africa, and Asia.

Digitalis comes from the Latin word *digitus*, or "finger," as a finger slips easily into one of the flowers. The origin of the name "foxglove" is shadier, but one suggestion is that it refers to the way the plant often grows in the disturbed ground around a fox's den or earth. Although very poisonous, foxgloves' elegant flowers are prized by gardeners.

D. purpurea is a hardy biennial (height 5-6ft, 1.5-1.8m), native to temperate Europe, with pretty purple, bell-shaped flowers. *D. lanata* (height 3ft, 1m) is a biennial or short-lived perennial with spiky leaves 5in (12cm) long. The spikes of creamy flowers appear in summer and are followed by capsules containing many seeds.

Harvesting

D. purpurea and *D. lanata* are both grown commercially for cardiac glycoside extraction. The leaves are picked before flowering and dried before pharmaceutical extraction. *D. lanata* is the main source of digoxin in the USA.

Medical use

The journey to the active compounds of *Digitalis* started in 1785, when the English physician and botanist William Withering learnt about the herbalists' remedy for water retention and how it also affected the heart, often unpredictably. *Digitalis* species contain cardiac glycosides, which make the heart muscles contract more strongly by inhibiting the activity of an enzyme (ATPase) that controls the movement of calcium, sodium, and potassium into the heart muscle. This helps it beat effectively.

Digoxin is the best-known cardiac glycoside. It is used to treat heart failure and certain types of atrial fibrillation (a form of irregular heart beat). In recent years, concerns about its toxicity and the development of newer drugs for these heart problems have led to questions around its use. It is now more common to use digoxin only if other drugs have not proved effective.

Digitalis lanata also contains another group of cardiac glycosides called lanatosides A, B, and C. The most recent research on one of these, lanatoside C, has focused on its anticancer potential. Gastric cancer is the third most common cancer in the world, and frequently has a poor prognosis due to a lack of effective drugs. In an in vitro study in 2018, Wu et al. showed that lanatoside C could inhibit the proliferation of gastric cancer cells—a promising start for a potential new therapy.

Just one molecule makes all the difference

Two of the *Digitalis* cardiac glycosides are digoxin and digitoxin. These are very similar in terms of their structure but differ in their half-lives and how they are eliminated. Digoxin has a shorter half-life than digitoxin and therefore fewer side effects. Digoxin is mainly eliminated by the kidneys, so can be given to patients with liver disease, whereas digitoxin is dealt with by the liver, so is more suitable for those with kidney disease.

CAUTIONARY NOTES

The cardiac glycosides that are contained within these **Digitalis** *species specifically affect the function and rhythm of the heart, so particular care is taken by medical practitioners and herbalists to use the correct dose. Getting it wrong can be fatal!*

DIOSCOREA VILLOSA
Wild yam

KEY USES

- Premenstrual syndrome (PMS)
- Menopausal problems, including hot flashes
- Labor pains
- Cramp
- Irritable bowel syndrome (IBS)
- Diverticulitis
- Colitis
- Crohn's disease
- Arthritis
- Asthma

Across the world, yams are a major food source: They are high in carbohydrates and a range of minerals and vitamins but low in protein. The common name "yam" is from a word meaning "eat" in some West African languages. Confusingly, in America the name "yam" also refers to the sweet potato, the unrelated species *Ipomoea batatas*.

Classification and habitat

About 600 species make up this large genus of tropical and subtropical climbers, found in Africa, America, Asia, and the Pacific islands. Although a few are grown as ornamentals, most are cultivated as food crops in warm areas.

The perennial *D. villosa* climbs to a height of 15ft (5m). It has slender rhizomes and pointed, heart-shaped leaves. Its tiny, drooping yellow-green flowers appear as spikes in the summer. *D. villosa* grows best in rich, well-drained soil in sun or partial shade. In North America, it's found in moist woods and along roads.

Harvesting

The roots and rhizomes are harvested in the fall and used fresh or dried for liquid extraction.

Medical use

Yams are a valuable source of food and contain hormone-like compounds. As an anti-inflammatory and antispasmodic plant, *D. villosa* relaxes spasms, stimulates the flow of bile, and dilates blood vessels. For IBS patients, wild yam extract can decrease gut spasms, stop diarrhea, and relieve bloating and cramping. It also soothes the uterine cramping associated with PMS.

An alternative drug trade

Hormones were a late discovery in the history of medicine but, following the isolation of cortisone in 1934, *Dioscorea* species such as *D. villosa* became a source of saponins. These could be cheaply converted into steroid drugs, such as oral contraceptives, anabolic (body-building) drugs, and corticosteroids. Large-scale cultivation of yams became a major industry in Mexico, producing over 80 percent of the raw material for steroidal drugs, until synthetic methods took over in the 1970s.

Twin diet?

The Yoruba tribe in Nigeria has a high number of twin births. Some put this down to their regular consumption of hormone-boosting yams. Comforting as it may be to think that the addition of yams to our diet could be a simple cure for infertility, researchers suggest that it's more likely to be attributable to hereditary factors.

While its traditional use has concentrated on its anti-cramping properties, it is now increasingly used to relieve menopausal symptoms, such as hot flashes. It's not clear how the steroid compounds in the wild yam work as, in the laboratory, several synthetic steps are needed to convert these compounds into active hormones. But there is anecdotal evidence for wild yam's efficacy. For best results, it's recommended that it is taken for several weeks, possibly combined with *Actaea racemosa* (black cohosh, p. 18).

Saponins (plant phytochemicals) isolated from *D. villosa* are slowly revealing anticancer potential, with one such compound, dioscin, highlighted in 2016 by Aumsuwan et al. as an anti-invasive drug against breast cancer cells grown in vitro.

Diosgenin, another *D. villosa* saponin, has demonstrated anti-inflammatory potential in forms of arthritis, for example, in an in vitro 2015 study, by Wang et al., of the cells involved in osteoarthritis. Certainly, the data support the traditional use of *D. villosa*, often combined with the bark of *Salix alba* (willow, p. 168), for the treatment of arthritis.

CAUTIONARY NOTES

Excessive consumption can irritate the gut.

ℰCHINACEA PURPUREA
Echinacea or snakeroot

KEY USES

- ◆ Common cold
- ◆ Wounds and boils
- ◆ Eczema
- ◆ Acne
- ◆ Bacterial infections: diphtheria, tonsillitis, and sinusitis
- ◆ Hemorrhoids

E. purpurea is cultivated widely in the USA and Europe, being the easiest *Echinacea* species to cultivate. Its aerial parts are thought to have the strongest medicinal activity.

Classification and habitat

Eleven species of hardy, herbaceous perennials make up this genus, which is native to the eastern USA. Echinacea is a popular garden plant, making a colorful border display from midsummer to early fall. It does need full sun and fertile, well-drained soil. *E. purpurea* grows to a height of 4ft (1.2m) and produces numerous daisy-like, honey-scented pink-purple flowers, with conical orange-brown centers, for cutting.

The genus name *Echinacea* comes from *echinos*, the Greek word for "hedgehog," describing the prickly scales of the plant's seed head.

Harvesting

Aerial parts, rhizomes, and roots are harvested in the fall. Echinacea extracts are widely available either in a liquid form or as powders or tablets.

Living up to its name?

It's fair to say that, despite centuries of traditional use and a regular slot in the top 10 selling herbs list, there is some disagreement as to whether echinacea really boosts the immune system and helps cure the common cold. This is partly down to variable preparations, or poorly designed or over-hyped experiments, and partly because, in the wake of a wealth of anecdotal evidence, there is a lack of financial incentive to investigate echinacea's properties fully. This is a common issue in the field of herbal medicine, unless there is even a hint that a plant might cure cancer—and that's not currently on the horizon for echinacea!

Medical use

E. purpurea, together with *E. angustifolia* and *E. pallida*, has been used throughout history to treat all manner of ailments, from the everyday cold, respiratory symptoms caused by bacterial infections, to wounds, snake bites, and blood poisoning.

Echinacea is most commonly used nowadays as a short-term treatment for common colds and sore throats and to boost the immune system. The jury is still out as to how it works—or if it really does—but even a cursory glance at the scientific literature will reveal studies showing how it purportedly enhances the activity of white blood cells, in various ways.

The most sensible, and possibly the most accurate, advice seems to be to take it at the onset of a cold, which may decrease its duration and severity. Even a weak effect is worth it and short-term use of the recommended dose is unlikely to do you any harm.

Scientists have tried to isolate the active ingredient in echinacea and have identified at least three different classes of compounds. In isolation, they may show some activity but it seems to be the sum of these parts that has the most effect. The hunt continues. One group, which were first discovered approximately 10 years ago, the phylloxanthobilins (natural products that arise from the degradation of chlorophyll) are attracting attention as possible candidates for the active principle accolade.

Echinacea angustifolia
Narrow-leaf coneflower

In its cultivated form, this plant joins *E. purpurea* as one of the main medicinal sources of echinacea.

ELETTARIA CARDAMOMUM

Cardamom

KEY USES

- Indigestion
- Colic
- Trapped wind
- Bad breath
- Sore throat
- Bronchitis
- Tonic
- High blood pressure

Cardamom came from India and Sri Lanka until the 1800s, when British farmers started planting cardamom as a second crop in their coffee plantations in South America, Africa, and Asia.

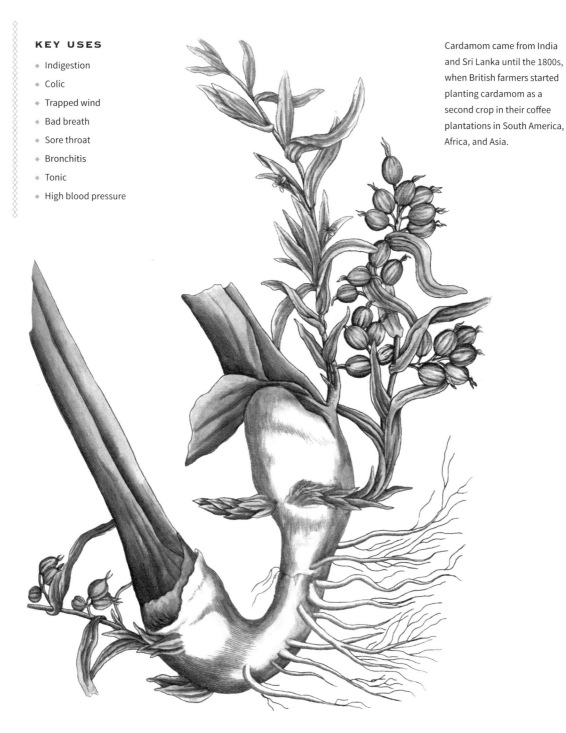

Classification and habitat

The *Elettaria* genus is made up of about four species of rhizomatous perennials which grow in India, Sri Lanka, Sumatra, and Malaysia. *Elettaria* comes from the Keralan word for the plant, *elettari*.

The perennial plant *E. cardamomum* grows to a height of 10ft (3m), bearing 2ft (60cm) long lanceolate (lancelike) leaves and white flowers on a spike. The pale green fruits contain capsules or pods with aromatic seeds.

E. cardamomum prefers rich, moist, well-drained soil in partial shade with a minimum temperature of 64°F (18°C). *E. cardamomum* can be grown under cover in temperate regions but will rarely produce flowers or fruits in these conditions.

Harvesting

The fruits are collected during the dry season and dried whole. The seeds are removed for oil extraction or made into liquid extracts, tinctures, or powders.

Medical use

E. cardamomum grows wild in the monsoon forests of Kerala, so much so that historically the economy of this region of southwest India—appropriately named the Cardamom Hills—was closely linked with the success of the crop. It was exported from the East to Europe for centuries along the ancient caravan routes.

Cardamom is a well-known Indian spice, adding warmth and a slightly spicy, sweet flavor to savory and sweet dishes. Its medicinal uses stem from the ancient Indian Ayurvedic and Chinese medical systems and center on the

Natural hypertension management?

An Indian research study by Verma et al. in 2009 suggested that high blood pressure could be lowered with daily doses of 0.1oz (3g) of cardamom powder for 12 weeks. High blood pressure is a significant health risk for cardiovascular diseases and, though this finding has not been confirmed in larger-scale investigations, cardamom could represent a natural approach to managing hypertension, particularly when it is first diagnosed.

Cardamom is rich in cineole, a potent antiseptic that kills bacteria. To freshen bad breath, discard the pods and chew on a few seeds.

digestive system—just as well, as it is often an ingredient in spicy dishes that can challenge the gut. Cardamom eases trapped wind, relieves colic, and helps with nausea and indigestion.

It is often used in combination with other soothing or warming plants: *Chamomilla recutita* (chamomile, p. 70) and *Zingiber officinale* (ginger, p. 210), respectively. The warming and antiseptic action of cardamom can be helpful for bronchitis and in a gargle for sort throats. A study in 2020 by Souissi et al. suggests that cardamom's uses could be extended to combating some types of periodontal infections—conditions that mainly affect the gums.

CAUTIONARY NOTES

Unusually, there are no documented side effects but, as always, medical advice should be taken before upping your intake beyond normal culinary levels.

ЕPHEDRA SINICA
Ma huang

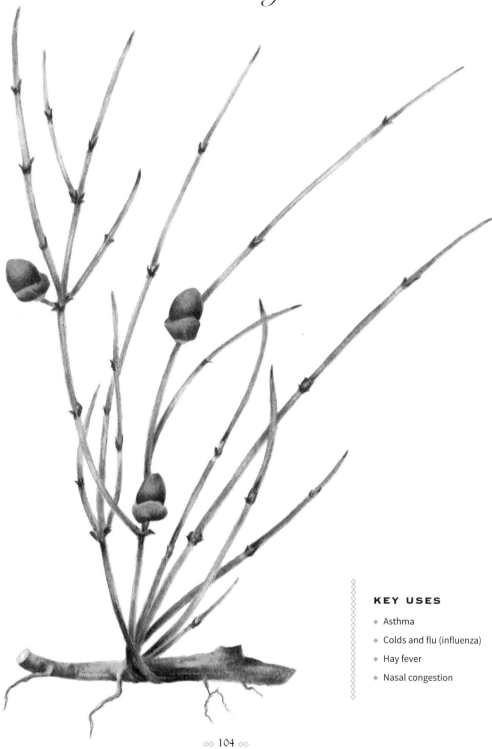

KEY USES

- Asthma
- Colds and flu (influenza)
- Hay fever
- Nasal congestion

Classification and habitat

The *Ephedra* genus contains about 40 species of shrubs and climbers. *E. sinica* is an evergreen shrub that can grow up to approximately 1ft (30cm) tall. This *Ephedra* species grows in dry locations at higher altitudes in northern China. It flowers from May to June, although as a type of gymnosperm (ancient "naked" seed-producing plants) its flowers are rather plain. The seeds ripen from August to September. The jointed green stems are the chief photosynthetic organs of the plant and these contain the alkaloids. This hardy plant will grow in well-drained to dry soil in sunny positions.

Harvesting

Stems are cut at any time and dried for use by the pharmaceutical industry or medical herbalists in powders, tinctures, and liquid extracts.

Medical use

Ma huang is one of the earliest and best-known drugs of Chinese traditional medicine, with descriptions of its use dating back to 100 CE. It was and still is used to treat the symptoms of bronchial asthma, colds, influenza, and hay fever. In the early 20th century, chemists isolated the major pharmacologically active compounds in ma huang: the alkaloids ephedrine and pseudoephedrine. These are central nervous stimulants that constrict blood vessels. Due to their vasoconstrictive action on the nasal mucosa, ephedrine and pseudoephedrine are highly efficient drugs for relief of nasal congestion, although their use is carefully regulated.

Drug bust

In 2014, a major drug seizure in southern China centered on the village of Boshe, one of China's biggest production centers for the illegal drug methamphetamine (meth). This is also the region of China where *E. sinica* is commercially grown. That's because not only does this crop provide the natural source of ephedrine—a key ingredient in Western medicines for asthma, among other ailments—but also for meth synthesis.

In recent years, ephedrine and pseudoephedrine have been also been used for retrograde ejaculation, a condition related to infertility where semen enters the bladder instead of emerging through the penis during orgasm.

Weight loss... at a price

Asthma treatment is now one of the standard clinical uses for pure ephedrine as a prescribed pharmaceutical drug but, in the past, dietary supplements have contained *Ephedra* for weight loss and increased athletic performance. *Ephedra* use has been linked to significant side effects, such as high blood pressure and stroke, so the FDA banned its use in such supplements in 2004. It seems there are still no magic bullets for weight loss—other than the obvious combination of healthy diet and exercise.

CAUTIONARY NOTES

You should definitely consult with a health professional before taking ma huang. There is a pretty long list of people who shouldn't use it, including those who are pregnant, as well as those who have heart disease, diabetes, or thyroid problems.

ERYTHROXYLUM COCA

Coca

KEY USES

- ◆ Fatigue
- ◆ Altitude sickness
- ◆ Anesthetic
- ◆ Psychoactive

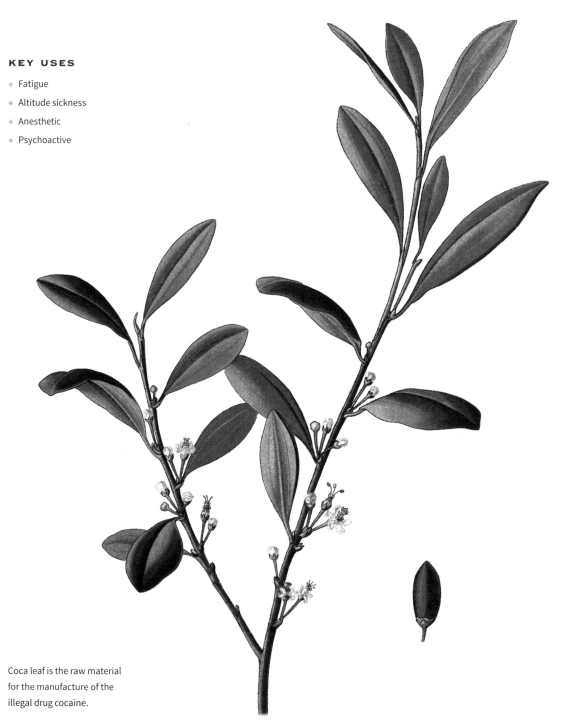

Coca leaf is the raw material
for the manufacture of the
illegal drug cocaine.

Classification and habitat

Erythroxylum coca is a small, evergreen tree (12ft, 3.5m) with straight branches, narrow oval leaves, and small yellow-white flowers, which mature into red berries.

Widely cultivated in the Andean region of South America (Peru, Bolivia, Colombia, Ecuador, and northwestern Argentina) where it grows wild, the plant is not easy to cultivate elsewhere, other than in regions with similarly high altitude and the hot, moist conditions *E. coca* prefers.

Harvesting

The leaves are harvested for use in herbal infusions or the manufacture of cocaine. They are picked once they break when bent, and spread on the ground in thin layers to dry in the sun.

Medical use

The Peruvian habit of chewing coca leaves can be dated back to at least 500 CE, when coca was used as a ritual plant. Chewed with lime or plant ashes, the leaves both soothe the user and increase energy levels. An infusion of the leaves is still drunk in the Andean regions as a remedy for altitude sickness and the sale of unprocessed coca leaves is legal in these areas.

The word "cocaine" often conjures up images of the illegal drug trade, not to mention the millions of acres of rainforest in South America

Cracking drug habits

In 1885, cocaine was marketed in the USA with the claim that it could "supply the place of food, make the coward brave, the silent eloquent and render the sufferer insensitive to pain." This was all true, but at the time, cocaine's addictive nature was not well recognized. The drug acts on the dopamine system in the brain, enabling a buildup of dopamine and producing the characteristic "high." Cocaine, particularly crack cocaine, highjacks the reward pathway in the brain more effectively than any other drug. Because of its rapid onset of action and intense, but short-lived, euphoria, crack cocaine (also known as "rocks" or "stones") often leads to a drug habit, which is difficult to crack.

that have been destroyed for *E. coca* cultivation since the early 20th century. But cocaine also has medical applications.

The alkaloid cocaine was isolated in 1860 and first used as an anesthetic in a cataract operation in 1884. Cocaine is an effective local anesthetic that works by blocking nerve impulses. It is used during procedures involving the mouth and upper respiratory tract. As a vasoconstrictor, cocaine also causes blood vessels to narrow, decreasing bleeding and swelling.

Cocaine is a psychoactive drug that also increases sweating and heart rate, and dilates the pupils.

Coca-Cola

Social use of cocaine and coca leaf products was popular during the 19th century. One of the most popular was made by John Pemberton in 1886. He called it "Intellectual Beverage and Temperance Drink," more recognizable to today's drinkers as Coca-Cola. The name refers to two of its original ingredients: coca leaves and kola nuts (a source of caffeine). The current formula remains a closely guarded secret!

CAUTIONARY NOTES

Psychological dependence with intense, compulsive drug-seeking behavior is characteristic of even short-term use of cocaine.

EUCALYPTUS GLOBULUS

Eucalyptus

KEY USES

- Colds
- Sore throat
- Fever
- Catarrh
- Bronchitis
- Nasal and sinus congestion
- Insect bites
- Wounds and abscesses
- Fungal skin conditions

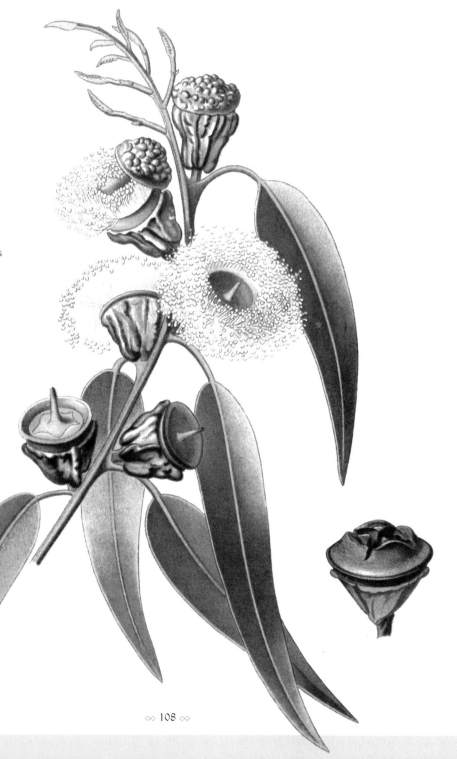

Classification and habitat

Over 500 species of aromatic evergreen shrubs and trees belong to this genus, which is native to Australia. Many are grown for timber or as ornamentals for their patterned bark and attractive foliage. Eucalyptus are among the world's fastest growing and tallest trees, with some species growing to at least 300ft (90m).

E. globulus is found in moist valleys in New South Wales and Victoria. It is known as the blue gum and is the floral emblem of Tasmania. This large spreading tree grows to 150ft (45m), with smooth, creamy-white peeling bark. The glossy adult leaves are sickle-shaped, while the flowers are an unusual oval shape with a silvery-blue color.

E. globulus is one of the hardier eucalyptus varieties and will grow at minimum temperatures of 5°F (−15°C) in fertile, well-drained, neutral to acid soil in full sun. Excess growth can be contained by cutting back in spring.

Harvesting

Leaves are cut as required and dried for infusions or distilled for their essential oil. Kino is collected from bark incisions and dried for use in powders, tinctures, and lozenges.

Medical use

Without eucalyptus, the Australian outback would be an even more barren place. The Aborigines are big fans of the tree, not only for its greenery and shade, but as a treatment for colds, fever, chest infections, and skin complaints. In America, it was commonly used to ease respiratory infections. Its main actions are as an expectorant and an antiseptic. Eucalyptus is effective against many bacterial organisms. An infusion of the leaves or diluted oil can be applied to insect bites and fungal skin infections.

Eucalyptus bark exudes an oleoresin, known as kino, which is rich in tannins and used in mouthwashes and throat syrups to ease inflammation. The leaves produce essential and aromatic oils, found in antiseptics and balms. A key chemical in eucalyptus is cineole (eucalyptol), which relieves nasal congestion, eases sore throats and coughs, and fights infections. In 2014, clinical trials (reviewed by Juergens) produced the first evidence of the benefit of using cineole as a long-term therapy in chronic obstructive pulmonary disease (COPD) and to improve asthma control. It is this oil that produces the strong scent and is contained in many over-the-counter medications with words like "vapor" and "rub" in the title.

Koala diet

The koala, that iconic image of Australian wildlife, eats mainly eucalyptus leaves, consuming 1–2lb (0.5–1kg) daily. Such a restricted diet can have its problems, particular when eucalyptus trees are so susceptible to the forest fires that wreak havoc every summer. Thankfully, the eucalyptus' survival is ensured by harvester ants who take the seeds into their underground stores, where they survive and can germinate safely away from the scorched earth.

CAUTIONARY NOTES

Eucalyptus essential oil should not be used internally, except if advised by a health professional. It's also unsuitable for children under five years old. The essential oil can irritate the skin.

GAULTHERIA PROCUMBENS
Wintergreen

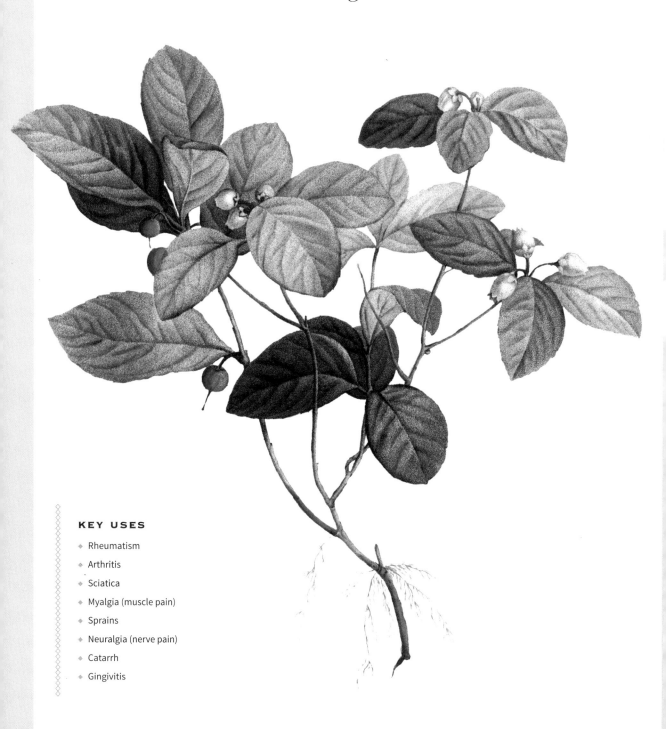

KEY USES

- Rheumatism
- Arthritis
- Sciatica
- Myalgia (muscle pain)
- Sprains
- Neuralgia (nerve pain)
- Catarrh
- Gingivitis

Classification and habitat

This genus includes 150 species of dwarf shrubs, mainly occurring in the Andes but also in North America, East Asia, and Australasia. *Gaultheria* was named after the French botanist and physician Jean François Gaulthier (1708–56), who worked in Canada.

G. procumbens is native to dry woods in eastern North America. The diminutive *G. procumbens* only grows to a height of 3–6in (7–15cm) and has a creeping habit. Its leaves are glossy and elliptical and it has solitary droplet-like pink-white flowers in summer. The round, red, aromatic fruits hang on the plant throughout the winter. This hardy ornamental grows in acid soil in partial shade.

Harvesting

The leaves are gathered from spring to early fall and dried for use in infusions and liquid extracts. The essential oil is extracted from fresh wintergreen leaves by a process of fermentation and distillation. The final product consists almost entirely of methyl salicylate. Nowadays, most methyl salicylate is synthesized.

Medical use

G. procumbens was used for aches and pains in native North American medicine and its expectorant properties were employed to aid breathing while carrying heavy loads or on hunting expeditions. This aromatic and warming plant is also applied topically for a wealth of rheumatic and arthritic conditions.

The essential oil extracted from *G. procumbens*—wintergreen oil—is used as an anti-inflammatory and topical pain reliever. The active ingredient in wintergreen oil, methyl salicylate, is closely related to aspirin (see *Salix alba*, p. 168) and, as such, has similar analgesic properties.

Like some other herbal remedies, the clinical trials are patchy at best, poorly designed or inconclusive at worst. Wintergreen oil may ease musculoskeletal pain in some patients, not in others. But there are new applications on the horizon. In 2013, the FDA concluded that

Oil of wintergreen is at least 96 percent methyl salicylate, which makes it smell and tasty minty.

wintergreen's active ingredient, methyl salicylate, either on its own or combined with other compounds such as eucalyptol (see *Eucylaptus globulus*, p. 108) and menthol, is both safe and effective for gingivitis and to control tooth plaque. And a 2017 study by Feng et al. found that a 0.25 percent solution had similar or higher antibacterial activity than an antibiotic against the bacteria that causes Lyme disease.

CAUTIONARY NOTES

Methyl salicylate and wintergreen oil can both increase the effects of blood-thinning anticoagulant drugs, such as warfarin. And methyl salicylate can be poisonous if large quantities are absorbed through the skin or ingested.

Watch out when using wintergreen around toddlers and young children, who may be attracted to wintergreen oil by its scent.

GINKGO BILOBA

Ginkgo

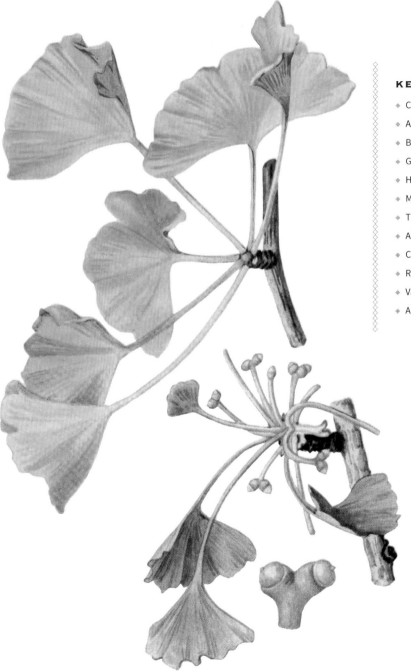

KEY USES

- Coughs
- Asthma
- Bladder complaints
- Gastroenteritis
- Hangovers
- Migraines
- Tinnitus
- Altitude sickness
- Cardiovascular problems
- Raynaud's syndrome
- Varicose veins
- Alzheimer's disease

Classification and habitat

Ginkgo biloba is the only species of tree in this genus and is found in China and Japan. The name *Ginkgo* describes the fruit and means "silver apricot" in Chinese; *biloba* means "two-lobed," referring to the split in the middle of the unique fan-shaped leaves. *G. biloba* grows to 130ft (40m) tall and the leaves, which are 5in (12cm) across, turn yellow-brown in the fall. The fruit is round and brown, rather like a plum in size, and has very little flesh covering the "nut." *G. biloba* is highly resistant to wind and snow damage but it does prefer full sun and rich, well-drained soil.

Harvesting

Seeds, from ripe fruits, are picked for traditional Chinese medicine, while the leaves are harvested as they change color in the fall.

Medical use

Long revered for its superpowers, ginkgo has been used in Chinese medicine for centuries to treat all manner of ailments, from asthma and coughs to hangovers and altitude sickness.

G. biloba contains two groups of active compounds: unique bioflavonoids (flavonoid glycosides) and terpene lactones. These compounds help to promote healthy circulation throughout the body, including the brain, and protect nerve cells in the brain against oxidative damage,

It is not advisable to eat uncooked ginkgo nuts but they are often roasted or cooked in stir-fries. At Chinese celebrations, such as weddings, the nuts are painted red—the color of happiness.

Go Gingko!

Ginkgo is sometimes referred to as Darwin's "living fossil." It dates back 270 million years and is the oldest living tree species. Cultivated in China since early medieval times, ginkgo first came to the notice of Western scholars in 1691 in Japan. Impervious to insects, fungi, and pollution, six specimens of this hardy tree even survived the atomic bomb in Hiroshima, earning them the accolade "bearer of hope."

supporting memory function. Ginkgo is probably most sought after in recent years for this potential to improve memory and reasoning in patients with Alzheimer's disease and other forms of dementia. It's a difficult link to prove, and clinical studies have shown mixed results. But *G. biloba* is well tolerated, and rarely causes side effects (see Cautionary Notes), so it is still a bestseller.

Cardiovascular conditions and peripheral vascular disease may also be susceptive to *G. biloba* treatment. As ginkgo stimulates blood flow, it's used for tinnitus, low blood pressure, Raynaud's syndrome, and intermittent claudication (inadequate blood flow, causing cramping leg pain).

A fruity business

Ginkgo has been cultivated in Europe for over 300 years and can be grown in domestic gardens, although you'll need to grow two trees of different sexes. Fruiting only occurs when male and female trees are grown together, as male and female flowers are borne on separate plants. And you might have to wait up to 20 years to see whether they fruit. With a life expectancy of 1,000 years, this ancient tree doesn't work to modern timetables!

CAUTIONARY NOTES

Ginkgo does interact with some prescribed medicines, like the anticoagulant warfarin, nonsteroidal anti-inflammatories like aspirin, and some antidepressants, so check with a health professional before taking it.

GLYCYRRHIZA GLABRA

Licorice

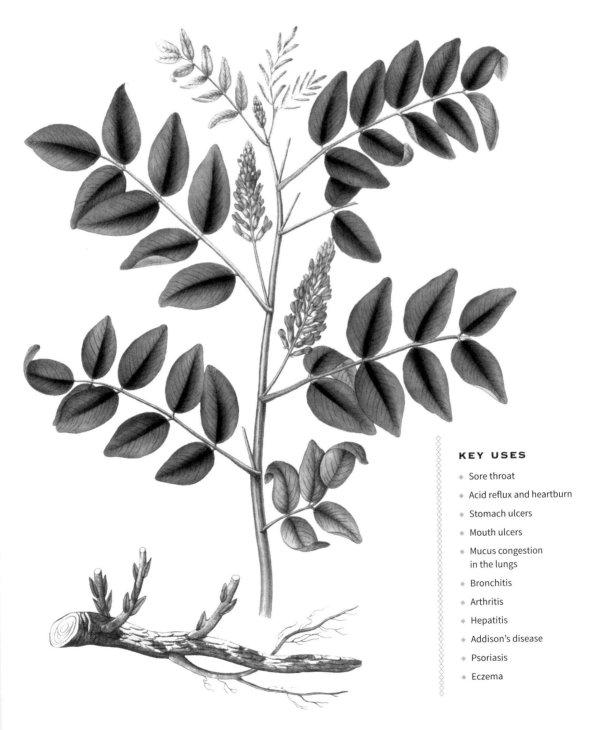

KEY USES

- Sore throat
- Acid reflux and heartburn
- Stomach ulcers
- Mouth ulcers
- Mucus congestion in the lungs
- Bronchitis
- Arthritis
- Hepatitis
- Addison's disease
- Psoriasis
- Eczema

Classification and habitat

Glycyrrhiza is a genus of 20 species of perennials found in Eurasia, Australia, and the Americas. *Glycyrrhiza* comes from the ancient Greek words *glykós* (sweet) and *rhiza* (root). This hardy perennial grows to 5ft (1.5m). It has downy stems and feathery, pinnate leaves with spikes of light-blue/violet flowers in the summer.

G. glabra grows best in sunny, but sheltered, positions in alkaline and moist, sandy soil. It needs deep soil to grow because the roots can be up to 4ft (1.2m) in length. It rarely flowers in colder climates, but this is of little concern if it's just the medicinal roots you're after!

Harvesting

The rhizomes are taken off the main tap root in early fall and dried for teas, eating, or extractions. The roots are boiled to extract confectionary licorice and pharmaceutical extracts or flavorings for soft drinks and beer.

Medical use

Licorice is a versatile plant that has been used since the time of Hippocrates in ancient Greece (460–375 BCE), and in Egypt and China, particularly for its tonic (for the liver and the adrenal glands) as well as anti-inflammatory properties.

The emulsifiying saponin glycyrrhizin is metabolized by the liver and eliminated from the body in bile.

Licorice root is up to 50 times sweeter than sugar; it was, and still is, often used, alongside other herbal remedies, to cover up bitter substances and improve their taste and actions.

Chewing licorice soothes inflammation and irritation throughout the gut. For example, in the throat it forms a soothing barrier against acid reflux and eases painful throat infections. Licorice tea is often used as a mouthwash for throat ulcers. As an expectorant, it helps to expel mucus from the lungs.

The anti-inflammatory actions of licorice relieve the muscle and joint pain associated with chronic inflammatory conditions such as rheumatoid arthritis. The chemical at the heart of these actions is glycyrrhizin. As this is converted into other compounds in the body, it not only enhances the action of the anti-inflammatory hormone cortisol, but can give you high or irregular blood pressure (see Cautionary Notes). Dose is key here, and that partly relates to how quickly your gut processes licorice. In 2017, the U.S. Food and Drug Administration suggested that eating 2oz (56g) of licorice a day for at least two weeks could cause arrhythmia (a form of irregular heartbeat).

Observational skills

In the 1940s, a Dutch doctor noticed some of his patients were recovering particularly quickly from stomach ulcers, but only those that had been taking licorice extracts sold in a local pharmacy. This is a perfect example of how medicine sometimes hinges on strong observational skills and notetaking. Dr. Revers discovered that glycyrrhizin, the compound that produces the intense, woody sweetness of licorice, was behind the finding. In the 1960s, its derivation carbenoxolone became the drug of choice for stomach and duodenal ulcers.

CAUTIONARY NOTES

Watch your intake of licorice, particularly if you have high blood pressure, as eating large amounts can exacerbate hypertension.

GOSSYPIUM HIRSUTUM
Cotton

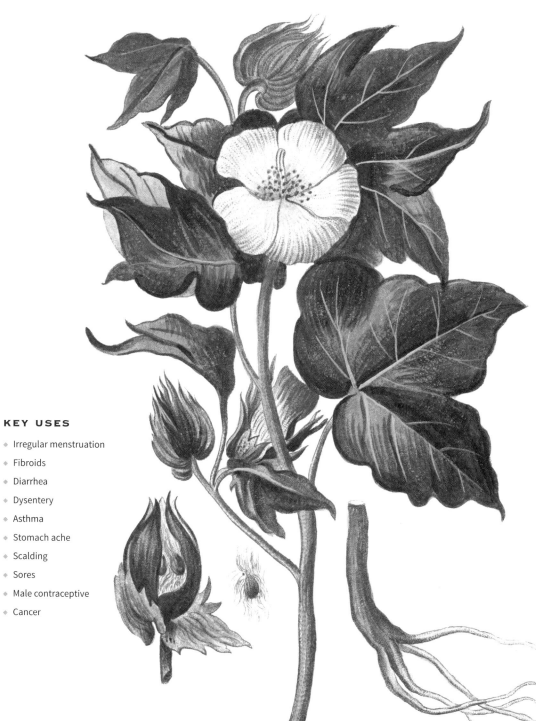

KEY USES

- Irregular menstruation
- Fibroids
- Diarrhea
- Dysentery
- Asthma
- Stomach ache
- Scalding
- Sores
- Male contraceptive
- Cancer

Classification and habitat

The genus *Gossypium* comprises 39 different species of annuals, perennials, shrubs, and small trees, which are found throughout warm and tropical regions. *G. hirsutum* is the best known, making up 90 percent of the world's cotton crop. Native to Central and South America, but now grown in many countries, this shrubby perennial has large, white, cup-shaped flowers.

G. hirsutum grows in rich, well-drained soil and needs sun to flower: The flowers are yellow and followed by the seed-bearing capsules called "bolls." These are covered in long hairs (hence the species name, from the Latin for "hairy"), which are spun to produce cotton thread, and short hairs, which are made into felt.

Harvesting

The leaves are picked in the growing season to make poultices, while the fruit is picked at the end of the summer. In the fall, the roots are lifted, then peeled and dried for tinctures and liquid extracts, and seeds are separated from fibers for oil extraction.

Medical use

Historically, in countries like Mexico, the roots were used to bring on periods in women with irregular menstruation, although the mechanisms behind this stimulation of the uterus are not well researched and the evidence is largely anecdotal. Roots were chewed to relieve stomach ache and other digestive complaints, while the fruit was eaten to treat fibroids and cancer. External uses of the leaves include the relief of scalding and sores.

The phenolic compound gossypol, which is isolated from the seeds, roots, and stems of the cotton plant, reduces sperm count. In Asia, gossypol was considered a promising male contraceptive but didn't really catch on due to various side effects, the most disturbing one being its irreversibility in a significant number of men! All is not lost, though, because a 2018 research paper by Wen et al. described some promising results with zero-order release of gossypol. This means that a drug is released at a controlled, constant rate. The results suggest that zero-order release can significantly improve the desired antifertility effect of gossypol and reduce its side effects.

Meanwhile, gossypol is also being investigated as a novel anticancer drug, with a 2019 review by Zeng et al. detailing its derivatives and the new ways they can be used in combination with other cancer therapies.

Family planning

Herbal contraceptives are a bit of a novelty. Like many herbal remedies, the levels of active compounds in cotton plants can vary significantly depending on growing and harvesting conditions. There is anecdotal evidence for their use, but with plenty of other tried and tested contraceptive methods, you'd be wise not to rely on them.

CAUTIONARY NOTES

G. hirsutum is very much a work in progress and is still a plant more commonly associated with the rag trade, so take professional advice before trying it out, particularly for contraceptive purposes.

HAMAMELIS VIRGINIANA
Witch hazel

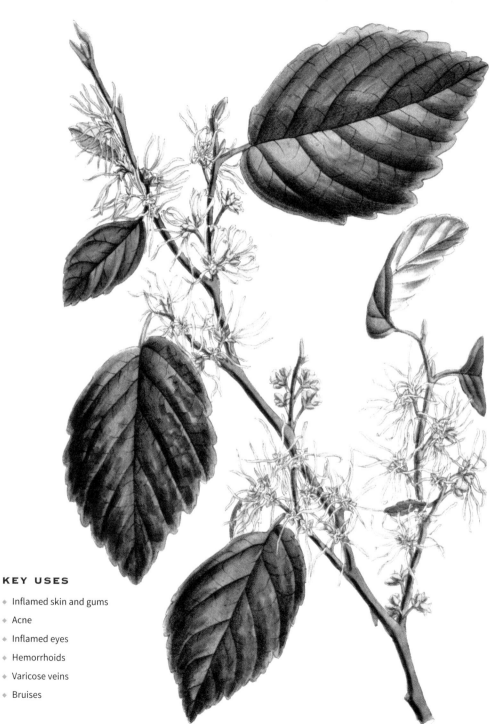

KEY USES

- Inflamed skin and gums
- Acne
- Inflamed eyes
- Hemorrhoids
- Varicose veins
- Bruises

Classification and habitat

Native to northeast America, *Hamamelis virginiana* is one of five deciduous shrubs and small trees in the genus. Found in moist woods, *H. virginia* (15ft, 5m) grows best in sunny positions in well-drained soil but needs watering when the weather is dry. The plant flowers from September to November, as the leaves fall, and some varieties have a strong smell.

The common name, witch hazel, refers to the supernatural powers attributed to the plant: the hazel-like branches were traditionally used when divining for water or gold.

Harvesting

The leaves are picked while they are green and the twigs are cut away in the fall while the plant is still flowering. Witch hazel water is distilled from the leaves and bark and combined with alcohol. Tinctures contain higher proportions of the tannins.

Medical use

Native North Americans used this plant medicinally and taught the European settlers about its uses. Bark preparations or poultices of the leaves were used to ease skin conditions—sunburnt, bruised, or inflamed skin—as well as digestive complaints such as diarrhea and dysentery.

There is evidence from small-scale studies that witch hazel lotions are effective in reducing hemorrhoid symptoms and size, and soothing inflammation from rashes or sunburn. As a toning and astringent facial cleanser, it minimizes skin puffiness, for example, around the eyes, and reduces pore size. Witch hazel can also help stop the bleeding of small wounds. Tea made from the bark or leaves can be an effective gargle for sore gums and throats.

Witch hazel is often combined with other herbs to treat various conditions, for example, *Areca catechu* (betel nut palm, p. 36) in a mouth gargle, *Arnica montana* (arnica, p. 38) for bruises and sprains, and *Hydrastis canadensis* (goldenseal, p. 122) for eye infections.

And new uses are being found for witch hazel. A 2019 research paper by Rasooly et al. suggests that a phenolic compound isolated from witch hazel, hamamelitannin, could be developed for use as a natural antimicrobial against bacteria such as *Staphylococcus*.

Astringent action

Witch hazel bark contains tannins. These compounds are widespread in plants and protect the tree from fungal and bacterial infections. Their name comes from their use in tanning leather and they are also present in large quantities in red wines and tea. Savoring tea in the mouth reveals their effects, as the tannins dissolve in the saliva and bind to proteins in the mouth. The denatured and precipitated proteins that form produce the so-called shrinking effect—that astringent aftertaste of tea. This sensation of tightening and drying is behind many of witch hazel's medical properties.

CAUTIONARY NOTES

Internal use of witch hazel is not recommended.

Distilled witch hazel water from a drugstore often contains minimal or zero tannins, so witch hazel tincture distilled with water is usually recommended.

HARPAGOPHYTUM PROCUMBENS

Devil's claw

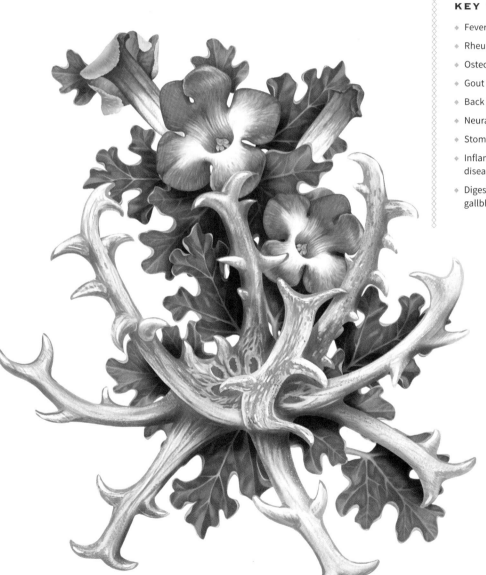

KEY USES

- Fevers
- Rheumatoid arthritis
- Osteoarthritis
- Gout
- Back pain
- Neuralgia
- Stomachache
- Inflammatory bowel disease (IBD)
- Digestive ailments of the gallbladder and pancreas

As a bitter herb, devil's claw stimulates the appetite and helps the absorption of food.

Classification and habitat

Nine species of perennials are found in this genus. They grow in the open, uncultivated grasslands of southern Africa, known as the veld. *H. procumbens* (maximum height 5ft, 1.5m) is a trailing plant with long, thick tubers. It has large, red-purple, solitary flowers, which are trumpet-shaped, followed by thorny fruits. The name "devil's claw" refers to the—rather lethal—large, claw-like protrusions on these fruit.

H. procumbens grows in sunny conditions, with a minimum temperature of 41–50°F (5–10°C), in sandy soil. This tender plant was once a common wild plant in the veld but is increasingly rare and now cultivated organically in Namibia.

Harvesting

The dormant tubers are lifted and dried for use in powders, ointments, or tinctures.

Medical use

This veld plant is a traditional African medicine. It was introduced to Europe and America by a South African farmer called G.H. Mehnert, who noticed the local people using the dried tubers for arthritis and digestive ailments. It can be taken internally for these conditions or as a poultice rubbed externally on rheumatic and arthritic joints.

Nowadays, devil's claw represents a first port of call for herbalists treating joint and muscle pain, and is well researched for rheumatic and arthritic conditions. The results in the medical literature are a little mixed, due to small sample sizes and lack of controls, but there is certainly plenty of research directed at devil's claw and its active compounds.

Watch your step

The thorny fruits are hazardous to wild animals who tread on them and even more so to mice, who supposedly encounter them on Madagascan mouse traps!

A 2019 review by Menghini et al. summarizes the findings, suggesting that devil's claw can both relieve pain, allowing a reduction in dose of nonsteroidal anti-inflammatories, and slow down the progression of rheumatoid arthritis and other inflammatory disorders.

One of the most active compounds in devil's claw is harpagide, a type of glycoside. A study by Chung et al. published in 2016 demonstrated that, in animal models, harpagide can stimulate bone growth and decrease the bone destruction that is seen in osteoporosis. Preventing age-related bone degeneration with a plant-derived compound would present a novel way of treating osteoporosis.

CAUTIONARY NOTES

Devil's claw should not be used during pregnancy. Care and medical advice should be taken if you have gallstones or stomach ulcers or are on prescribed medication.

Hydrastis Canadensis
Goldenseal

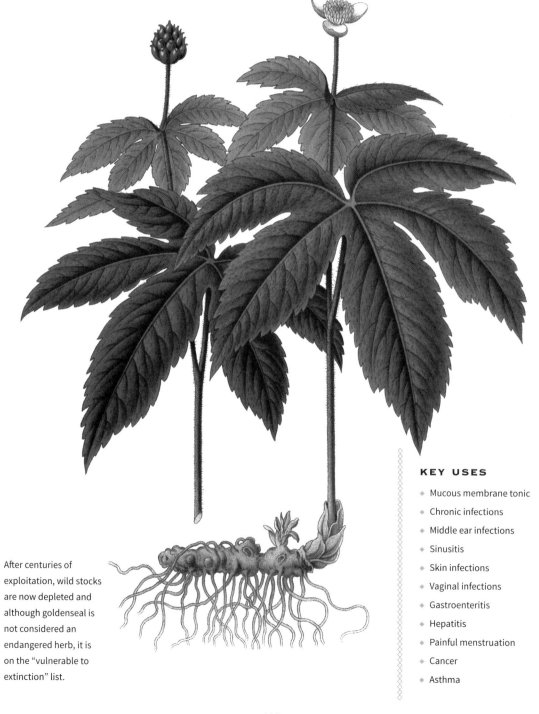

After centuries of exploitation, wild stocks are now depleted and although goldenseal is not considered an endangered herb, it is on the "vulnerable to extinction" list.

KEY USES

- Mucous membrane tonic
- Chronic infections
- Middle ear infections
- Sinusitis
- Skin infections
- Vaginal infections
- Gastroenteritis
- Hepatitis
- Painful menstruation
- Cancer
- Asthma

Classification and habitat

Native to Canada and America, *Hydrastis canadensis* is one of two species of rhizomatous perennials in this genus. Goldenseal grows to a height of 8–15in (20–38cm), in full or partial shade and moist soil. The springtime flowers are unspectacular but the leaves have a deeply toothed appearance and the rhizomes are gnarled and chrome yellow. The fruits look like raspberries, although they're not edible.

The name "goldenseal" comes from the scars that form near the base of the stem. When the stem breaks, the resulting scar resembles a gold wax letter seal.

Harvesting

Goldenseal is a slow-growing plant and its rhizomes are harvested after three to five years of growth. The rhizomes are lifted in the fall and dried for use in teas, tinctures, tablets, gargles, and liquid extracts.

Medical use

Once abundant in North America's shady woodlands, goldenseal's crinkly root was used by the Cherokee people for a wide range of conditions, including cancer (although its efficacy for this is unproven). Quickly adopted by settlers in the 18th century, goldenseal's popularity spread to Europe, where it was prescribed for digestive and respiratory ailments.

One of goldenseal's chief actions is on bacterial, viral, or fungal infections that affect mucous membranes, so it has a reputation for treating chronic infections, such as glandular fever, local fungal infections, and chronic gastroenteritis. The roots contain isoquinoline alkaloids, including hydrastine and berberine (see *Berberis vulgaris*, p. 46), which are natural antibiotics and anti-inflammatories. Berberine, for example, has been shown to stimulate immune cells to produce the cytokine IL-12, a small molecule that can modulate inflammatory reactions in conditions such as asthma.

Goldenseal often works best when it's combined with other herbs, for example, *Echinacea purpurea* (p. 100) for colds and flu and *Vitex agnus-castus* (p. 206) for menopausal problems.

False negatives

Goldenseal was once rumored to mask illegal drugs in the urine and give false negative results for drugs such cocaine and cannabis. The idea came from the novel *Stringtown on the Pike* (1909), by the pharmacist John Uri Lloyd—it's a novel idea but not one that has any basis in truth!

Metabolism disrupters

The goldenseal compounds berberine and hydrastine inhibit the activity of enzymes that break down small molecules in the body. The result is that many prescription drugs stay in the bloodstream longer and are therefore more potent.

CAUTIONARY NOTES

Pregnant women should definitely avoid goldenseal, as it can cause uterine contractions. High doses are toxic and potentially fatal. Consulting a health professional is essential, particularly if you're thinking of taking it as an alternative cancer treatment or are on prescription medications.

HYPERICUM PERFORATUM

St. John's wort

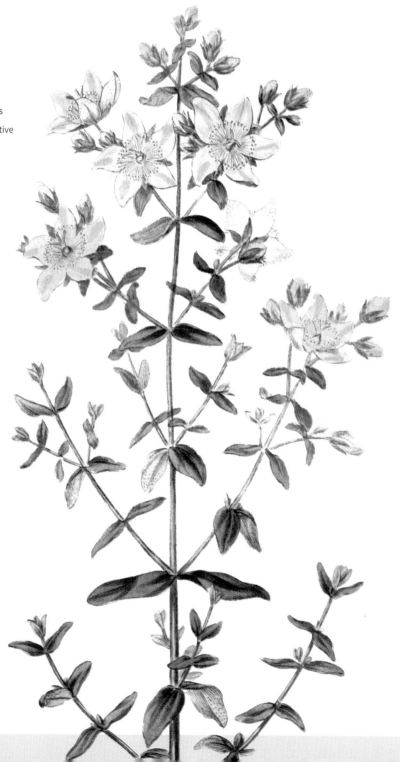

Classification and habitat

Hypericum perforatum belongs to one of the largest groups of flowering plants. The *Hypericum* genus contains about 470 species. *H. perforatum* is a sprawling, leafy herb (height 12-24in, 30-60cm) that grows in open areas throughout much of the world's temperate regions. The species name *perforatum* refers to the dark dots found on the leaves and flowers—minuscule glands that release the essential plant oils and resins.

In domestic gardens, *H. perforatum* will grow in full sun to partial shade, in moist but well-drained soil. It will crowd out other plants, so some gardeners plant it in a pot first and bury the pot in the garden to keep it under control.

Harvesting

The whole plant is harvested while it is in flower and the flowers are either used to extract the active compounds or infused in oil to be used as a skin preparation.

Medical use

St. John's wort (SJW) is one of the most studied herbal medicines and its use dates back to the time of the ancient Greeks. It produces dozens of biologically active substances, although two—hypericin and hyperforin—have the greatest medical activity. Clinical trials have shown that SJW can be beneficial in treating mild to moderate depression. A 2017 meta-analysis by Ng et al. suggests that it may be as effective as selective serotonin reuptake inhibitors (SSRIs), the class of drugs that are typically used as antidepressants.

Hypericin Hyperforin

The complex molecule hypericin was originally thought to be responsible for the antidepressant properties of SJW but recent research suggests that hyperforin has a prominent role to play too.

There is also evidence that it can relieve anxiety and seasonal affective disorder (SAD).

Infused in oil, SJW is traditionally used for relieving the symptoms of nerve pain, sunburn, and bruising. Recent studies suggest that topical SJW can also be used for wound healing: It stimulates immune cells, promotes repair, and acts as an antibacterial.

A saint's herb

This brightly colored perennial begins to flower around the Feast of St. John (June 24). Traditionally on this day, SJW was thrown into fires to protect against evil spirits and in France the plant was known as *chasse-diable*, or "devil chaser." Another legend holds that the plant released its blood-red oil on August 29, the day of St. John's beheading.

CAUTIONARY NOTES

St. John's wort can make some people sensitive to sunlight when ingested. And research suggests it can increase the rate at which the liver processes certain medications. Check with a pharmacist or health professional before taking SJW, particularly if you are taking contraceptive pills or immunosuppressant drugs. **H. perforatum** *is toxic to livestock and is listed as a noxious weed in seven western states in the United States. Programs promoting its eradication are underway in Canada, California, and Australia.*

LAVANDULA OFFICINALIS
SYN. *L. ANGUSTIFOLIA*
Lavender

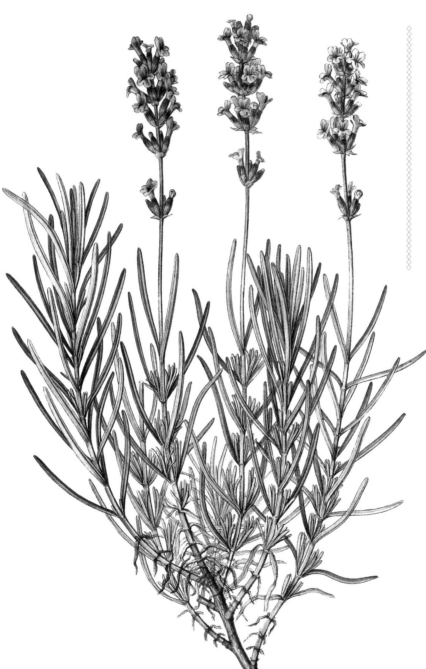

KEY USES

- Insomnia
- Stress and anxiety
- Nasal congestion
- Headaches
- Indigestion
- Respiratory ailments
- Wound healing
- Fungal infections
- Insect repellent
- Painful joints and muscles

Lavender is traditionally associated with Provence in the South of France, where it supplies the perfume trade, but it is also grown as a commercial crop in other countries, such as Tasmania.

Classification and habitat

There are at least 45 species of lavender. *Lavandula officinalis* (also *angustifolia*) is one of the most popular scented shrubs in European and North American gardens. Romans used lavender to perfume their baths; hence the derivation of its name from the Latin *lavare*, meaning "to wash."

L. officinalis can grow up to 3ft (90cm) high, with aromatic gray-green leaves and, in midsummer, richly scented purple flowers. It likes full sun and well-drained, sandy soil, and grows best in areas with cold, hard winters. Lavender should be pruned in spring or late autumn.

Harvesting

The aromatic volatile oils are present in all parts of the plant, apart from the roots. The flower buds are harvested when the flowers are about to open.

Medical use

Lavender appears in the oldest herbals and has been used by every civilization, from the ancient Egyptians, Greeks, and Romans to the present day.

Its internal uses center on the nervous system and digestion. Lavender essential oil inhaled, or taken in a tea or tincture, has an uplifting and, at the same time, calming effect on the mind. In the digestive tract, lavender soothes spasms and can relieve flatulence, nausea, and indigestion. Lavender's antispasmodic activity means that it's often used in the treatment of respiratory ailments such as cough, flu, asthma, and bronchitis.

Used externally, the essential oil is antiseptic and antifungal, and speeds the healing of wounds, insect bites, minor burns, and athlete's foot. It also acts as a local pain reliever, easing sore joints and muscles, or can be massaged into the forehead or temples for headaches and migraines.

Lavender combines well with *Rosmarinus officinalis* (rosemary, p. 166) to relieve nervous exhaustion and with *Thymus vulgaris* (thyme, p. 196) for respiratory conditions.

The power of scent

Dried lavender holds its scent for a long time. Lavender bags under a pillow are a tried and tested remedy for inducing sleep. Inhaling the scent of lavender induces a sense of calm; hence its use in bath and shower products. Now science has confirmed the relaxing properties of linalool, the sweet-smelling alcohol found in lavender extracts. In 2018, Harada et al. revealed that vaporized linalool must be smelled—not absorbed in the lungs—to produce its calming action. This is thought to be because linalool triggers olfactory receptors in the nose and so stimulates the brain via that route. It's hoped that linalool could be used in clinical situations to relieve anxiety, for example, before administering general anesthetic.

Fire plant

Like the Australian eucalyptus (p. 108), lavender is full of volatile oils. In very hot, dry regions, lavender can spontaneously combust. In fact, the plant regenerates well after such fires as these encourage germination of the seeds.

CAUTIONARY NOTES

Unlike most essential oils, lavender is safe to apply neat on the skin. Rarely, the oil can cause contact dermatitis.

Science has recently confirmed what aromatherapists have long known: Inhaling the scent of lavender is relaxing.

*L*INUM USITATISSIMUM
Linseed or flaxseed

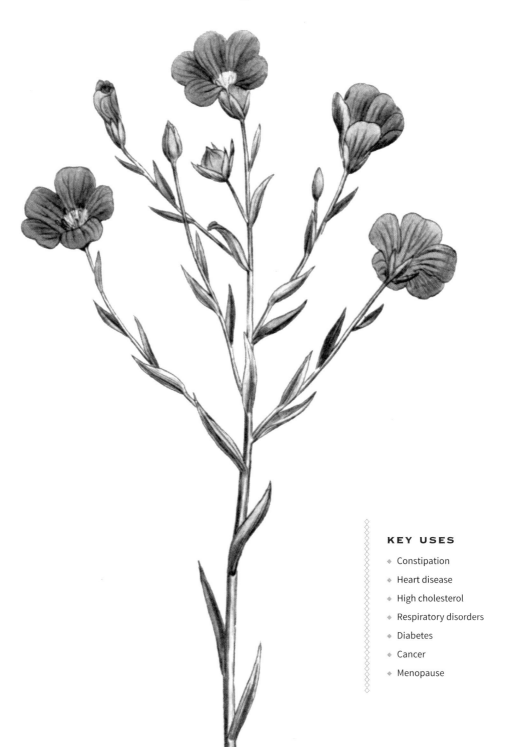

KEY USES

- Constipation
- Heart disease
- High cholesterol
- Respiratory disorders
- Diabetes
- Cancer
- Menopause

Classification and habitat

One of 200 plants in the *Linum* genus, *L. usitatissimum* is native to the Mediterranean and Central Asia. It is a hardy annual that grows to 4ft (1.2m). The distinctive sky-blue flowers appear in the summer and are followed by spherical capsules containing shiny, oval but flat seeds. *L. usitatissimum* grows well in cool temperate regions. It is mainly a commercial crop, with 60 percent of its production coming from China and Canada. The Latin name *usitatissimum* means "most useful."

Harvesting

The ripe seeds are collected and stored whole in airtight bags, in the refrigerator or freezer, as they can easily go off. The oil from the pressed seeds also has a very short shelf life.

Medical use

L. usitatissimum has been cultivated since at least 5000 BCE. Its seed has been found in Egyptian tombs and, in the 8th century, the French king Charlemagne passed laws requiring its consumption in order to preserve the health of the population. The fiber the seeds contain absorbs a large amount of fluid. Soaked seeds, drunk with additional water, are a safe natural remedy for constipation. Linseed was also used in hot poultices for treating boils and skin diseases such as eczema and herpes. These poultices are even said to act as "tweezers," to draw out splinters.

Linseed oil is very high in fiber, omega-3 fatty acids, and the antioxidant lignin—all of which contribute to its many health benefits, particularly for the cardiovascular system. These effects include lowering blood pressure and cholesterol,

Batting power

Linseed oil has another traditional use: in the game of cricket. Rubbed into willow cricket bats, it repels water and stops the cracking and shrinking of the wood.

anti-inflammatory actions, and inhibition of arrhythmia (irregular heart rhythm).

In the gut, linseed both acts as a laxative and helps to prevent the absorption of fats and sugars, so is useful in lowering cholesterol levels and helping to control diabetes.

Linseed oil contains ten times more phytoestrogens, such as lignans, than other seeds, making it one of the key herbal remedies for menopausal symptoms that are associated with declining estrogen levels, such as hot flashes.

Lignans provide antioxidant benefits, protecting cells from free radical damage. In the world of cancer research, flaxseed oil is attracting interest for the prevention and treatment of breast, colon, and prostate cancers.

A seedy name?

The name "flaxseed" is often used interchangeably with linseed. And that's entirely accurate. Linseed comes from the common flax plant, *L. usitatissimum*—the same plant that is used to grow the flax fiber from which linen is made. Some flax plants produce more seeds than others and the linseed, or flaxseed, crop comes from these.

CAUTIONARY NOTES

Always take linseed with plenty of water to avoid bloating and discomfort. Research into linseed's use in cancer treatments is still a work in progress...

Omega-3 fatty acids are commonly found in oily fish but linseeds are a good vegetarian source. Linseeds are also high in fiber and contain lignans—phytoestrogens with antioxidant properties.

LOBELIA INFLATA

Indian tobacco

KEY USES

- Asthma
- Bronchitis
- Pleurisy
- Rheumatism
- Sprains
- Insect bites

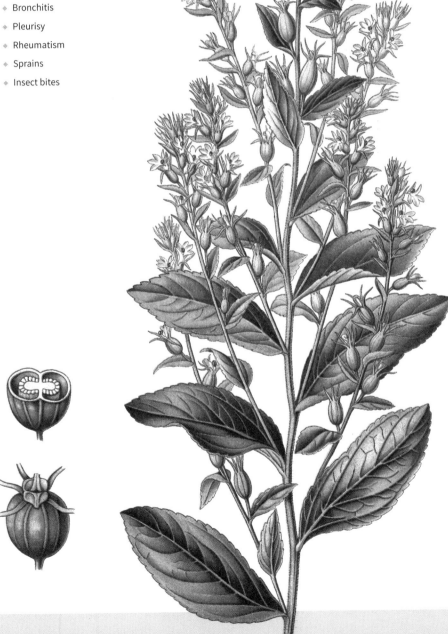

Classification and habitat

This large genus is made up of about 360 species of annuals, perennials, and shrubs, growing throughout temperate and tropical zones, particularly in the Americas. *Lobelia inflata* is most common in North America. It is a downy annual (maximum height 2ft, 60cm) with toothed leaves and light-blue, pink-tinged flowers. *L. inflata* grows well in sun or partial shade and prefers slightly acidic soil.

The genus name *Lobelia* comes from the physician to King James I of England, Matthias de l'Obel (1538–1616), who was interested in plants for their pharmacological properties. Two of the plant's common names reveal lobelia's most common use and side effect, respectively: asthma weed and pukeweed!

Harvesting

Whole plants are cut when the fruits are ripe and used fresh or dried in infusions, liquid extracts, or pharmaceutical extractions.

Medical use

L. inflata was used by Native Americans for bronchial complaints and its species name, *inflata*, sums up its action on the lungs. The plant's use as an antiasthmatic was popularized by Samuel Thomson (1769–1843), a pioneer of American herbal medicine.

Lobelia is still used for respiratory conditions (particularly in cough mixtures) but with qualifications (see Cautionary Notes), and is also applied to the skin for muscle pain, rheumatic nodules, sprains, and insect bites. Lobelia's properties as a respiratory stimulant are caused by an alkaloid called lobeline. This relaxes the airways, acts as a decongestant, and eases wheezing.

L. inflata is often combined with other herbs administered for bronchial complaints, for example, *Thymus vulgaris* (thyme, p. 196) for asthma.

Switching off depression: lobeline, extracted from *L. inflata*, is the subject of tantalizing new research. Reporting in 2017, Philip *et al* discovered that lobeline can block certain receptors in the brain that play a role in the development of depression.

Lighting up... or not?

Lobelia is included in some antismoking products because it acts as a nicotine agonist. This means that it binds to the same receptors on cells and produces the same actions as nicotine but as a partial agonist, with only up to 20 percent of the potency of nicotine. However, the latest review, by Stead and Hughes in 2012, reported that there is no evidence available from long-term trials and the short-term evidence suggests that lobeline does not help people stop smoking. Lobeline is not currently licensed for such use in the USA.

The nicotine story may not end there, though. It was reported in 2018 that, in preclinical studies, lobeline inhibited hyperactivity induced by nicotine and amphetamines. Martin et al. showed that, in adults with ADHD, lobeline produced a modest improvement in working memory, although attention spans were not improved.

CAUTIONARY NOTES

Lobelia can cause nausea and vomiting, so should only be taken when prescribed and at the correct dose. It may interact with lithium, so take extra care if you're on this medication.

LYCIUM BARBARUM
Goji berry

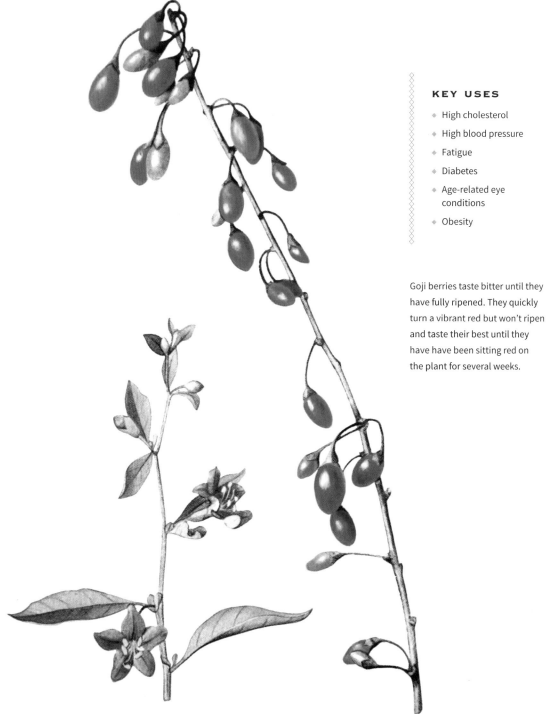

KEY USES

- High cholesterol
- High blood pressure
- Fatigue
- Diabetes
- Age-related eye conditions
- Obesity

Goji berries taste bitter until they have fully ripened. They quickly turn a vibrant red but won't ripen and taste their best until they have have been sitting red on the plant for several weeks.

Classification and habitat

Goji berries come from two boxthorn species: *Lycium barbarum* and *L. chinense*, although most high-quality fruit comes from *L. barbarum*. This genus is part of the Solanaceae, or nightshade, family and contains about 100 species of deciduous and evergreen shrubs. They grow in most temperate and subtropical regions.

The Latin name comes from a Greek word for the ancient region of Lycia in Turkey, where the plant was found growing. *L. barbarum* is native to lowland China and is a fast-growing deciduous shrub, reaching 12ft (4m). The small purple and funnel-shaped flowers appear in summer followed by bright red berries.

L. barbarum is easy to grow, producing a rich harvest of berries if it's grown in full sun. It is hardy and will tolerate wind and salty air, so it can be grown as a hedge in coastal gardens.

Harvesting

L. barbarum produces fruit after two to three years of growth. It has a long harvest season and fruits throughout the summer until the first frost. For wholesale, the fruit is usually shipped from Chinese growers. These fruit are dried and contain significantly lower quantities of vitamins and other antioxidants. Health food stores also sell goji berry powder, capsules, juice, and tea.

Medical use

The Chinese have been using goji berries, called *gou qi si*, for over 2,000 years as a food supplement and a medicinal aid. Goji berries are said to boost the immune system; enhance brain function; decrease obesity and protect against diabetes,

Protein packages

Goji berries are very nutritious. Fresh berries have high levels of antioxidants, as well as vitamins B and C. Both fresh and dried berries contain all nine essential amino acids—the building blocks of proteins (of which there are 20 in total), which are absolutely essential for health. And goji berries contain 10 times as much protein as blueberries.

cancer, heart disease and age-related eye diseases; and increase life expectancy (see "Off the scale").

There are some grand claims in that list but the evidence from large-scale, properly controlled clinical trials is not there to support all of these… yet. There are some promising signs, though. For example, in 2018 Li et al. demonstrated in a small study that some of the pigments that decrease in the eye condition macular degeneration could be replaced by those found in *L. barbarum*, for example, the antioxidant carotenoid zeaxanthin. The increase in these macular pigments was associated with improved vision.

Off the scale

In China, consuming goji berries is associated with longevity. One story describes the herbalist Li Qing Yuen, who consumed the berries daily and allegedly lived from 1678 to 1930! A lifespan of over 250 years is legendary, but myths spurn trends, and goji berry sales increased 637 percent in the USA between 2017 and 2019.

*C**AUTIONARY* *N**OTES*

Eating small quantities—a handful daily—is unlikely to cause any problems. Larger amounts may lead to stomach upsets. And there are reports that goji berries interact with certain medications, such as the anticoagulant warfarin, resulting in adverse effects.

LYCORIS SQUAMIGERA
Magic lily

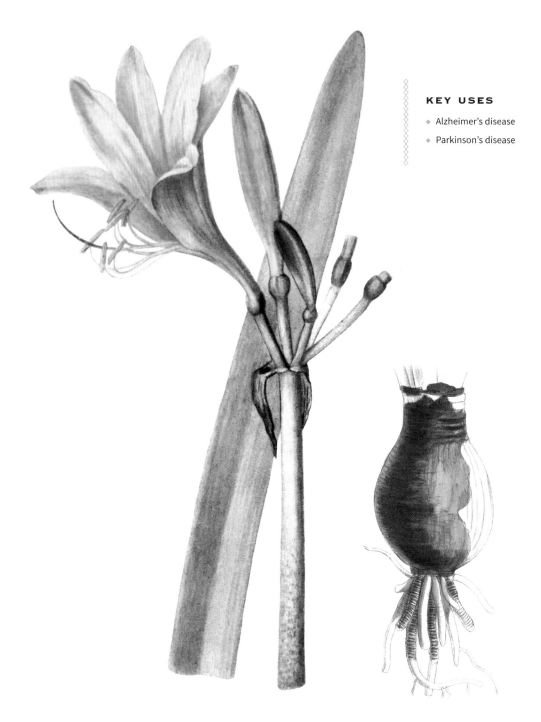

KEY USES

- Alzheimer's disease
- Parkinson's disease

Classification and habitat

Lycoris squamigera belongs to the amaryllis family, Amaryllidaceae, and is thought to come from China or Japan. It is a bulbous perennial that is cold-hardy but makes a show-stopping ornamental plant when grown in clusters in domestic gardens. It has several common names, including the resurrection, magic, or surprise lily, thought to refer to the plant's habit of producing flowers in late summer long after the spring foliage has died back.

L. squamigera grows in well-drained soil in full or partial sun, reaching heights of up to 2ft (60cm). The plant blooms from late summer to early fall, producing six to eight pink, trumpet-like flowers.

Harvesting

The bulbs are harvested for pharmacological extraction of active compounds.

Medical use

Unusually for a book on herbal medicine, there is scant evidence for this plant in traditional use. It wasn't until the 1940s that one of its principal active components, galantamine, was first described in observational studies in the Caucasus Mountains of southern Russia. Even this data is somewhat shrouded in mystery. But what is now well known is that galantamine is a cholinesterase inhibitor: It works by blocking the enzyme acetylcholinesterase, which breaks down acetylcholine—an important neurotransmitter associated with memory and other functions in the body, such as muscle control.

Galantamine was developed as a neuromuscular drug in the 1960s, particularly in Eastern European countries for the treatment of polio (now largely eradicated after worldwide vaccination programs). As reports of galantamine's effect on memory and understanding were discovered, it was developed as a drug for Alzheimer's disease in the 1990s, alongside another plant-derived compound, rivastigmine (see *Physostigma venenosum*, calabar bean, p. 152).

Sadly, intellectual property disagreements and restricted plant supplies have hampered further research into galantamine, despite the fact that a drug such as this, which targets a key pathway of the nervous system, may have wide-ranging therapeutic applications in the future. For example, a 2015 study by Pagano et al. suggests that cholinesterase inhibitors like galantamine may be able to treat cognitive impairment in patients with Parkinson's disease.

Untapped potential

Galantamine is uncomplicated in its metabolism and excretion by the body; distributes widely throughout the body's tissues, including crossing the blood–brain barrier; and its action is reversible in a matter of hours. It is probably one plant-derived therapeutic drug that still has a long list of untested applications.

CAUTIONARY NOTES

Galantamine is not a miracle cure for Alzheimer's—a notoriously intractable disease to treat—although it does produce small improvements in cognition in patients with mild to moderate symptoms.

MENTHA × PIPERITA
Peppermint

KEY USES

- Irritable bowel syndrome (IBS)
- Colic
- Flatulence
- Indigestion
- Nausea
- Nasal congestion
- Chest infections
- Asthma
- Tonsillitis
- Itching
- Headaches

Mint's antispasmodic action, combined with its relaxing effect on the nervous system, means that it's frequently used for conditions ranging from asthma and IBS to headaches and insomnia.

Classification and habitat

The mints are a complex group, with hundreds of varieties caused by hybridization both in the wild and in cultivated plants. *Mentha × piperita* is native to Europe and the Middle East but is now grown worldwide. It is a fragrant, hardy perennial whose leaves have a minty aroma. It grows to 3ft (90cm) high and produces lilac-pink flowers in midsummer. It does best in sun or light shade but grows in almost any soil in most climates.

The genus name *Mentha* has its origins in Greek mythology, which describes how the jealous queen Persephone turned the beautiful water nymph Minthe into a plant, albeit one that Persephone's husband, Pluto, imbued with a powerful fragrance.

Harvesting

Mint leaves can be harvested between May and October and made into an infusion, a tincture, or capsules.

CAUTIONARY NOTES

The essential oil should only be used internally under the supervision of a medical practitioner or trained herbalist and is not recommended for children under the age of five.

Hybrid vigor

Many species of mint are used interchangeably, as they all have similar aromatic, culinary, and medicinal properties. Peppermint has the most pronounced therapeutic effects. *M. × piperita* is a hybrid of *M. aquatica* (watermint) and *M. spicata* (spearmint). It was first discovered growing in an English field of spearmint in the 17th century, and this natural hybrid is now grown for the fragrant oil contained in its leaves and flowers.

Medical use

Peppermint was probably first cultivated for medicinal purposes by the Egyptians and, by the mid-18th century, Americans and Europeans were widely taking mint for colic, flatulence, and indigestion, to name but a few applications—peppermint is a key player in the most versatile essential oils stakes.

Nowadays, peppermint oil capsules are taken as a remedy for indigestion and to relieve the symptoms of irritable bowel syndrome (IBS). The essential oil acts on the colon by reducing spasms and decreasing the sensitivity of the nerve endings in the bowel wall. Menthol in the essential oil is responsible for peppermint's distinctive aroma, taste, and cooling sensation, as well as its medicinal effects.

Menthol is a rubefacient—a substance in skin creams that makes the skin red by dilating capillaries and increasing blood circulation. Menthol is often used in ointments to relieve itching and, for its analgesic properties, to ease the pain of sore backs, cold sores, mouth ulcers, and headaches.

Menthol is also antiseptic, making mint a helpful treatment for colds, flu, chest infections, and tonsillitis. Menthol's decongestant action means it's often found in nasal decongestants.

MUCUNA PRURIENS
Velvet bean

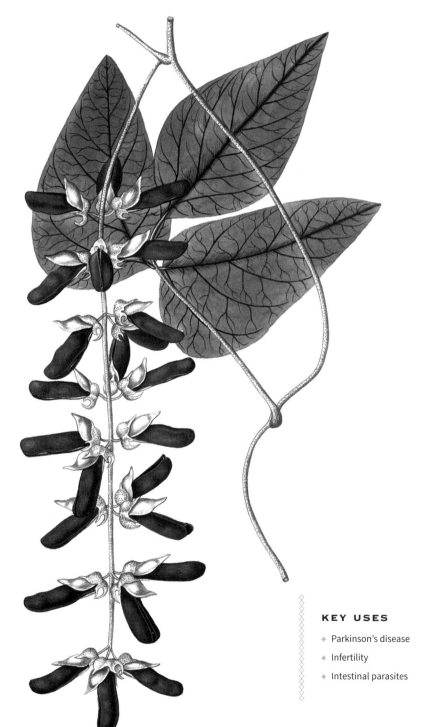

KEY USES

- ◆ Parkinson's disease
- ◆ Infertility
- ◆ Intestinal parasites

Classification and habitat

Approximately 100 species of woody climbers and shrubs belong to this leguminous tropical genus. *Mucuna pruriens* grows in areas of Asia, although it has become naturalized elsewhere. *M. pruriens* grows in well-drained but moist humus-rich soil in sun or partial shade and a minimum temperature of 64°F (18°C).

It is an evergreen, tender climber with vines that can grow to more than 50ft (15m) long. The clusters of white, lilac, or purple flowers are followed by flattened pods that contain three to six seeds and are covered in orange or dark brown bristles or hairs. The species name *pruriens* comes from the Latin word for "itching," referring to the irritant nature of the seed pods.

Harvesting

The roots are cut as required and the seed pods are collected when ripe and, unusually among plants, the bristly hairs are harvested by scraping the seed pods. The seeds are cooked and ground to a paste while the seeds and hairs are dried and powdered.

Medical use

Velvet bean was traditionally used to treat nervous conditions, for male infertility, as an aphrodisiac (seeds) and a diuretic (roots), and to treat intestinal parasites (seed pod hairs). In Ayurvedic medicine, it was used for controlling diabetes and the symptoms of Parkinson's disease. Few of these applications have been followed up by scientific studies, with the notable exception of the latter.

Fertility food

In a small-scale study published in 2010 by Shukla et al., a three-month trial of oral daily doses of *M. pruriens* seed powder was shown both to help the management of stress and to improve sperm quality.

The seeds of *M. pruriens* revolutionized the treatment of Parkinson's disease in the 1960s, when it was revealed that they contained levodopa or L-dopa. Patients with Parkinson's don't have enough dopamine in their brains to control their movements. L-dopa is converted into dopamine in the brain, thus helping control the classic Parkinson's symptoms of jerky or stiff limbs.

Levodopa is now usually manufactured by the pharmaceutical industry, but a scientific report in 2017 by Cilia et al. confirmed that *M. pruriens* provides a sufficient dose and is as efficacious as the prescription drug, and potentially better tolerated. A plant source of levodopa could provide an alternative way of achieving long-term therapy for patients with Parkinson's disease, if cost is an issue.

Famine food

M. pruriens seeds contain hallucinogenic, toxic compounds. Despite this, the seeds are edible if boiled in several changes of water and have been used as a food source during famines.

Treating worm infestations with the seed pod hairs was first recorded in 1756, by the Irish physician and botanist Patrick Brown, in his seminal work *The Civil and Natural History of Jamaica*.

CAUTIONARY NOTES

The seed pods are an extreme irritant to the skin, eyes, and mucous membranes.

OENOTHERA BIENNIS
Evening primrose

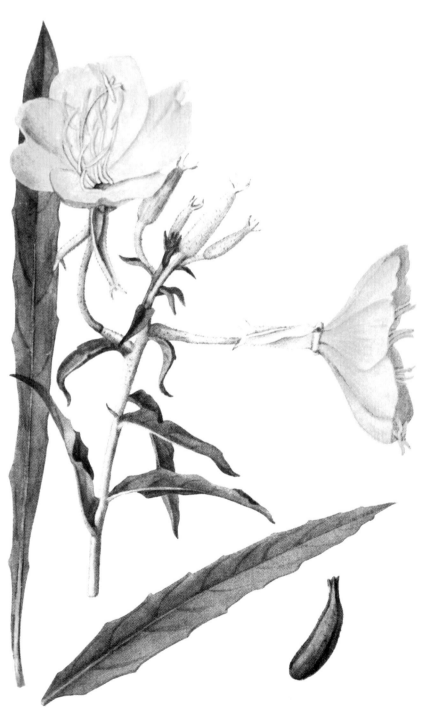

KEY USES

- Premenstrual syndrome (PMS)
- Menopause
- Sleep disorders
- Acne
- Eczema
- Breast pain
- Nerve pain
- Rheumatoid arthritis
- Heart health
- Asthma
- Gastrointestinal complaints
- Wound healing

Classification and habitat

Eighty species of annuals, biennials, and perennials make up this genus. *Oenothera biennis* is a biennial plant (height up to 5ft, 1.5m) with fragrant, bright yellow flowers that open in the evening; hence its common name. The flowers are followed by downy pods containing tiny seeds. *O. biennis* is a native of North America but is widely naturalized elsewhere and thrives on wasteland, particularly in sandy and poor soils.

Harvesting

The whole plant is collected, with the oil extracted from the ripe seeds.

Medical use

Traditionally, evening primrose was considered to aid sleep and relieve pain, asthma, and gastrointestinal complaints. Poultices were applied to wounds and bruises to help with healing, and the Native American Cherokee and Iroquois people used the hot root externally as a hemorrhoid remedy. Alongside these traditional applications (many of which relied on evening primrose oil's anti-inflammatory nature), those for menstrual and menopausal symptoms have continued to this day.

The seed oil contains omega-6 fatty acids. The human body can produce all the fatty acids it needs, except two types: omega-6 (linolenic acid, LA) and omega-3 fatty acids (alpha-linolenic acid, ALA). Both types need to come from our diet. They are vital for growth and repair, and to make other fatty acids and lipid compounds such as prostaglandins. The latter can regulate stomach acids and temperature, lower blood pressure, and control inflammation.

Cosmetic comfort

Evening primrose oil supplements alleviate certain inflammatory skin diseases, such as psoriasis and dermatitis. And emollient skin creams containing the oil are widely used in the cosmetic industry to help with sun damage, dry skin, and aging. The seeds can be ground for use in facial scrubs

The essential nature of these fatty acids and the long history of evening primrose oil use means that it is now being fully investigated in scientific and clinical studies. A report in 2019 by Mahboubi concluded that sustained use—up to four months—does alleviate PMS, gestational diabetes, menopausal hot flashes, and breast pain. And in 2020, a small-scale study by Sharif and Darsareh, over eight weeks, showed that postmenopausal women's psychological symptoms were alleviated by taking evening primrose oil. Other purported applications (which are thought to arise from evening primrose oil's ability to block inflammatory processes), for diseases such as rheumatoid arthritis, heart disease, dementia, multiple sclerosis, and nerve damage in diabetes, require more detailed research.

Evening primrose is grown commercially for its seed oil. One capsule contains oil extracted from several hundred seeds.

Cautionary Notes

Internal use can occasionally cause an upset stomach and rarely an allergic reaction. Topical external use may also trigger an allergic response. Like all skin creams, a spot test is encouraged before using more widely. Those on epilepsy medication should take advice from a medical practitioner before using evening primrose oil.

PANAX GINSENG
Chinese ginseng

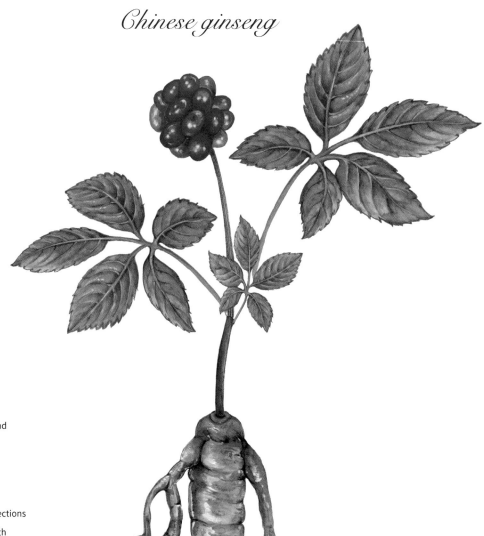

KEY USES

- Low stamina and endurance
- Fatigue
- Dementia
- Diabetes
- Respiratory infections
- Chronic ill health
- Male tonic
- Erectile dysfunction
- Low sperm counts
- Cancer

Classification and habitat

Ginseng is a member of the Araliaceae (ivy) family, with just a few members in the *Panax* genus. It is a short, slow-growing perennial (height 28–36in, 70–90cm) with pronounced, fleshy roots.

Panax comes from the Greek, meaning "all healing," referring to the traditional belief that ginseng can heal all parts of the body. The species name *ginseng* originates from the Chinese words *jen sheng*, meaning "man-herb"—the roots closely resemble a human figure and the plant is often used as a male tonic. Ginseng thrives in cool climates with good annual rainfall. It is no longer a common wild herb but is extensively cultivated in China and Korea.

Harvesting

The root is harvested and processed into tinctures, tablets, or liquid extracts. Older roots (at least four years old) have the most activity and can be chewed or made into a tea.

Medical use

Not to be confused with Indian ginseng (*Withania somnifera*, or ashwagandha, p. 208) or Siberian ginseng (*Eleutherococcus senticosus*), *P. ginseng* is vital to Chinese traditional medicine. It is listed in the current Chinese Pharmacopeia of 2,000 remedies, among those which restore the balance of the body, the yin and yang, and adjust the body's energy flow, the *qi*. Ginseng is the best known and most widely used of the *qi* tonics.

P. ginseng was traditionally, and still is, a remedy of choice for the elderly, for whom it's

CAUTIONARY NOTES

Root extracts need to be of high quality: A standardized extract is best. Excess may cause headaches and restlessness, especially if taken with stimulants, such as caffeine.

Repaying a debt

Ginseng is so valued as a plant that, in 2010, it was reported that the North Koreans had tried to partially repay their national debt to the Czech Republic with 22 tons of ginseng root. Communist Czechoslovakia was a leading supplier of heavy machinery and trucks to North Korea. The story goes that the now-capitalist Czechs remained unconvinced that they needed an injection of vigor—rather than one of cash!

said to boost vitality, pep up the immune system, and improve endurance. Ginseng can also enhance mental and physical performance as well as increase sexual vitality, particularly in men with low sperm counts.

With ginseng, it's all about numbers. The herb has been in use for over 5,000 years, has had at least that number of scientific papers published on it, and boasts a list of medical conditions that, while not quite in the thousands, does include quite a few!

A detailed 2017 review, by Mancuso and Santangelo, focused on the clinical evidence, demonstrating particular effectiveness of ginseng in treating specific diseases, such as dementia, diabetes mellitus, respiratory infections, and cancer. There has been growing research on ginseng because of its favorable pharmacokinetics: the active compounds called the ginsenosides, found in the roots and extracts of ginseng, are processed in the intestine into metabolites with multiple biological actions. These include inhibiting the production of reactive oxygen species (ROS), which damage cells, and enhancing immune and central nervous system function.

Ginseng is thought to be most effective if it's taken in low doses and long-term; it is often used with *Ginkgo biloba* (see p. 112), particularly when taken to treat erectile dysfunction or as a memory aid in the elderly. And combined with *Echinacea purpurea* (see p. 100), ginseng helps boost immune system function.

PAPAVER SOMNIFERUM

Opium poppy

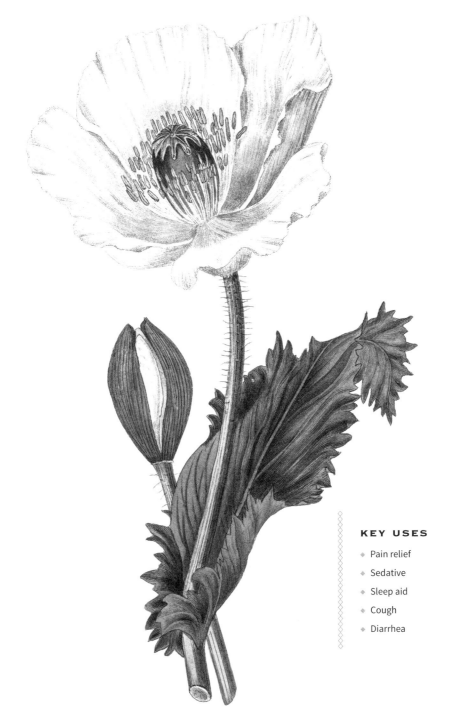

KEY USES

◆ Pain relief

◆ Sedative

◆ Sleep aid

◆ Cough

◆ Diarrhea

Classification and habitat

The *Papaver* genus is made up of 50 species of annuals and perennials, which are found in parts of Eurasia, southern Africa, and Australia. *P. somniferum* is an erect annual (maximum height 5ft, 1.5m), with showy, short-lived flowers varying in colour from white to purple, but always with four overlapping petals. The plant, especially the "pepperpot" seed capsule walls, contains vessels filled with a sticky white latex. *Somniferum* refers to the fact that the poppy induces sleep.

All poppies make attractive ornamental plants. It is legal to grow opium poppies in the UK but it is against the law to process them, which even includes picking them. In the USA, *P. somniferum* is a Schedule 2 controlled substance, so it is technically illegal. In domestic gardens, legal varieties of poppies, of which there are many, will create a vivid display, particularly if there is plenty of sun. Poppy seeds can lie dormant for years until they're disturbed by the plough or war (see "Flanders Fields," p. 147).

Harvesting

Opium is dried latex from the poppy's seed capsules. To collect opium, the unripe egg-shaped capsules are cut as the flower petals fall away. The latex or juice that is excreted is opium in its crudest form. This is collected and made into "cakes," which are wrapped in poppy leaves and dried in the sun.

Approximately 12 percent of opium consists of the painkiller morphine, which is extracted by the pharmaceutical industry or processed to produce synthetic opioids for medicinal use and heroin for the illegal drug trade. Codeine can be extracted from the poppy plant but nowadays it is more commonly synthesized from morphine, which is present in much higher concentrations than codeine.

Most parts of the opium poppy, *P. somniferum*, are toxic but the seeds are used for flavoring and texture, particularly in bread and cakes. Although these seeds do contain opium, the amount derived from culinary use of poppy seeds is negligible

Medical use

Opium, extracted from poppies, is one of the world's most ancient remedies and it has been difficult to find a painkiller to equal it, despite the fact that it is one of the most addictive substances known. Poppy seeds have been found in Egyptian grain stores dating back to 4500 BCE, and records of poppy's use are found on Sumerian clay tablets from around this time too. The plant was used as a sedative, to induce sleep, to ease bowel cramps, and as a painkiller, both in Europe and Asia. Poppies traveled along the Silk Road as cultivation extended from the Mediterranean to China, where the plant was eventually responsible for the Opium Wars (see p. 147).

Opium has many other derivatives, including oxycodone, used in pain relief..

Self-seeders: poppies spread very easily, with a single plant producing at least 50,000 seeds

A MOST POTENT POPPY

The poppy is linked with pain, addiction, and war, with the relief of the former being its most positive association. Many of the top ten prescribed opioids in the USA are derived from chemicals found in opium. Morphine is the sine qua non of potent painkillers.

Morphine, the active principle in opium, was isolated in 1803. This represented a first in the history of chemistry, as it was the first alkaloid to be isolated. Opiates like morphine and codeine bind to opioid receptors in the brain and spinal cord (the central nervous system) to interfere with pain signals, depressing the sensation of pain. They also create a "high" by activating the reward centers in the brain, releasing feel-good chemicals such as dopamine.

Morphine is one of the most effective pain-relieving drugs and remains the standard against which all new pain relievers are measured. Codeine is prescribed for the relief of moderate pain and is found in anti-cough preparations, as it also suppresses coughs. Codeine is converted to morphine by an enzyme in the liver. Oxycodone is synthesized from thebaine, another compound found in opium, and is also used for pain control.

Splitting open the poppy

In 2010, Jillian and Facchini discovered something that had been eluding scientists for decades: the genes that allow the poppy plant to produce codeine and morphine. Now that the genetic sequences are known, this allows scientists to research alternative ways of synthesizing these drugs, or introducing the genes into other plants, or even fungi, to do their work for them. Modern science is beginning to replace the need for poppies.

Getting the "O" word right

The distinction might be subtle but there is an important difference between an opiate and an opioid. Opiates are chemicals found in the opium plant, like codeine and morphine. Opioids are a broader category of drugs that includes opiates and refers to any substance—natural, semisynthetic, or totally synthetic—that binds to the opioid receptors in the brain. Semisynthetic opioids, whose starting structure is a natural opiate like codeine, include prescription pain-killers like hydrocodone and oxycodone, whereas totally synthetic drugs (manmade from scratch) include fentanyl and methadone.

Papaver somniferum
Opium poppy

Fentanyl, originally developed as a surgical anesthetic, is up to 100 times more powerful than morphine, while methadone is used as a heroin substitute to help heroin users come off the drug and relieve withdrawal symptoms.

Drug addiction

Heroin was first synthesized from morphine in 1874 and was used medically from 1898 until its addictive nature gradually emerged. It was made illegal in the USA in 1924, but as recently as the 1950s, heroin was still being prescribed by family doctors in the UK, until it was criminalized there, too, in 1956.

The receptors for heroin are located in the areas of the brain that are responsible not only for pain but the sensation of reward. Heroin stimulates these receptors so strongly that very quickly —some say after only one shot—users become addicted. As the addiction continues, the dial gets turned up, so more shots and higher doses are required to achieve the same high.

Other fully synthetic opioids, not only those derived from the poppy, have similar effects. So much so that, after high levels of routine prescription of opioid drugs over a number of decades, the USA is seeing annual deaths of at least 30,000 people attributed to opioid drug overdoses.

Opium Wars

Before the 1868 pharmacy act in the UK, a bewildering array of places, from stationers and wine merchants to ironmongers and barbers, were selling opium or its alcohol-based form, laudanum. It was used for an equally diverse list of conditions from whooping cough to headaches and inflammation of the intestines. And it was credited with providing inspiration to artists and writers. By the 19th century, the international trade in opium was of great economic importance. Opium dens, where opium was smoked in

Flanders Fields

In the UK, a relative of *P. somniferum*, the wild poppy *P. rhoeas*, is the symbol of Armistice Day, which marks the end of World War I on November 11, 1918. Approximately 40 million emblematic poppies are made every year to be worn in recognition of the lives lost on the battlefields of northern Europe: £50 million ($61 million) to support ex-servicemen and women is raised in the process. This glowing red poppy grew freely on land "ploughed" by war. It inspired the Canadian physician and poet Lieutenant Colonel John McCrae to write his famous poem, the first stanza of which reads:

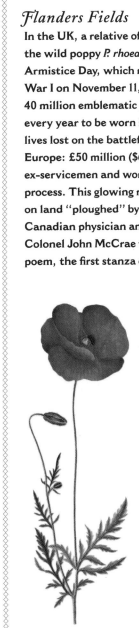

In Flanders fields
　the poppies blow
Between the crosses,
　row on row
That mark our place;
　and in the sky
The larks, still bravely
　singing, fly
Scarce heard amid
　the guns below.

Papaver rhoeas
Field poppy

a pipe, became prevalent in China, Southeast Asia, France, and North America. When China tried to tackle the increasing problems of addiction, by banning heroin imports, Britain declared war and defeated the Chinese in the Opium Wars of the early 1840s.

PAUSINYSTALIA YOHIMBE
Yohimbe

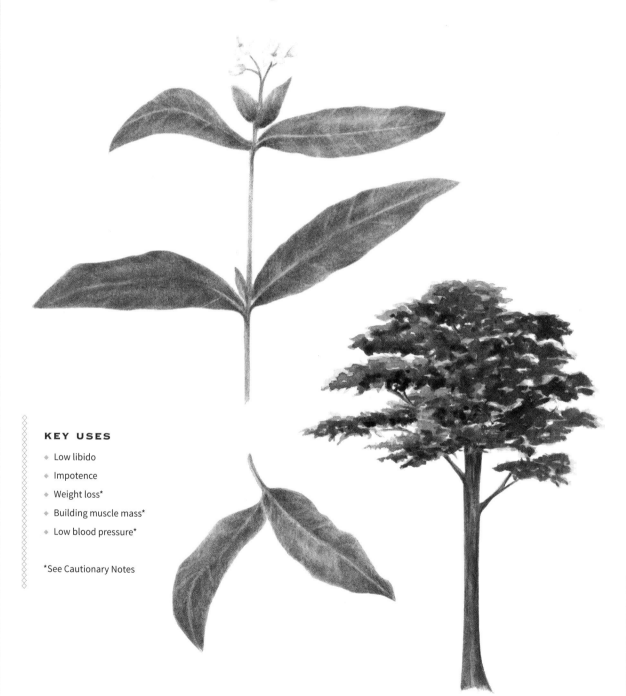

KEY USES

- Low libido
- Impotence
- Weight loss*
- Building muscle mass*
- Low blood pressure*

*See Cautionary Notes

Classification and habitat

This genus, found in West Africa, comprises 13 species of large trees, with characteristic tubular flowers that appear in winter in the wild.

This tender evergreen tree grows to 90ft (27m) tall and has reddish-yellow wood and long, glossy, dark green leaves (14in, 35cm). Yohimbe grows in moist soil with high humidity and minimum temperatures of 59–64°F (15–18°C).

Harvesting

The bark is gathered from wild plants, as the tree cannot be cultivated. The bark is dried in strips for liquid preparations and extractions. Yohimbine, the main component, can either be obtained from the bark or chemically synthesized.

Medical use

Medicinal use of yohimbe bark started in Europe in the 1890s. The bark of the tree contains the alkaloid yohimbine, which is used as an aphrodisiac. Yohimbine blocks the release of adrenalin and, in the correct dose, acts as a sexual stimulant. It also has a stimulant effect on the heart, increasing heart rate and blood pressure. Yohimbine hydrochloride is a form of yohimbine sold as a prescription drug in the USA and the UK, to treat impotence or erectile dysfunction. It also helps counteract the sexual side effects of some antidepressants.

This prescription drug, with its effective and well-researched applications, is a different beast to the dietary supplements made from the bark of the tree. These are sold for impotence, athletic performance, weight loss, low blood pressure, and more, but the clinical research confirming these effects is lacking. What is better documented are the risks of taking these supplements, including tachycardia (a rapid heartbeat), anxiety, high blood pressure, and even heart attacks.

Yohimbe may not be recommended for all of its potential uses (see Cautionary Notes) but there are some new ones on the horizon. In 2018, a study by Liu et al. described 10 new alkaloids isolated from *P. yohimbe* that showed promising immunosuppressive activity and a 2020 review by Lo Faro et al. included *P. yohimbe* as one of the plants requiring further investigation for the psychoactive nature of some of its alkaloids.

CAUTIONARY NOTES

Prescription drugs are tightly controlled; dietary supplements much less so. Dietary supplements containing yohimbe are not for sale in many countries but, in the USA, yohimbine-containing dietary supplements are sold for enhancing libido, for weight loss, and as aids for bodybuilding. The concentration of yohimbine may vary, but it is best to avoid these supplements, particularly if you're taking heart medication or antidepressants.

Fatal fat-burn?

P. yohimbe is freely available to buy online, usually advertised with natural-looking images of piles of the unprocessed bark. One of its selling points is that it enhances the breakdown and loss of fat in the body and, at around $30–$40 to buy, it may seem like a good investment to help shift extra pounds. However, a more detailed search in the medical literature reveals reports that highlight its cardiac toxicity and potentially fatal consequences.

Yohimbe bark is harvested in the rainy season, when the yohimbine concentration is at its highest.

PETROSELINUM CRISPUM
Parsley

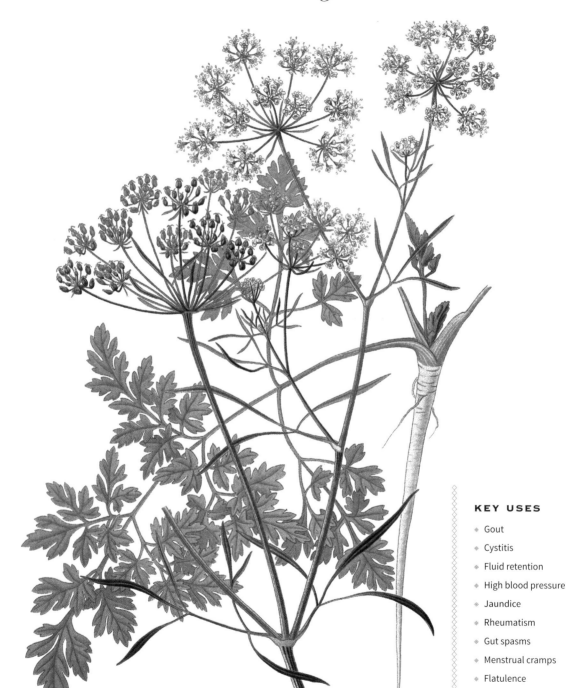

KEY USES

- Gout
- Cystitis
- Fluid retention
- High blood pressure
- Jaundice
- Rheumatism
- Gut spasms
- Menstrual cramps
- Flatulence

Classification and habitat

Petroselinum crispum, one of three species in this genus, is a bright-green biennial, which is native to Central and Southern Europe, but is naturalized and widely cultivated elsewhere. Growing to a height of 2ft (60cm), it has curly, serrated leaves, small yellow-green flowers from early summer to early fall, and seeds that ripen from midsummer to early fall. Parsley, given its Mediterranean origins, grows best in moist, well-drained soil in full sun. It can be grown in pots.

Harvesting

The leaf is most commonly picked fresh before flowering, for both cooking and medicinal purposes, when plants are over 6in (15cm) tall. The seeds are picked in late summer or early fall and the roots are harvested when they're two years old, then dried for tinctures and liquid extracts. Oil is distilled from the leaves and seeds.

Medical use

Parsley has historically had something of an association with the dead. The Greeks used it in funeral rituals and, in the Dark Ages, it was believed that displacing the plant would lead to certain death. These seem to be strange associations for what is a mild and frequently eaten culinary herb, and one that is often used as a domestic medicine.

Parsley leaf is high in readily absorbable vitamins and minerals and, as a digestive aid that can relive indigestion and bloating, it is a good addition to salads and cooked dishes. Medicinally, the roots and seeds are most potent, with marked effects on the urinary tract and rheumatic conditions.

One of parsley's primary medical applications is as a diuretic. Parsley root increases urine production and clearance of waste products, and is useful in treating edema (excess body fluid), cystitis, jaundice, and kidney stones. Parsley contains myristicin and apiol, compounds that are thought to increase the output of urine by increasing the flow of blood to the kidneys.

Sweet-smelling breath

Parsley's strong green color represents a high concentration of chlorophyll, a known deodorizer, so chewing on a sprig of parsley acts as a natural breath freshener.

More than just a garnish

Parsley packs quite a punch on the vitamin and mineral front. It's high in vitamins A, B12, C, and K, as well as antioxidants, calcium, iron, and potassium. A feature of the daily diet in the Mediterranean area, the herb's high potassium content is part of the mechanism by which it acts as a natural remedy against high blood pressure. And parsley's phytoestrogens make it a valuable supplement for women, stimulating regular menstruation and relieving menstrual cramps.

CAUTIONARY NOTES

Parsley is perfectly safe as a garnish or ingredient in food but, if you have kidney disease, do not use large amounts (several cups a day or an excess of the essential oil), as it increases urine flow and puts pressure on the kidneys. Do not use medicinally during pregnancy or breastfeeding: Parsley is thought to stimulate contractions and suppress milk production respectively.

PHYSOSTIGMA VENENOSUM

Calabar bean

◇◇◇◇◇◇

KEY USES

- ◆ Glaucoma
- ◆ Alzheimer's disease
- ◆ Myasthenia gravis

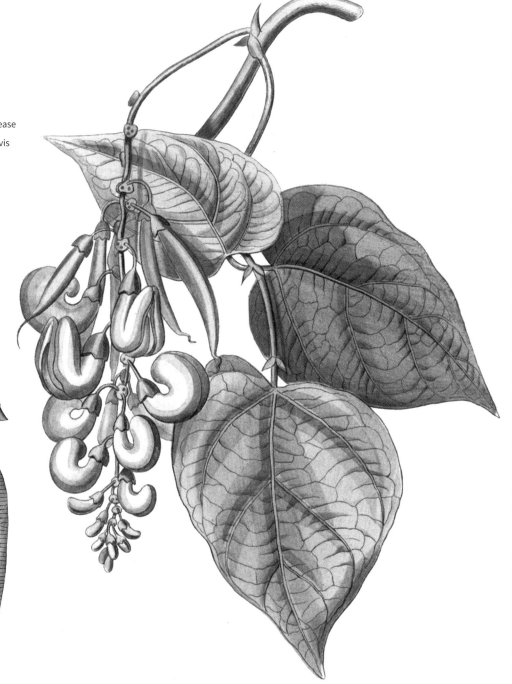

Classification and habitat

This genus comprises four West African tropical perennial climbers. *Physostigma venenosum* grows to 50ft (15m) and bears drooping pink or purple, pea-like flowers in spring, followed by brown-black seeds, the Calabar beans, in oblong pods. *P. venenosum* grows in rich, well-drained soil in sun, with minimum temperatures of 59–74°F (15–18°C).

Harvesting

The seeds are harvested when they're ripe, usually in the rainy season, and their outer coat removed for extraction of alkaloids.

Medical use

The discovery of the active principle of *P. venenosum* helped to solve one of the major challenges faced by ophthalmologists: how to reduce blindness due to glaucoma. This eye condition occurs when the optic nerve, which connects the eye to the brain, becomes damaged. It is usually caused

The ordeal bean

In the mid-19th century, Scottish missionaries visiting Old Calabar in Nigeria became aware of the local belief that drinking a Calabar bean concoction would reveal who was guilty of a crime. In fact, death was a common "side effect"—labeled as proof of guilt—but the seeds still found their way back to Scotland, where their alkaloids were first studied in some detail. The ordeal bean eventually led to the discovery of physostigmine.

Another canny Scot

Mary Broadfoot Walker was a Scottish doctor who, in 1935, described the effect of physostigmine on the signs and symptoms of myasthenia gravis. This is an autoimmune disease where autoantibodies to acetylcholine receptors attack the receptors and cause muscle weakness. Her revelations about myasthenia gravis, met with some skepticism at the time, still form the basis of diagnostic testing and treatment. Physostigmine increases the amount of acetylcholine available and so helps muscle activation and contraction.

by the pressure of excess fluid in the eye. In 1863, the Scottish doctor Sir Thomas Fraser isolated physostigmine, which was shown to lower intraocular pressure and control the progression of glaucoma.

Another medical application for physostigmine is in treating Alzheimer's disease, for which there are relatively few drugs available to treat symptoms and a lack of successful therapies that modulate disease progression. Two of the currently licensed drugs for mild to moderate Alzheimer's disease are derived from natural products: galantamine, from *Lycoris squamigera* (magic lily, p. 134), and rivastigmine. The latter is based on the chemical structure of physostigmine from *P. venenosum*. Like galantamine, it is a cholinesterase inhibitor. Scientists do not yet fully understand how cholinesterase inhibitors work to treat Alzheimer's disease, but the current thinking is that they prevent the breakdown of acetylcholine—the brain chemical important for memory and thinking.

CAUTIONARY NOTES

Excess use can cause muscular weakness, respiratory failure, and cardiac arrest. Atropine (from Atropa belladonna, *deadly nightshade, p. 44) is an antidote. Physostigmine counters toxic levels of atropine, and vice versa.*

PILOCARPUS MICROPHYLLUS

Jaborandi

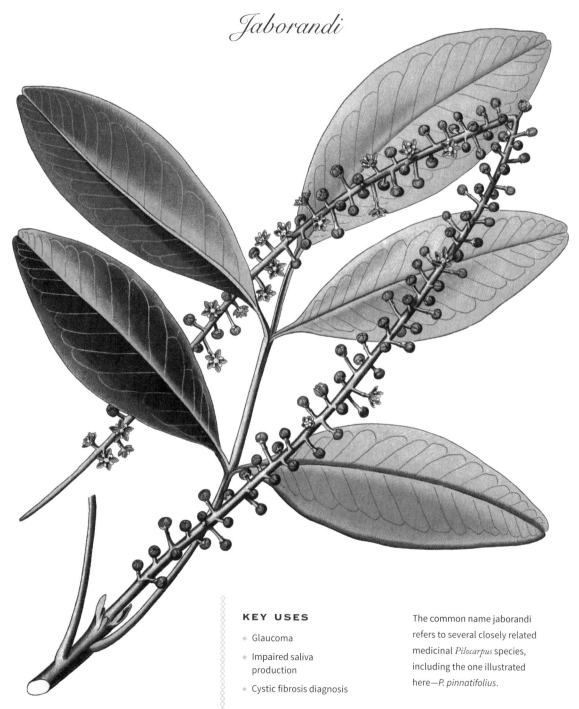

KEY USES

- Glaucoma
- Impaired saliva production
- Cystic fibrosis diagnosis

The common name jaborandi refers to several closely related medicinal *Pilocarpus* species, including the one illustrated here—*P. pinnatifolius*.

Classification and habitat

The *Pilocarpus* genus contains about 20 species of shrubs and small trees, which grow in tropical America, particularly the rainforests of Northern Brazil and the West Indies. *P. microphyllus* is a tender evergreen shrub or tree (height 5–20ft, 1.5–6m), with yellow-green leaves and small red-purple flowers followed by two-valved fruits. *P. microphyllus* grows in rich, well-drained soil in partial shade and high humidity, with minimum temperatures of 59–64°F (15–18°C).

The common name Jaborandi is derived from the Brazilian Tupí-Guaraní word *ya-mbor-endi*, meaning "what causes slobbering."

Harvesting

The leaves are picked and dried for extraction of alkaloids or for use in tinctures or liquid extracts.

Medical use

Native South Americans chewed the leaves of *P. jaborandi* to stimulate saliva, leading to one of the uses for this plant today. The leaves were introduced to Western medicine in 1873, when the Brazilian doctor Symphrônio Coutinho traveled to Europe, bringing samples of the leaves with him. French physicians couldn't quite believe the quantity of sweating and salivation that the leaves induced. Their curiosity led to the isolation of pilocarpine in 1874, by Drs. Hardy (England) and Gerrard (France), and it has now been used to treat glaucoma, alongside physostigmine (see p. 153), for approaching 150 years. It is on the World Health Organization's List of Essential Medicines, which details those medicines that combine safety and efficacy to deliver the most efficient and fundamental healthcare.

Pilocarpine also has another, slightly unusual, application for a plant-derived compound: as part of a diagnostic test for cystic fibrosis (CF). This condition is caused by a faulty CFTR gene—the gene that controls the movement of water and salt in and out of the body's cells. The effect of this inherited genetic mutation is that sticky mucus builds up in the lungs and digestive system.

Genetic testing and the sweat test are the two key ways of diagnosing CF. The sweat test detects the quantity of chloride (salt) in the sweat. Pilocarpine binds to receptors in the sweat glands and, when applied to the skin with a small electrical stimulus, induces the sweat glands to produce sweat, which is collected for analysis. CF patients have more chloride in their sweat than people without CF.

Studies in 2018 by Cifuentes et al. also showed that pilocarpine is an effective way to stimulate the production of saliva, for treatment of the dry mouth that is seen in patients with the autoimmune disease Sjögren's syndrome or, in a separate study by Malallah et al., to correct impaired salivary gland function in patients who have had radiation therapy for neck and head cancers.

CAUTIONARY NOTES

Pilocarpine may cause increased sweating, flushing, headache, nausea, or blurred vision. Sticking to the prescribed dose is essential, as an excess may be fatal.

Extinction looms

P. microphyllus is the main commercial source of pilocarpine but the species is under threat. During the dry season, collectors go into the forest and harvest the leaves by hand, depleting the plant of mature leaves and leading to high plant mortality. The commercial value of pilocarpine led to jaborandi's exploitation and, by the 1990s, it was considered an endangered species in Brazil. The biosynthesis of pilocarpine, better tree management, or genetic breeding programs are all being explored to protect jaborandi from extinction.

PIPER NIGRUM
Black pepper

KEY USES

- Fever
- Urinary conditions
- Indigestion
- Food poisoning
- Nasal decongestant
- Antiemetic
- Parkinson's disease
- Type II diabetes
- Cancer

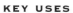

Grind peppercorns for fresh pepper, as the active component piperine breaks down quickly when exposed to air.

Classification and habitat

There are over 1,000 species in this genus of evergreen climbers, shrubs, and small trees. *Piper nigrum* is native to southern and eastern India but is now grown in nearly every tropical region. Vietnam grows around 35 percent of the world's supply, followed by India, Brazil, China, and Sri Lanka.

As a climbing vine, this woody perennial grows to a height of 12ft (4m), with oval leaves and tiny white flowers, followed by spindly clusters of round red berries, each about ¼in (6mm) in diameter. *P. nigrum* grows well in moist, well-drained, and organically rich soils. Minimum temperatures of 59–64°F (15–18°C) are required, with high humidity. The plant will fruit after about four years of growth and continue fruiting for around ten years. *P. nigrum* makes an attractive pot plant.

Harvesting

The fruit clusters are picked unripe or ripe and used fresh or dried, ground or in decoctions, depending on culinary or medical usage.

Medical use

P. nigrum frequently earns the accolade of the world's most widely used spice. It's also one of the oldest known spices: Pepper was the main commodity traded along the caravan routes of the East and was introduced to Europe, and beyond, from Southeast Asia in the 5th century.

This pungent warming herb was traditionally used to lower fever, stimulate the taste buds, and promote digestion. In Western and Ayurvedic medicine it is regarded as an expectorant, and in traditional Chinese medicine it is used as a tranquilizing antiemetic (anti-vomiting) herb.

Pepper gets its telltale bite from the active principle of *P. nigrum*, the alkaloid piperine. As a stimulant, black pepper encourages gastric secretions, as piperine interacts with receptors in the gut, and eating black pepper is associated with the prevention of food poisoning, attributed to piperine's antibacterial effects.

Piperine pipeline

The scientific literature is full of exciting new research on piperine. Its use as a scaffold for bioactive compounds is still in the early stages but Chavarria et al. (2016) have shown that piperine derivatives modulate the disease process in neurological disorders such as Parkinson's and epilepsy. A 2016 report by Derosa et al. discussed piperine's ability to lower insulin resistance in type II diabetes. And in 2018, Manayi et al. presented highly promising data on piperine's potential as an anticancer agent with a multitude of positive effects on the immune system and inhibition of cancer cell growth and metastases. New treatments based on piperine are very much in the pipeline…

Color code

Pepper comes in several types, depending on when the *P. nigrum* fruit or berries are harvested and the way they are processed. If the fruit is picked under-ripe, these soft, green peppercorns can be dried or preserved in brine. The ripe fruit is bright red. White pepper is ground from the hard seed, which is revealed when the flesh of the ripe fruit is removed. Black peppercorns are unripe or almost ripe fruit that have been cooked or dried in the sun. They are ground to produce black pepper.

CAUTIONARY NOTES

It would be difficult to eat fiery pepper in large amounts, but the active principle derived from it, piperine, increases the availability of certain drugs and supplements in the body, so consult a clinician before taking it.

PISONIA GRANDIS
Bird-catcher tree or lettuce tree

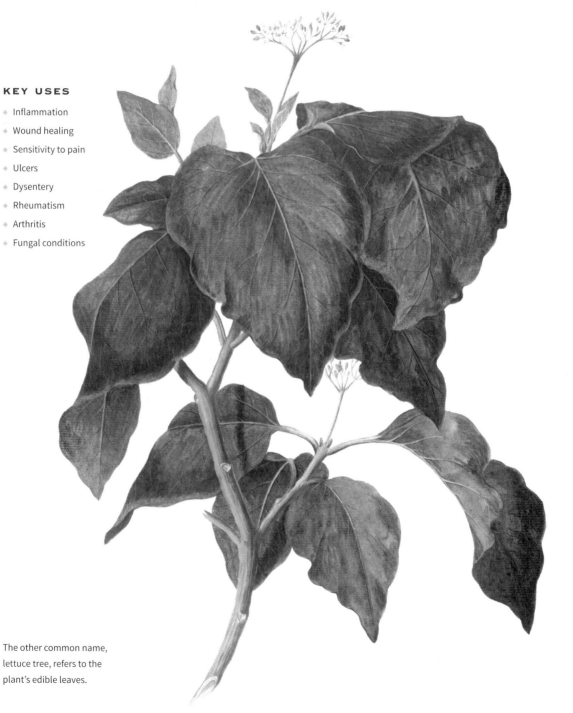

KEY USES

- ◆ Inflammation
- ◆ Wound healing
- ◆ Sensitivity to pain
- ◆ Ulcers
- ◆ Dysentery
- ◆ Rheumatism
- ◆ Arthritis
- ◆ Fungal conditions

The other common name, lettuce tree, refers to the plant's edible leaves.

Classification and habitat

Pisonia grandis is widely distributed throughout the Indian Subcontinent, from the Himalayas to Sri Lanka. The genus name recognizes William Piso, the 17th-century Dutch physician and naturalist. Known in Tamil as *Leechai kottai keerai*, it is a tall, evergreen, soft-wooded tree (maximum height 80ft, 25m), and a member of the Bougainvillea family. *P. grandis* has long (12in, 30cm), light-green leaves; small greenish-white, funnel-shaped flowers; and long fruits, shaped like a baseball bat.

P. grandis will grow outside India, including in the USA, where, providing there is no frost and it is sheltered from wind, it grows best in sandy, acidic, well-drained soils in full sun.

Grand but deadly too

Thickets of the tall *P. grandis* are selected as nesting sites by certain seabirds. The tree's seeds attach themselves to the feathers of small birds, trapping them and explaining one of the tree's common names, bird-catcher tree. The sticky seeds impair the birds' flight and can eventually kill them. Studies have shown that the bird population in some areas can be decimated as a result. But the plant is dependent on the birds too. Larger birds carry the seeds with them, allowing dispersal of the plant. A balancing act is required. In the Seychelles, the Seychelles warbler, which preferentially nests in the bird-catcher tree, has been brought back from near extinction by careful habitat management.

Anxiety relief?

Anxiety affects one in every eight people worldwide and is an important research area. Many benzodiazepine-type drugs used to allay anxiety have significant side effects, so research is ongoing to find plant-derived medications with more specific anxiolytic (anti-anxiety) effects. A 2011 animal study by Rahman et al. showed that an extract of *P. grandis* leaves has anxiolytic activity comparable to a standard dosage of diazepam.

Harvesting

The leaves, stem, and root of *P. grandis* are collected, the leaves for both culinary and medical purposes and the stems and roots for extraction of medically active components.

Medical use

P. grandis has been used for centuries in Indian traditional medicine for diabetes and as an anti-inflammatory; it's also utilized to reduce sensitivity to pain and to treat ulcers, dysentery, and snakebites.

Southern Indians cook and eat the young leaves in salads and also use them for the treatment of arthritis. There are scientific studies reporting on the anti-arthritic activity of extracts of the leaves and the anti-inflammatory potential of both leaves and roots. The active compounds include allantoin and pinitol.

CAUTIONARY NOTES

Eating the leaves in salad-size quantities is not thought to cause any ill effects.

The starry looking molecule pinitol certainly plays a key role in *P. grandis*' anti-inflammatory and antidiabetic properties.

PLANTAGO MAJOR
Plantain →

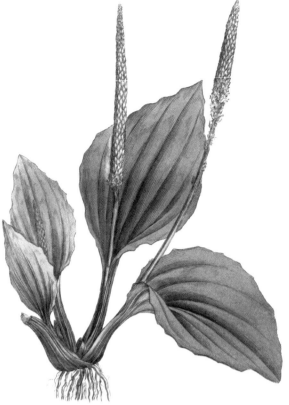

KEY USES

- Minor cuts and bleeding
- Wound healing
- Skin and peptic ulcers
- Burns
- Insect bites and stings
- Bacterial skin infections
- Anti-inflammatory
- Catarrh
- Constipation
- Acid indigestion
- Irritable bowel syndrome (IBS)

PLANTAGO OVATA
← *Psyllium*

KEY USES

- Constipation
- IBS
- Lowers cholesterol
- Regulates blood sugar levels

The common name psyllium is derived from the Greek word for flea, *psulla*, referring to the fact that the clusters of reddish-brown seeds look like fleas. Each *P. ovata* plant produces approximately 15,000 seeds over its lifetime.

Classification and habitat

The *Plantago* genus contains about 250 species of annuals, biennials, and perennials. *P. major* is a perennial weed (height 12-15in, 30-38cm), common in Europe and elsewhere. It has large radial rosettes of leaves and a few long (6in, 15cm), slender, densely-flowered green spikes. *P. major* is a pernicious weed of lawns and paths but there are also varieties that are grown as ornamentals. It thrives in sandy, gravelly, moist soil in the sun or partial shade.

P. ovata is grown in India, in the regions of Gujarat and Rajasthan. It grows to a similar height to *P. major* and also has spikes of flowers that mature into seedpods.

Harvesting

P. major leaves are best used fresh and can be picked all year round. The rosette of plantain leaves is harvested by cutting at the top of the root. The roots and seeds are also harvested for skin preparations and pharmacological extractions.

P. ovata seeds are gathered once a year and ground to harvest the husk. This form of fiber, psyllium, is usually ground into a powder.

Medical use

Native North Americans used *P. major*, or plantain, for rattlesnake bites. It was one of the nine herbs in the Anglo-Saxon *Nine Herbs Charm*, prepared for the treatment of skin infections—including rabid dog bites. In the Gaelic language, plantain is called "the healing herb."

The juice from freshly crushed plantain leaves, sometimes combined with mashed roots, is still used by herbalists to clean and disinfect cuts and insect bites or bee stings. These preparations will also stop bleeding from minor cuts and help skin ulcers and burns to heal. *P. major* can be combined with *Hamamelis virginiana* (witch hazel, p. 118) to treat hemorrhoids.

Plantain's anti-inflammatory properties mean it's well regarded as a treatment for colds, hay fever, coughs, and sore throats. Sinus congestion and catarrh build-up respond well to plantain, as

Englishman's foot

Plantain, also known as Englishman's foot, is supposed to appear in every country where the English have settled—allegedly carried in the turn-ups of their pants! Certainly, it was introduced to North America by European colonizers and, colonial considerations aside, it's a weed that has traveled across the world. The genus name *Plantago* comes from the Latin word for plant (*planta*) and plantain is a familiar sight by well-trodden footpaths, on roadsides, and in meadowland.

do acid indigestion, peptic ulcers, and irritable bowel. In all these cases, an infusion is best, although a tincture is sometimes used. The seeds have a tremendous capacity to absorb water, swelling to up to 14 times their volume in the gut, acting as a laxative and soothing irritated mucous membranes.

As with *P. major*, the fiber in the seeds of *P. ovata* has marked laxative properties, but psyllium husk is more than just a treatment for constipation. It is also a prebiotic, meaning it provides food for our beneficial gut bacteria. A 2019 research paper by Jalanka et al. showed that eating psyllium changed the composition of gut bacteria, favoring those that produce short-chain fatty acids. These are a subset of fatty acids that are produced during the fermentation of plant fiber by gut bacteria, and play a role in maintaining health and preventing the development of disease.

CAUTIONARY NOTES

Side effects are rare but, on the skin, P. major occasionally causes dermatitis. For both Plantago species, excess ingestion may cause abdominal pain, cramps, or diarrhea.

PODOPHYLLUM PELTATUM

American mandrake or May apple

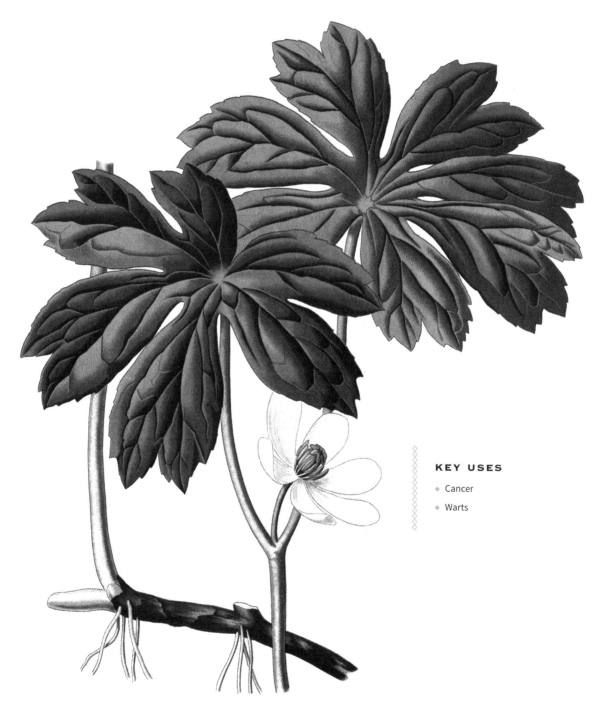

KEY USES

- Cancer
- Warts

Classification and habitat

Podophyllum is a genus of about 10 species of perennials, found in North America and the Himalayas. *P. peltatum* grows in eastern North America and is a striking woodland plant.

The species name is derived from the Greek *pous*, for foot, and *phyllon*, for leaf. This perennial (height 12–18in, 30–45cm) has long red-brown rhizomes (6ft, 2m) and upright stems, carrying the drooping umbrella-shaped leaves. *P. peltatum* produces white flowers in spring, followed by yellow plum-like fruits. In domestic gardens, *P. peltatum* grows well as a hardy ornamental in moist, humus-rich, acidic soils in sheltered semi-shade, but extra care is needed when handling the plant (see Cautionary Notes).

Harvesting

The flowers and resulting fruits are the only edible parts of the plant. The rhizomes are lifted in autumn and dried for use in tinctures and resin extracted for pharmaceutical preparations.

Medical use

The Native Americans used *P. peltatum* in minute doses as a purgative, an emetic, and a liver tonic. The resin, obtained by ethanol extraction of the dried roots and rhizomes, was used externally for removing warts. This resin is known as podophyllin and is only used topically because of its highly irritant properties. The major active compound in podophyllin is the lignan podophyllotoxin. It was first isolated in 1880 and its structure first proposed in 1932.

Following the centuries-old use of materials containing podophyllin in traditional medicine, in the 1950s, scientists began the search for podophyllotoxin derivatives. Their efforts were rewarded with the development of a new class of antitumor agents. These target the DNA unwinding enzyme topoisomerase II, which is involved in DNA replication and, therefore, the growth of cells. Topoisomerase activity is particularly increased in rapidly dividing cancer cells.

Topoisomerase II inhibitors, like etoposide and teniposide, are an example of several derivatives made from podophyllotoxin used in cancer treatments. Etoposide treats a number of different cancers, including testicular cancer, lung cancer, lymphoma, leukemia, neuroblastoma, and ovarian cancer. Teniposide is used primarily to treat small cell cancers, brain tumors and acute lymphocytic leukemia in children.

Mandrake men
This American mandrake, *Podophyllum peltatum*, should not be confused with another mandrake, *Mandragora officinarum*, the strange plant whose forked root resembles a human form and has narcotic and hallucinogenic properties.

CAUTIONARY NOTES

Only the lemon-flavored fruits are edible: The rest of the plant is highly poisonous and even handling may cause poisoning, as the active substances can be absorbed through the skin. The anticancer drugs derived from P. peltatum—etoposide and teniposide—like many such therapies, can have significant side effects.

RAUVOLFIA SERPENTINA

Indian snakeroot

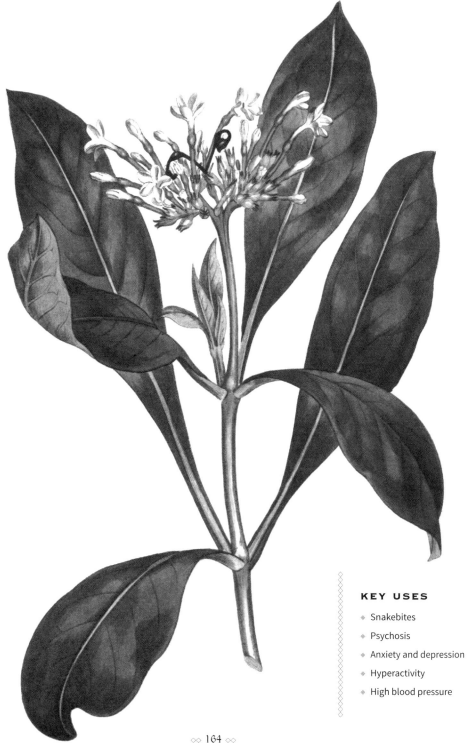

KEY USES

- Snakebites
- Psychosis
- Anxiety and depression
- Hyperactivity
- High blood pressure

Classification and habitat

This genus comprises over 100 species of evergreen and deciduous shrubs and small trees. They grow mostly in tropical and subtropical regions. *R. serpentina*, which is native to the Indian subcontinent and East Asia, is a low (3ft, 1m), evergreen shrub. It has pointed leaves (up to 5in/13cm long) and tiny white or pale pink spring flowers, followed by shiny red, pea-sized berries.

R. serpentina grows in well-drained soil in the sun or partial shade, with minimum temperatures of 50–55°F (10–13°C).

Harvesting

The roots are harvested in winter from plants that are at least 15 months old, and dried for use in powders or decoctions, or for commercial extraction of alkaloids. It is now also possible to make reserpine synthetically.

Medical use

R. serpentina's species name came from one of its earliest recorded uses, in managing snakebites and madness—but not necessarily together! Using the Sanskrit word *sarpagandha*, it is recorded in the Hindu medical work *Charaka Samhita*, the first version of which was written in 600–200 BCE. In 1563, a Portuguese account published in Goa described the plant as "the foremost and most praiseworthy medicine." Snakeroot tea has been used for centuries in India for treating hysteria and anxiety. Mahatma Gandhi was even said to have been a regular snakeroot tea drinker—and he was certainly a calm individual.

Most importantly, *R. serpentina* gets a spot on the "herbs that changed the world" list because it contains the first known tranquillizer. The chemistry of *R. serpentina* was initially described in 1887 in Java: It contains at least 25 alkaloids and, in 1952, the most important one, reserpine, was isolated. When reserpine's effects on the central nervous system were discovered the following year, the word "tranquilizer" came into use.

The prolonged and significant tranquilizing effect that reserpine induces meant it was once used to treat a range of psychotic conditions, although this use is now largely discontinued due to concerns about side effects such as low blood pressure, ulcers, nightmares, nasal congestion, and depression. But reserpine's discovery opened the door to the discovery of other tranquilizers and drugs that act on the central nervous system. Reserpine also reduces high blood pressure and is sometimes used for hypertension, although newer antihypertensive drugs, which have fewer side effects on the central nervous system, are now the preferred treatments.

Botanical discoveries

The *Rauvolfia* genus is named after Leonhard Rauwolf, a 16th-century German physician and scientist. He was the first modern botanist to collect and describe the exotic flora of the Near East. His own account of his travels in the Levant from 1573 to 1575 provides a fascinating account of early scientific field trips.

CAUTIONARY NOTES

R. serpentina *is still used by herbal practitioners for the treatment of high blood pressure, although it is recommended that suitably low doses are used and patients are carefully screened to minimize the occurrence of depression.*

ROSMARINUS OFFICINALIS
Rosemary

KEY USES

- Enhances memory and mental performance
- Low mood
- Mental exhaustion
- Headache
- Poor digestion
- Gut spasms
- Aching muscles and joints
- Antibacterial
- Antioxidant
- Anti-inflammatory

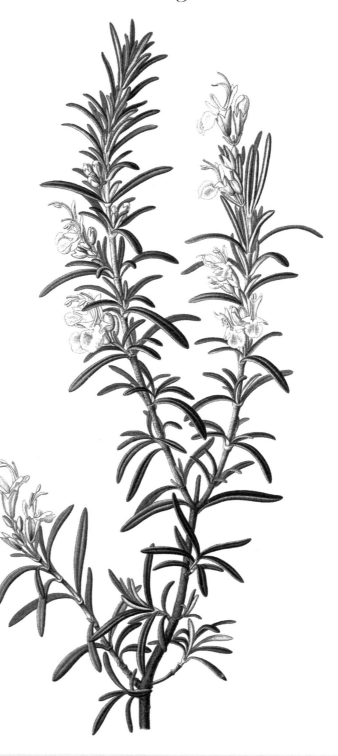

Classification and habitat

Rosmarinus officinalis, commonly known as rosemary, belongs to the Lamiaceae family, as do sage (p. 170) and thyme (p. 196). Rosemary is a culinary and medicinal plant native to the Mediterranean region and cultivated around the world. It is a perennial shrub, growing up to 6½ft (2m), with aromatic needle-shaped leaves and pale blue or white flowers that are produced from early spring to late fall. Rosemary grows best in well-drained soil, in the sun, and is an attractive and fragrant addition to gardens.

Rosemary means "dew of the sea," or "rose of Mary," depending on who you believe! The latter stems from the story that Mary, during her flight to Egypt, threw her blue cloak over a white-flowered rosemary bush, turning its flowers to that delicate blue.

Harvesting

New leaf growth is cut for culinary and medicinal purposes. The essential oil is produced by distillation from the flowers.

A mental boost

Smelling rosemary essential oil can boost mental performance. Shakespeare's tragic character Ophelia, in the play *Hamlet*, recognized this: "There's rosemary, that's for remembrance; pray, love, remember." This was written in 1599–1601, and modern science now backs it up. For example, a small-scale study in 2018 by Netmatollahi et al. showed that a twice-daily dose of 500mg of rosemary could boost memory, reduce anxiety and depression, and improve sleep quality in university students.

The flowers of *Rosmarinus officinalis* range from pale violet-blue to white.

Aromatic chemistry

R. officinalis contains dozens of active compounds that broadly fall into the chemical groupings of phenolic compounds, di- and triterpenes, and essential oils. Every year at least 100 scientific papers are published detailing the chemical, biological, and therapeutic properties of these compounds—too many for this short overview of rosemary! One example is rosmarinic acid, which inhibits the production of inflammatory molecules and helps keep the airways open in asthma.

Medical use

Rosemary has been used for centuries as a flavorsome ingredient, especially in Mediterranean cuisine, and for medicinal purposes. Like many aromatic herbs in the mint family, rosemary reduces gut spasms and aids digestion. It also has antibacterial, antioxidant, and anti-inflammatory actions. A search of the medical literature reveals a huge array of conditions for which rosemary has been shown to be beneficial. Applications range from reducing pain, inhibiting bacterial infections, and inhibiting cancer cell proliferation, to control of body weight and enhancing brain function and mood.

Many of these studies cover internal applications but, used externally, rosemary is said to cure dandruff and boost hair growth, and reduce sciatic and other nerve pain. It is also an ingredient in muscle rubs and the diluted essential oil will ease aching joints.

CAUTIONARY NOTES

Rosemary rarely causes problems but, used externally, the essential oil can very occasionally result in an allergic reaction

SALIX ALBA
White willow

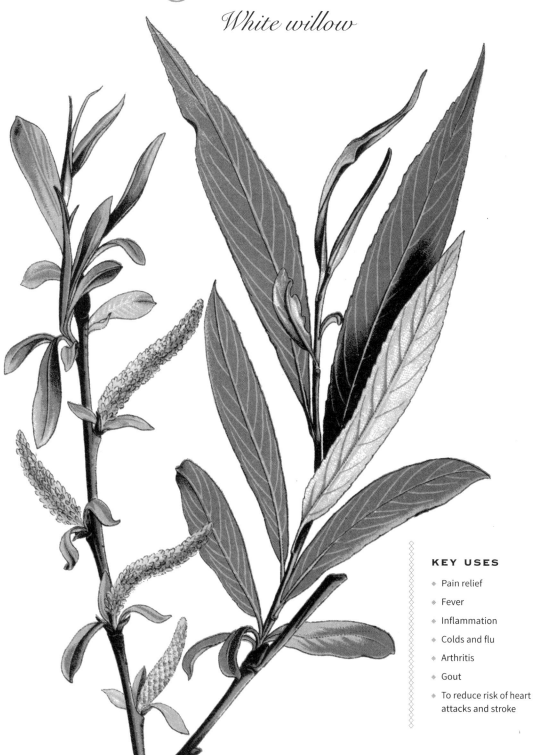

KEY USES

- Pain relief
- Fever
- Inflammation
- Colds and flu
- Arthritis
- Gout
- To reduce risk of heart attacks and stroke

Classification and habitat

Salix alba is a fast-growing, deciduous tree (height 80ft, 25m) native to Europe and Western and Central Asia. The undersides of the leaves have a white appearance and the clusters of tiny flowers are called catkins. The tree grows in most soils but it thrives near water. The "weeping willows" of metaphorical poets like Keats conjure up its typical appearance.

Harvesting

Both the leaves and bark of willow contain the active ingredients. The bark can be harvested all year round.

Medical use

S. alba has a long history of use in the treatment of pain and reduction of fever. In 1763 Reverend Edward Stone from Oxfordshire, UK, used bark extracts to reduce malarial fever.

He went on to gather and dry a pound (0.5 kg) of willow bark to make a powder that he distributed to 50 people. Stone found it to be a "powerful astringent and very efficacious in curing agues and intermitting disorders," those relapsing and recurring fevers of many infectious diseases. He had discovered salicin, a chemical similar to aspirin (acetylsalicylic acid). In combination with the herb's powerful anti-inflammatory plant compounds (flavonoids), salicin is responsible for the pain-relieving and anti-inflammatory effects of willow bark extracts.

The bark may be taken—in the form of a tincture, capsule, or infusion—as a first aid remedy for headache, toothache, back pain, muscle and joint inflammation, stiffness, and gout.

Many believe that willow is the natural source of aspirin. It is and it isn't. Although willow bark contains aspirin-like substances, it is not the herbal equivalent. Willow bark is only effective as a painkiller and an anti-inflammatory because of the combined action of the flavonoids with the salicin. Willow species contain just a small quantity of salicin, which alone would be insufficient to produce the analgesic effect.

Aspirin—an aspirational drug

Aspirin continues to be a revolutionary drug. From the early reports of the anti-inflammatory and pain-relieving properties of willow bark, written up on an Egyptian papyrus, to the naming and production of acetylsalicylic acid as aspirin by Bayer in 1899, it was set to be a commercial and medical success.

Aspirin is still one of the most used and researched drugs in the world, with an estimated 700 to 1,000 clinical trials conducted each year. The most recent meta-analyses suggest that prophylactic daily use of low-dose aspirin can reduce the risk of heart attacks and stroke, as well as certain cancers (bowel, stomach, and esophageal), although there are still concerns about the risk of gastrointestinal bleeding.

CAUTIONARY NOTES

In a recent study, a bark extract containing salicin was shown to be significantly better at treating pain in patients with osteoarthritis than a placebo. It may be preferable to aspirin-type anti-inflammatories in some arthritic patients because the herb causes few side effects. In contrast to synthetic aspirin, willow bark extract does not damage the gut lining in susceptible people.

SALVIA HISPANICA
Chia →

KEY USES

- Constipation
- Irritable bowel syndrome (IBS)
- Obesity
- Diabetes
- High blood pressure
- Anti-inflammatory
- Cancer

SALVIA OFFICINALIS
← *Common sage*

KEY USES

- Indigestion
- Liver complaints
- Excessive lactation and salivation
- Night sweats
- Dementia
- Arthritis
- PMS and menopause
- Mouth, throat, gum, and skin infections
- Asthma
- Antibacterial

Classification and habitat

Sage is a member of the mint family (Lamiaceae), which includes other aromatic culinary and medicinal herbs, such as rosemary (p. 166) and thyme (p. 196). Sage comes in over 500 varieties, many of which are used medicinally but only a few of which are used in cooking. The genus name *Salvia* comes from the Latin *salvare*, to heal.

S. hispanica is native to Mexico but is now cultivated in South America and the Southwestern United States. It is an annual plant, growing to nearly 6ft tall (1.8m), with purple flowers and tiny oval seeds measuring less than 0.1in (1mm). The seed name "chia" comes from the Aztec word *chian*, meaning "oily."

S. officinalis has been cultivated in Northern Europe since medieval times and was introduced to North America in the 17th century. Growing to a height of 24in (60cm), this evergreen perennial shrub has captivating gray-green leaves, with a texture like velvet. The blue-mauve flowers appear in early summer. Sage is hardy, so it is a good ornamental plant for cooler climates. It grows in well-drained to dry, neutral to alkaline soils, in sunny conditions.

Harvesting

The ripe chia seeds of *S. hispanica* are used whole or in drinks.

S. officinalis leaves are picked from spring to fall for immediate use or for drying and distillation of essential oil. The dried leaves are used for culinary purposes, or medically in infusions, tinctures, and liquid extracts.

Cautionary Notes

Sage is toxic in excess or if used for too long. Like many herbs, it's not recommended in pregnancy.

Sage suppresses sweating

Sage is an important herb for the night-time sweats of menopause. Scientists are still probing why it may work but it's likely to be related to the modulation of pathways in the brain that regulate sweating.

Medical use

Sage is a stalwart of herbal medicine. In Europe, sage was renowned for its antiseptic and anti-inflammatory properties, as a remedy for sore throats, and to relieve indigestion and flatulence. The powerful blend of active compounds in sage, including the antioxidants, has been implicated in treating inflammatory conditions like rheumatoid arthritis, asthma, and atherosclerosis. The ancient Egyptians used *S. officinalis* to increase fertility, although the current medical literature on this is thin on the ground, if not nonexistent. The latest research does support a role for sage in treating premenstrual and menopausal symptoms (Abdnezhad et al., 2019; Bommer et al., 2011).

The Romans used sage to improve memory and there are tantalizing glimpses in scientific studies (Lopresti, 2017) that back up this traditional use, suggesting that sage is worthy of further study for Alzheimer's disease.

The diet of the ancient Mexican Aztecs and Incas was rich in chia seeds from *S. hispanica*, a similar seed to *Linum usitatissimum* (linseed, p. 128). These seeds are high in omega-3 and omega-6 fatty acids, antioxidants, and fiber. They are also a good source of plant protein, with four tablespoons containing as much protein as a glass of milk. Chia seeds have attracted something of a following as a superfood in recent years and there is scientific evidence to support their role in combating cancer, diabetes, heart disease, and high blood pressure (Ullah et al., 2016; Marcinek and Krejpcio, 2017). Chia seeds are used whole, added to foods and smoothies, or mixed with water, lemon juice, and sugar to make a rather thick, jellylike "drink."

SAMBUCUS NIGRA
Common elder

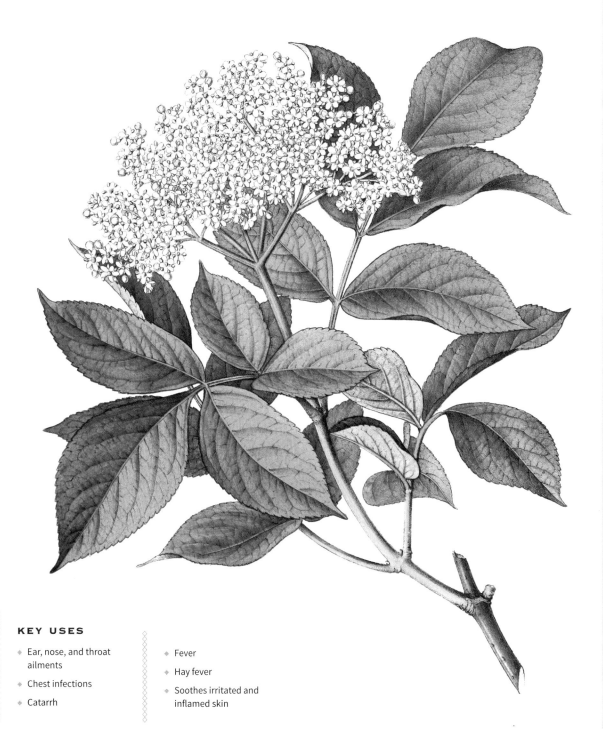

KEY USES

- Ear, nose, and throat ailments
- Chest infections
- Catarrh
- Fever
- Hay fever
- Soothes irritated and inflamed skin

Classification and habitat

Sambucus is a genus of about 20 species of small deciduous trees, shrubs, or temperate perennials. *S. nigra* is native to Europe but grows in other parts of the world too.

It is thought that the common name "elder" comes from the Anglo-Saxon word for fire: *aeld*. The stems are hollow and can be used to fan the flames of a fire, or turned into a musical pipe—*sambuke* in Greek; hence the genus name *Sambucus*.

Elder trees are fast-growing, reaching a height of around 30ft (10m). They prefer moist, nitrogen-rich soil, but will grow in either sunny or semi-shaded positions, on the edge of woods or in hedgerows.

Harvesting

The fragile cream, scented flowers are picked in early summer, when they're covered in yellow pollen, and used fresh to make elderflower cordial or wine, or dried for teas and tinctures.

The ripe berries are dark purple and soft by the late fall. It's a delicate balancing act knowing when to pick them: Too early and they are underripe; too late and they fall prey to frost or birds. They can be eaten fresh (or frozen for later use), although they are quite tart unless cooked in condiments or puddings.

Medical use

An infusion of elderflowers has been used for centuries to ease the symptoms of colds, coughs, sore throats, and flu. A meta-analysis by Hawkins et al. in 2019 concluded that elderberry supplements significantly reduced upper respiratory symptoms and recovery time, and presented a safe way of treating routine cases of the common cold and flu.

Hollow uses

Once the soft pith is removed, the hollow stems can be used to make panpipes or popguns, a fact that was recognized by the 17th-century English herbalist Culpeper, who wrote: "I hold it needless to write any description of this, since every boy that plays with a pop-gun will not mistake another tree instead of Elder."

As an over-the-counter remedy, the extract, or fresh berries, can be safely given to adults and children alike, to lessen the likelihood of developing sore throats, colds, and coughs. These antiviral effects may be due to the inhibition of virus attachment in the airways and/or an enhancement of the immune response by, for example, increasing the production of pro-inflammatory cytokines, which are molecules that modulate the immune response.

Elderflowers are said to reduce fevers by inducing sweating. Sinus and middle-ear infections are also eased by elderflower's anti-catarrhal action. Taking elderflowers with nettles (*Urtica dioica*, p. 198) will reduce the itchy throat, sneezing, and runny nose of hay fever, especially if taken in the weeks leading up to the hay fever season.

While the clinical evidence is most convincing for elder's use to treat colds and flu, there is some limited evidence that it might be used to help treat cancer, fight bacteria such as *Helicobacter pylori* (which causes stomach ulcers), protect against skin damage from UV (ultraviolet) light, and act as an antidepressant. The number of scientific reports on elderberry has been increasing steadily since the 1990s, so no doubt more solid data will emerge!

CAUTIONARY NOTES

Elderberries are safe to consume but avoid unripe ones, as these are mildly toxic. The leaves and branches of S. nigra *are poisonous.*

Ripe elderberries are a good source of antioxidants, including Vitamin C, and provide a natural remedy, drunk in soothing syrupy cordials (or even as a wine), for colds, sore throats, and flu.

SANGUINARIA CANADENSIS

Bloodroot

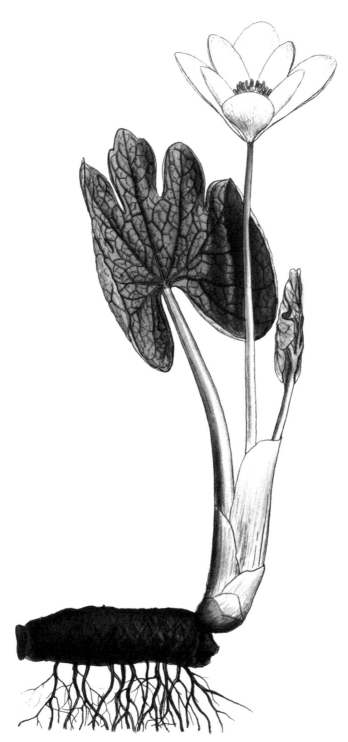

KEY USES

- Respiratory conditions
- Emetic
- Antibacterial
- Mouth plaque
- Skin cancer

Classification and habitat

Sanguinaria canadensis is in a class of its own—quite literally. This single representative of the *Sanguinaria* genus belong to the Papaveraceae, or poppy, family and is a native of woodlands in North America.

Bloodroot's name, from the Latin word *sanguis*, meaning "blood," refers to its striking root, which is reddish-brown on the outside and blood-red inside. Contrasting with its dramatic rhizomes, the showy white flowers, which are shaped like cups and tinted with pink or purple, appear right at the beginning of spring. For this reason, it's a popular addition to shady borders and rock gardens, growing to a maximum height of 2ft (60cm). *S. canadensis* prefers well-drained, humus-rich soil in partial shade or full sun.

A black salve

As expected for a plant that treats multiple conditions, the rhizomes contain several biologically active alkaloids. One of these, sanguinarine, has been shown to have antibacterial properties. There was some excitement about this in the 1980s and 1990s, to the extent that saguinarine was used in toothpastes and mouthwashes to inhibit plaque formation. More recently, its use has been associated with oral cancer. Similarly, the salve made out of bloodroot, black salve, which is sometimes used as a skin cancer treatment, is toxic and may actually be a carcinogen in its own right!

CAUTIONARY NOTES

Bloodroot is best taken on advice by a medical professional or a trained herbal practitioner. It may cause nausea and vomiting if taken internally.

Ant business

S. candaensis relies on ants for its seed dispersal. This is a simple but essential process that goes by a complicated name: myrmecochory. Both the plant and the ants are winners, as the seeds have an extra appendage on them that provides the ants with a nutritious meal, leaving the seed intact and protected in the ants' nest, ready for germination.

Harvesting

The rhizomes are collected in the fall and dried for tinctures, ointments, or liquid extracts.

Medical use

The Native Americans were familiar with bloodroot, for its ability to dye materials—such as skin and implements—red, but also for its healing powers. Since ancient times, bloodroot has been used to treat respiratory conditions and to induce vomiting, as a therapy. In the 19th century, doctors known as the Eclectics, American physicians who made use of botanical remedies, popularized bloodroot as a remedy for coughs, pneumonia, headaches, hepatitis, and cancer. *S. canadesis* can be combined with *Lobelia inflata* (Indian tobacco, p. 130) for asthma or *Capsicum* (chili, p. 60) and *Salvia officinalis* (sage, p. 170), for pharyngitis.

One for the future

Bloodroot has had multiple therapeutic applications over the centuries. Despite concerns about one of the older ones—the use of black salve for skin cancer (see above)—it turns out that sanguinarine, or other bloodroot alkaloids and their derivatives, have more to reveal. The mechanisms are still being investigated, but scientific reviews by Achkar et al. (2017) and Fu et al. (2018), strongly suggest that new cancer drugs may be developed from bloodroot in the near future.

SERENOA REPENS

Saw palmetto

KEY USES

- Cystitis
- Low sperm count
- Low sperm motility
- Impotence
- Enlarged prostate gland
- Polycystic ovary disease
- Premature hair loss
- Diuretic
- Anti-inflammatory

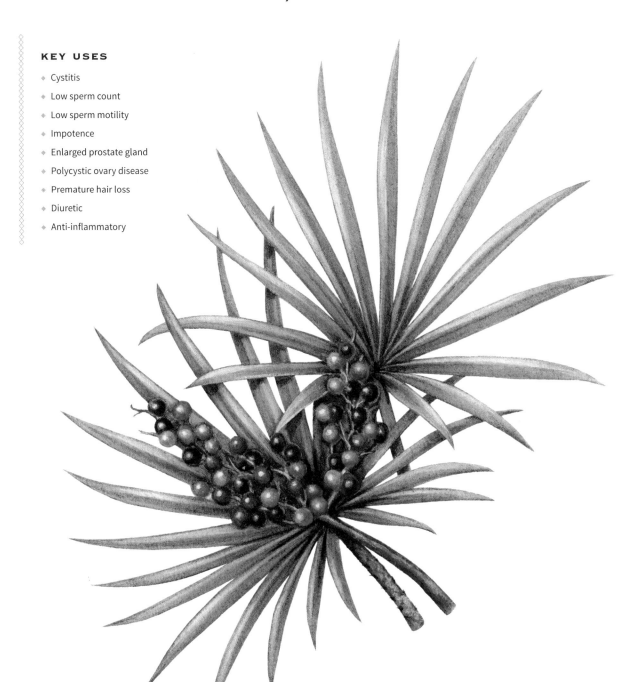

Classification and habitat

Serenoa repens is the sole representative of this genus. The genus name comes from the pioneering Harvard botanist Sereno Watson (1826–1892), who named many North American plants following expeditions across the country. *S. repens* is native to North America and grows mainly in southeastern coastal areas, especially along the Florida coast. It is a shrublike palm growing to a maximum height of 12ft (4m). The white, vanilla-scented flowers appear in spring and summer and the fruits in early winter. These resemble black olives and are edible and sweet.

S. repens' fan-shaped leaves make it popular as an ornamental. It is frost-hardy but grows best in minimum temperatures of 50–55°F (10–13°C), in moist, well-drained soil in sunny conditions.

Harvesting

The ripe fruits are harvested in the summer and partly dried for infusions, liquid extracts, and tinctures, or fully dried and powdered to be made into tablets or capsules.

Medical use

The seeds of saw palmetto were eaten by indigenous North Americans in Florida and Georgia. They recognized the tonic, digestive, and strengthening properties of the fruits. Saw palmetto fruits were also used for urine infections, making use of their anti-inflammatory nature, and as a diuretic to reduce water retention.

Cautionary Notes

Saw palmetto is generally safe, although occasionally it may cause stomach upsets or headaches. As saw palmetto influences hormones, it is probably best to avoid it when taking the contraceptive pill, or when pregnant or breastfeeding.

Aphrodisiac

Over the last 200 years, saw palmetto has acquired a reputation for the treatment of male sexual problems, but it is thought to enhance libido in both sexes. Given its effects on the androgen hormones, this is perhaps not surprising, but the medical literature doesn't currently support anything more than wishful thinking on this front. Or, to put it another way, the studies just haven't been performed yet!

This plant now has something of a reputation as a male herb, not from a biological or botanical point of view but because it is associated with treating male sexual or reproductive problems. Benign prostatic hyperplasia, more commonly known as an enlarged prostate gland, is a focus of current research. Saw palmetto helps to relieve mild to moderate symptoms, such as difficulty in passing urine or urinary frequency. But—and there's always a "but" in the clinical studies—a report by Amdii and Al' Shukri in 2018 found that not all extracts are equal in terms of their clinical effectiveness. Saw palmetto is often used in combination with stinging nettles (*Urtica dioica*, p. 198).

Any positive data is thought to be down to saw palmetto's anti-androgenic properties: androgens are a group of hormones that have numerous functions, including regulating prostate activity. In women, saw palmetto extract is attracting interest for treating the elevated androgens seen in polycystic ovary syndrome. This is characterized by irregular menstruation, acne, and weight gain.

Hair loss is on the list too. A scientific paper by York et al. published in 2020 suggests that saw palmetto is worthy of investigation for male pattern baldness, which affects a large proportion of men and some women—the androgen influence at work again.

SILYBUM MARIANUM

Milk thistle

KEY USES

- Liver diseases including cirrhosis and hepatitis
- Jaundice
- Indigestion
- Poor milk production
- Hemorrhoids
- Cough remedy

The name "milk thistle" comes from the milky sap in the leaves, the white "veins" on the leaves, and the plant's thistle-like appearance. The leaves can be eaten in salads.

Classification and habitat

The *Silybum* genus contains two species found throughout Europe, around the Mediterranean, and in East African mountainous regions. The biennial *S. marianum* is now naturalized in the Americas and Australia and grown worldwide for medicinal purposes. Despite its comic name, *Silybum* is actually derived from the Greek *silybon*, describing the "tuft" of these thistle-like plants. And *marianum* relates to a legend about Mary's milk trickling down the leaves to produce a variegated effect. *S. marianum* is an annual or biannual, growing to a height of 4ft (1.2m), with purple flowers followed by black seeds in the summer. This hardy, attractive, but prickly, ornamental likes well-drained soil in sunny positions.

Harvesting

The leaves are cut as it flowers and the seeds are collected when they're ripe. The plant is dried for tinctures and infusions or for silymarin extraction.

Medical use

Records of milk thistle's use as a medicinal plant can be dated to the ancient Egyptians. In the medieval period, it was widely grown in monastery gardens. Milk thistle contains silymarin, which detoxifies and acts as a tonic for the liver, apparently to such an extent that animals dosed with it don't get the irreversible liver damage induced by death cap fungus (*Amanita phalloides*). It is also used to treat alcohol, drug, and chemical poisoning, indigestion, and hemorrhoids; to promote milk production when breastfeeding; and to relieve coughs and loosen catarrh.

Silybin

Recent studies suggest that silymarin extract (containing the potent molecule silybin) has antioxidant and anti-inflammatory properties, and may have uses in the treatment of metabolic syndrome and diabetes, skin conditions, and cancer.

Milk thistle for melancholy

The English herbalist John Gerard (1545–1612) favored milk thistle for all diseases of "melancholy." Nowadays the word melancholy is used to describe a type of sadness, but it comes from the Greek words *melan*, meaning black, and *chole*, meaning bile. In the Middle Ages, melancholy described liver and bile-related diseases.

Silymarin is a collective term for the active principles in milk thistle, namely, a mixture of flavonoids found in the leaves, fruits, and seeds. Silybin is one of the most potent molecules in this mixture. The liver is the only organ in the body that can regenerate after damage and silybin appears to be involved at several levels. It alters the membrane of liver cells, blocking toxins from entering the cells, and enhances liver regeneration by stimulating the production of new cells to replace damaged ones.

Milk thistle chasers

Hangovers are unpleasant at the best of times, particularly if your tipple of choice has a high alcohol content. But chasers of an extract of apple-flavored milk thistle might just ease that hangover and protect the liver from toxins.

CAUTIONARY NOTES

Milk thistle is generally regarded as safe, although it may occasionally cause an upset stomach or allergic reactions. It is worth ensuring that tablets or capsules contain standardized extracts of 70–80 percent silymarin.

SIMAROUBA GLAUCA

Paradise tree

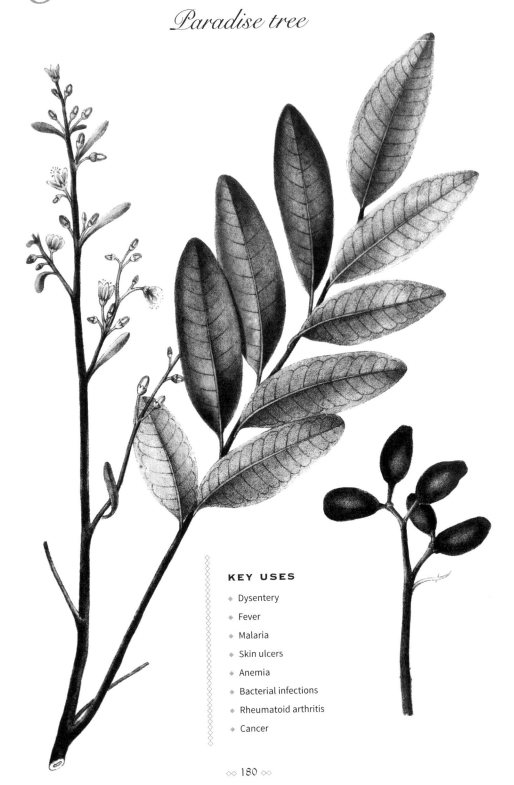

KEY USES

- Dysentery
- Fever
- Malaria
- Skin ulcers
- Anemia
- Bacterial infections
- Rheumatoid arthritis
- Cancer

Classification and habitat

The genus *Simarouba* is one of 32 genera belonging to the Simaroubaceae family. *S. glauca* is one of several confirmed plants in this genus and is native to Central America, the Caribbean, and southern Florida. It is a fast-growing evergreen tree, which grows to approximately 50ft (15m) and thrives in the rainforest understory or in semi-shaded woodland. The flowers, which are pollinated by bees, have five yellow-white overlapping petals and are followed by purple-black fruits. *S. glauca* grows in a range of soils, including those that are very alkaline, although it prefers soil that is moist.

Harvesting

The leaves and bark are harvested all year round for medicinal purposes, the seed for its oil, and timber for making furniture.

Medical use

For centuries, indigenous South Americans have used the leaves and bark of the paradise tree to treat dysentery; hence one of its common names: dysentery bark. In a study published in 1956, Van Assendelft et al. showed that glaucarubin, a glycoside isolated from *S. glauca*, could treat amoebic dysentery with 90 percent effectiveness. Since then, other studies have demonstrated the paradise tree's ability to treat diarrhea caused by bacteria such as *Salmonella* and *Shigella*. The main active principles are a group of triterpenes called quassinoids, which are responsible for both the anti-dysentery and the antimalarial properties of the plant.

Cautionary Notes

At high doses (in the region of five times the recommended amount), S. glauca *can cause nausea or vomiting and increase perspiration and urination.*

Expelling invaders

Science is revealing the secrets of medicinal plants and why they sometimes produce quite toxic molecules. Tricaproin, isolated from *S. glauca*, is one of those molecules attracting interest as an anticancer treatment. In the plant, it's now known that tricaproin repels another kind of invader: in this case, insects.

Traditional medicine has also used *S. glauca* extensively to treat cancers, although it's only just beginning to emerge quite how it works and what the active molecules are. In 2018, Jose et al. published research showing that a triglyceride molecule, tricaproin, isolated from the leaves was, at least in part, responsible for the anticancer activity of *S. glauca* leaf extracts against colorectal cancer in vitro.

A lifetime's work

In 1986, a husband and wife team were given four seeds of *S. glauca* by the Indian government. Drs. Shyamsundar and Shantha Joshi's instructions were to plant the seeds and study the plant's potential as a fuel and edible oil source and to help replenish deforested areas. Nearly 35 years on, there are now more than 2,000 paradise trees at Bangalore's University of Agricultural Sciences. Here the two scientists have demonstrated, alongside others, powerful antimicrobial, antidiabetic, antioxidant, and anti-inflammatory effects. Their findings that *S. glauca* can act as a palliative, to ease the side effects of chemotherapy in cancer patients, add to an increasing understanding of this plant's use as a cancer treatment in itself. Now retired, the couple are still sharing their medical advice and vision for the plant. Visitors are provided with both a cup of paradise tree tea and some seeds to spread the word... and the tree!

STEPHANIA ROTUNDA

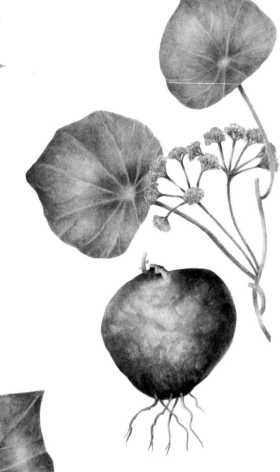

KEY USES

- Fever
- Malaria
- Headache
- Asthma
- Diarrhea
- Painkiller and sedative
- Drug addiction

STEPHANIA TETRANDRA

Han fang ji

KEY USES

- Water retention
- Bacterial infections/ biofilm formation
- Rheumatism
- Arthritis
- Hypertension
- Cancer

Classification and habitat

Stephania tetrandra is a perennial climbing vine that is native to China and Taiwan and grows to a height of about 10ft (3m). The flowers grow in a spiral fashion around the stem and it produces small green flowers in late spring. *S. tetrandra* grows best in cool, wooded areas.

S. rotunda is also a creeper. It grows in the mountains of Cambodia and other Asian countries.

Harvesting

The roots of *S. tetrandra* are collected, and the stems, leaves, and tubers of *S. rotunda*, depending on which medical application is needed.

Medical use

S. tetrandra, or *han fang ji*, to use its Chinese name, is one of the 50 key herbs of traditional Chinese medicine. It is used to relieve pain and promote urine production. Recent research has revealed that han fang ji owes its diuretic properties to tetrandrine, an alkaloid that increases the excretion of urine. Tetrandrine is also immunosuppressive, antibacterial, anti-inflammatory, and antihypertensive. The latter function relates to its ability to expand coronary blood vessels, thereby increasing blood flow and lowering blood pressure.

Tetrandrine is now on the list of potential new anticancer drugs. Although there are some concerns about its bioavailability, research is revealing some novel ways that tetrandrine may help cancer patients. For example, a study by Zhao et al. in 2018 demonstrated that tetrandrine increases the susceptibility of cancer cells to

Suppressing the stickiness
A research paper by Zhao et al. in 2013 showed that tetrandrine isolated from *S. tetrandra* could prevent the formation of *Candida albicans* (yeast) biofilms. Biofilms are collections of one or more types of microorganisms, such as yeast or bacteria, which attach themselves to a surface by a sticky film. Bacteria do this on our teeth to form dental plaque. Biofilms are potentially dangerous because they can grow on all sorts of surfaces—including artificial heart valves, pacemakers, and catheters—and bacteria in biofilms are more resistant to antibiotics.

radiation treatment. And a review by Bhagya and Chandrashekar in 2018 discusses how tetrandrine can help reverse the multidrug resistance that is often a real barrier to successful cancer treatment. Many of these studies are currently only in vitro, but they are paving the way to curing cancer.

S. rotunda has traditionally been used mainly for the treatment of fever and malaria, an activity that is attributed to its alkaloids, many of which are still being discovered. One, rotundine, also known as levo-tetrahydropalmatine, has been used as a sedative and analgesic in China for nearly 50 years. Over the last 10 years, several research groups have explored, and are continuing to explore, its use in treating cocaine and nicotine addiction, particularly in preventing relapses.

CAUTIONARY NOTES

Tetrandrine in S. tetrandra is known to interact with enzymes in the body that metabolize drugs, thus changing levels of these in the body. Take advice from a health professional before taking either of these powerful Stephania species.

New antimalarials?
In 2014, Desgrouas et al. described how a compound from *S. rotunda*, called cepharanthine, might be a way of controlling the alarming rise in drug resistance of the malaria parasite, *Plasmodium falciparum*. In 2016, Le et al. isolated another alkaloid, stepharotudine, to add to the list of 28 known alkaloids—another one for the antimalarial bathroom cabinet perhaps?

STEVIA REBAUDIANA
Stevia

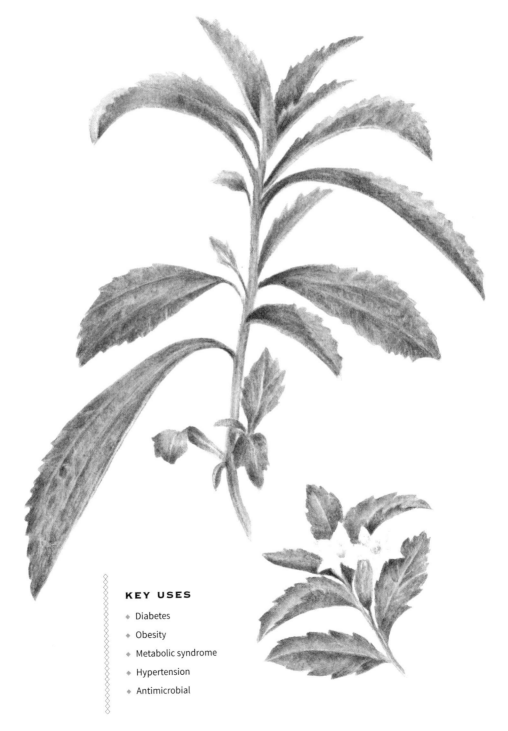

KEY USES

- ◆ Diabetes
- ◆ Obesity
- ◆ Metabolic syndrome
- ◆ Hypertension
- ◆ Antimicrobial

Classification and habitat

Stevia rebaudiana belongs to a genus of approximately 240 species of herbs and shrubs that are part of the Asteraceae, or sunflower, family. This tender perennial is native to Brazil and Paraguay: the local Guaraní people called stevia *ka'a he'e*, meaning "sweet herb." The plant's species name recognizes the Paraguayan chemist Ovidio Rebaudi. Although it originated in South America, this herbaceous shrub is now widely cultivated in many parts of the world, including Bangladesh, Central America, China, Korea, and Thailand.

S. *rebaudiana* grows to a height of about 2ft (60cm), thriving in humid environments such as the rainforest, but it can also be grown at home as a pot plant. The elongated leaves are accompanied by delicate white flowers.

Harvesting

The leaves are harvested all year round but are at their sweetest before the plant flowers. Leaves can be used either whole or to produce commercial extracts, often including other sweeteners. To sweeten tea or desserts, one teaspoon of sugar can be substituted for ¼ teaspoon of ground stevia leaves.

Fooling our taste buds

Our tongues are big drivers of what we eat and how we perceive food. The tongue can be "mapped" into areas that detect sweet, salty, sour, and bitter flavors. The tip of the tongue carries the sweet taste buds, or receptors, which detect carbohydrates that may be a useful energy source. But it's not quite that simple, as stevia clearly provides no energy, yet is very sweet. Scientists now think that's because the active components stevioside and rebaudioside-A bind to the sweet receptors with a higher affinity than glucose, and therefore stimulate a sensation of sweetness at much lower concentrations than glucose.

Sweet discovery

When the Europeans arrived in South America around 500 years ago, the Guaraní people were one of the first tribes they encountered. Over time, their indigenous herbal knowledge was shared but it wasn't until 1887 that the Italian botanist Moisés Santiago Bertoni fell upon the stevia plant. He described how tiny fragments of the leaf, no more than ¼ inch (6mm) across, could "keep the mouth sweet for an hour."

Medical use

The Guaraní have used *S. rebaudiana* for centuries. They chewed the leaf, or used it to sweeten their local tea, yerba mate. The leaves contain a complex mixture of sweet diterpene glycosides, including stevioside and rebaudioside-A, which make stevia around 300 times sweeter than glucose (sugar). Remarkably, for such a sweet plant, stevia carries zero calories and can be added to all sorts of foodstuffs, particularly fizzy soft drinks, with no danger of piling on the pounds. For this reason, stevia is valued in the fight against obesity, metabolic syndrome, and diabetes, especially in cases of early onset diabetes, where it can help keep blood sugar levels under control. Studies are still ongoing but a 2016 review by Ferrazzano et al., suggests that it's also worth investigating the antibacterial effects of stevia, which may help prevent tooth decay.

CAUTIONARY NOTES

Excess consumption may result in stomach upsets. Follow FDA guidelines and consult your herbalist or a medical professional for advice.

SYZYGIUM AROMATICUM

SYN. *EUGENIA CARYOPHYLLATA*

Clove

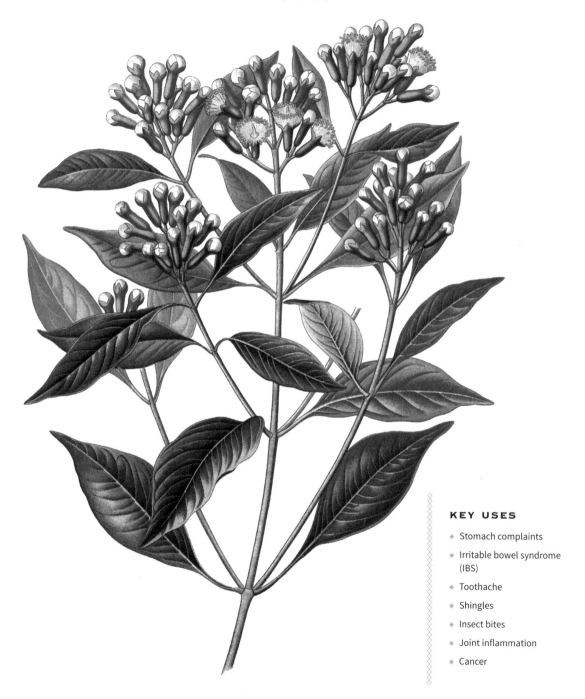

KEY USES

- Stomach complaints
- Irritable bowel syndrome (IBS)
- Toothache
- Shingles
- Insect bites
- Joint inflammation
- Cancer

Classification and habitat

There are approximately 450 species of evergreen trees and shrubs in this genus, growing throughout Africa, Australia, and Asia. *S. aromaticum* is a tree with aromatic flowers, which is native to the volcanic Maluku Islands (Moluccas) in Indonesia, but is now grown widely as a commercial crop throughout the tropics.

It grows to 66ft (20m) tall and has shiny, aromatic, leathery leaves, which are salmon-pink when young. The fragrant flowers of summer are followed by aromatic purple berries. *S. aromaticum* grows in well-drained, fertile soil, in sun and at minimum temperatures of 59–64°F (15–18°C).

The name *Syzygium* comes from the Greek *syzogos*, or "joined," and describes the paired leaves.

Harvesting

The unopened flower buds are harvested as they appear and sun-dried to be used whole or made into a powder or essential oil.

Medical use

Indigenous to the Maluku Islands, the Spice Islands of Indonesia, cloves were an important part of the development of the international spice trade. In traditional Chinese medicine, cloves have been used for hiccups, gastroenteritis, diarrhea, and stomach pain. A potent antiseptic, cloves added to food may help prevent food poisoning. As a tonic, *S. aromaticum* relieves sickness and flatulence.

Alongside its antiseptic properties, clove oil is also a mild anesthetic. It has long been associated with the relief of toothache (and has attracted interest as a possible way to prevent dental plaque).

Clove wars

In the 17th century, the Dutch were the guardians of the spice trade in Indonesia. They ensured their monopoly by destroying surplus clove trees and, in the Amboina Massacre in 1623, executing the British who were trying to set up a rival trading post.

The diluted oil can also alleviate nerve pain in places other than in the mouth, for example, being applied to the skin for conditions like shingles.

The volatile oil contains 60–90 percent eugenol, which is responsible both for some of the medicinal properties of cloves and for their characteristic smell. Eugenol is thought to lower the risk of digestive system cancers and reduce joint inflammation. A study in 2018 by Fangjun and Zhijia suggests eugenol is a potential chemotherapeutic agent against human lung cancer. Cloves also contain a variety of flavonoids, including kaempferol and rhamnetin, which may contribute to clove's anti-inflammatory and anticancer properties.

Native to the rainforests of Indonesia, cloves are the unopened flower buds of *S. aromaticum*. The cloves are pink when fresh, turning brown as they dry, and exude oil when squeezed.

TABEBUIA IMPETIGINOSA

Pau d'arco

KEY USES

- ◆ Fungal infections
- ◆ Bacterial infections
- ◆ Pain relief
- ◆ Ulcers
- ◆ Dysentery
- ◆ Boils
- ◆ Cancer

Pau d'arco is often taken in conjunction with other herbs such as *Echinacea purpurea* (echinacea, p. 100) or *Hydrastis canadensis* (goldenseal, p. 122) to treat bacterial stomach infections or candidiasis (thrush).

Classification and habitat

The *Tabebuia* genus contains about 100 species of deciduous and evergreen shrubs and trees, mainly of the flowering variety. They are found across a central belt of Central and South America and the West Indies, with *T. impetiginosa* found growing from Argentina to northern Mexico. It is a large tree, often reaching heights of 100ft (30m), with dark brown wood, gray bark, and vivid pink flowers. *T. impetiginosa*'s striking flowers make it a spectacular ornamental to grow in tropical climates but the plants often refuse to "perform" in pots.

Harvesting

The inner bark is collected to make herbal teas, capsules, liquid extracts, or dried powders. Liquid extracts of pau d'arco, which are dissolved in alcohol, contain the highest concentration of the active molecules.

Medical use

The plant's inner bark has been used in traditional medicine in Central and South America for many centuries, for the treatment of pain, arthritis, inflammation of the prostate, fever, dysentery, boils, ulcers, and cancer.

Certain infections seem to be particularly susceptible to pau d'arco: It is thought to inhibit the mechanisms by which bacteria and fungi generate energy. For example, it is a traditional South American remedy for yeast infections such as candidiasis. Candidiasis is an infection of the fungus *Candida albicans*, which results in oral or vaginal thrush.

It's all in the name!

Pau d'arco is Portuguese for "bow tree," reflecting the plant's traditional use for making hunting bows. The timber is known as lapacho and is valued for its strength and fine appearance, making it suitable for furniture-making. The species name relates to the plant's use in treating the bacterial skin condition impetigo.

The chemical composition of pau d'arco has been extensively studied. The most prevalent and active principles are the naphthoquinones, including lapachol and β-lapachone, which are extracted from the bark. Lapachol was shown to have antibiotic properties in 1956 and research into its mechanisms is still ongoing. A study in 2013 by Macedo et al. showed that β-lapachone can act in tandem with other antimicrobials to inhibit strains of the methicillin-resistant *Staphylococcus aureus* (MRSA) bacteria.

Pau d'arco came to the fore as a cancer preventative, and for cancer treatment, in Brazil in the 1960s, but the scientific data to back this up is not all positive. Lapachol does demonstrate strong anti-proliferative activity against cancer cells, but getting round its high toxicity is still a stumbling block. Lapachol also appears to decrease the invasion of cancerous cells, so much so that Balassiano et al. (2005) suggested that lapachol could represent a scaffold for the development of novel antimetastatic drugs, to stop cancerous cells spreading. β-lapachone does not dissolve well in water, so designing analogs that are more water-soluble is necessary to increase its bioavailability in the body. After all, the average human body is around 60 percent water.

CAUTIONARY NOTES

Take only on medical advice. Pau d'arco is not recommended for use during pregnancy or for those on anticoagulant medication.

TAXUS
BACCATA
Common Yew →

KEY USES

◆ Solid cancers—bladder, breast, cervical, lung, ovarian, prostate, and Kaposi's sarcoma

TAXUS
BREVIFOLIA
← *Pacific Yew*

Classification and habitat

Taxus brevifolia is one of a genus that includes 30 species of evergreen shrubs and conifers, which grow throughout northern temperate zones. It is found along the Pacific coast of North America—hence its common name—but also grows inland. Pacific yew is slow-growing, becoming a small tree (30ft, 10m high) with slender, drooping branches, leathery leaves, and reddish-purple bark. Spring flowers are small and cream and are followed by poisonous, green-brown berries. As an attractive and evergreen ornamental, Pacific yew is frequently used in gardens to create a hedge. It produces a great canvas for other plants and the yew's dense foliage both reduces noise pollution and provides privacy. This hardy plant prefers well-drained soil in sun or shade.

T. baccata is another member of this genus, growing as a small- to medium-size evergreen conifer (maximum height 66ft, 20m). Its leaves are narrow and leathery and the red fruits appear on the female plants after flowering. The wide trunk (up to 10–13ft, 3–4m diameter) partly contributes to the tree's longevity, as it can split under the pressure of a heavy old tree without becoming diseased or causing the tree to die.

Sacred yew

T. baccata, the common yew, is traditionally found near churches or in graveyards in Europe, particularly in the UK and Northern France. The reasons for this are somewhat lost in the mists of time, but it is thought that yews were planted there because their long life evoked eternity. Or, perhaps because they are so toxic, it discouraged famers from letting their farm animals graze in burial grounds. Such was the perceived power of the ancient sacred yews that cuttings were transplanted all over the world.

A long-lived relative

The common yew (*T. baccata*) is very long-lived, with some British specimens at least 2,000 years old. *T. baccata* is only considered ancient when it's 800 years old. *T. brevifolia* doesn't quite reach this age but this slow-growing species can still clock up several hundred years. Like its British relative, all parts are highly poisonous.

Harvesting

The bark is collected from fall to spring for the extraction of active compounds. The needles of *T. baccata* are now also commonly used in the extraction, synthesis, and plant cell culture of the chemotherapeutic drug Taxol.

Medical use

The Native North Americans identified some of Pacific yew's medicinal properties, making teas from the needles and bark, and treating wounds with crushed needles. The very hard wood was also made into implements, such as paddles, but it wasn't until the 1960s that the Pacific yew revealed its most successful secret: the anticancer drug paclitaxel, sold under the brand name Taxol (see p. 192).

Cautionary Notes

Taxol is a prescription-only drug and is administered via an intravenous injection in hospital. Like many powerful, and inherently toxic, cancer drugs, Taxol often comes with side effects, including hair loss; nausea, diarrhea, and vomiting; nerve problems; and a compromised immune response.

BARKING UP THE RIGHT TREE

The ancient medicinal roots of the Taxus *species or, more accurately, the yew's bark, have yielded one of the world's most successful cancer drugs. Taxol is well-researched, with over 80,000 scientific papers in the scientific literature. That's some 10–1,000 times more than the other plants and plant-derived drugs covered in this book.*

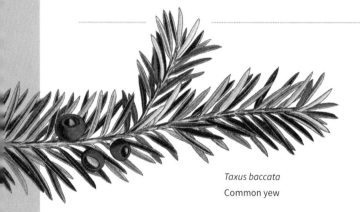

Taxus baccata
Common yew

Paclitaxel, commonly referred to by its brand name Taxol (or Onxol), is the best-known and most frequently prescribed plant-derived drug for cancer in the USA. The drug's name, Taxol, comes from the genus name for the yew, *Taxus*.

A long journey

Botanists have always played a role in the discovery of new drugs—for cancer and in other areas of medicine. In the 1960s, the botanist Arthur Barclay, from the U.S. Department of Agriculture, worked with the U.S. National Cancer Institute where he, and others, screened 35,000 plants for anticancer activity. The Pacific yew stood out, and in 1969, the most active component of the extract was isolated and its structure published in 1971. Taxol was selected for commercial development in 1977, first tested in patients in 1984, and approved as a cancer drug by the FDA in 1992.

Taxol is one of the anticancer drugs that inhibit the function of microtubules within cells. Microtubules have several functions, one of which is to control the process of cell division and replication. Inhibition of the microtubules' function disrupts cell division and kills cells, particularly rapidly dividing cancer cells. Taxol works by inhibiting depolymerization of microtubules, while vincristine (from *Catharanthus roseus*, Madagascan periwinkle, p. 66) inhibits polymerization.

Lessons for yielding new antivirals

With the onset of the COVID-19 pandemic in 2020, scientists rushed to find new antiviral therapies, alongside the search for a vaccine. There is no suggestion that paclitaxel has any efficacy in treating coronaviruses but it provides a classic example of a drug discovery pathway that can guide the development of novel antiviral drugs. Screening plant chemicals for antiviral activity, just as paclitaxel (Taxol) arose from an anticancer screening, is just the beginning of that process. Half of all drugs approved between 1981 and 2014 were derived from plant-derived natural compounds.

Taxus baccata saves the day

Taxol can now be prepared semi-synthetically by extracting a precursor compound, called 10-deacetylbaccatin III, from the needles of Pacific yew's relative *T. baccata* and then carrying out a four-stage synthesis to create Taxol. These needles are harvested without killing the tree and they have a tenfold higher yield than extracting Taxol direct from the tree. Scientists can also manufacture the drug by culturing plant cells from the needles, a renewable process that, with the help of the latest genetic engineering, is increasing the yield and efficiency of Taxol production.

The alkaloid paclitaxel (Taxol), derived from *Taxus* species, plays a central role in the treatment of ovarian, breast, and lung cancers. Like many cancer drugs, Taxol works better for some people than others. Targeting chemotherapies to those who will benefit most is the aim, as scientists begin to identify biomarkers that will signal a tumor's susceptibility to Taxol.

THEOBROMA CACAO

Cocoa

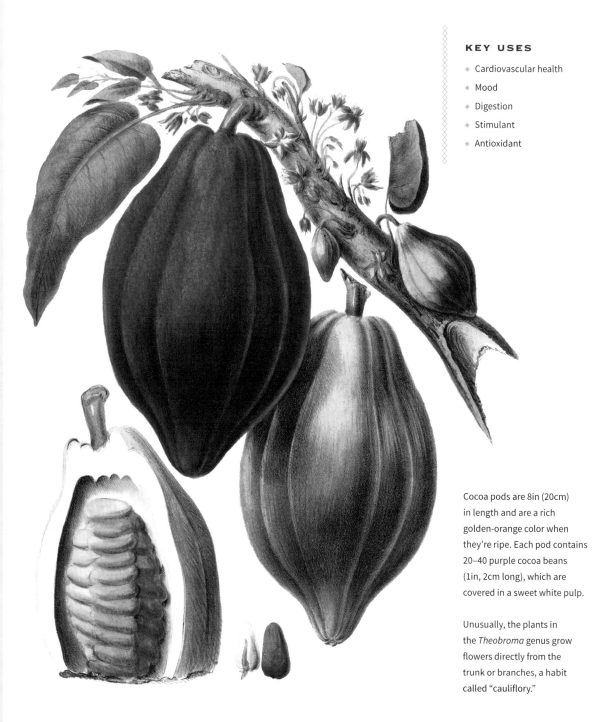

Cocoa pods are 8in (20cm) in length and are a rich golden-orange color when they're ripe. Each pod contains 20–40 purple cocoa beans (1in, 2cm long), which are covered in a sweet white pulp.

Unusually, the plants in the *Theobroma* genus grow flowers directly from the trunk or branches, a habit called "cauliflory."

Classification and habitat

Theobroma cacao is one of a genus of about 20 species of evergreen, tropical American trees. *T. cacao* grows in a tropical belt from approximately 10° north to 10° south of the Equator, with most cocoa grown in Africa. *T. cacao* is a small tree (25ft, 8m), growing in the forest understory, hence its dependence on plenty of rain and a rich soil. It is only ready to harvest when the plant is about four years old.

Harvesting

Cocoa beans are harvested from the ripe pods. The beans are fermented, dried and bagged, winnowed, roasted, and ground. The resulting thick, chocolate-colored liquid, known as "mass," is the basis of all chocolate and cocoa products, including moisturizing skin creams and lip salves.

Medical use

For centuries, cocoa beans were valued as a food, a medicine, and an aphrodisiac in South America. The Aztecs called cocoa *yollotl eztli*, which translates as "heart blood," and may relate to the resemblance between the cacao pod and the heart. It's also a reminder that *T. cacao* was used as a heart tonic—not a use that springs to mind for modern-day milk chocolate, laden with fat, sugar, and calories. But it's all down to how much you eat and, most importantly, which type. Dark chocolate is still calorific but it is better for you

Addictive

Chocolate is a unique food, eliciting activity in regions of the brain that are associated with drug addiction. Keeping that chocolate craving in check is still beyond the reach of modern science, but that doesn't mean there's any shortage of studies. Some point the way forward. A study by Casperson et al. (2019) showed that sugar seems to enhance the addictive effect, so stick to high-cocoa dark chocolate that's low in sugar, and you should be on the right track.

Mood altering

Chocolate enhances your mood. That's because cocoa stimulates the brain to produce neurotransmitters such as endorphins and serotonin—the so-called "happy hormones." These induce a sense of wellbeing but also make chocolate addictive. Chocolate is also a stimulant: Caffeine increases the heart rate; theobromine dilates blood vessels and works alongside caffeine to give an energy boost; and theophylline is a bronchodilator, helping the lungs work more efficiently.

because it is particularly rich in antioxidants, like the flavonols, which protect against cell damage in the heart, circulatory system, and the stomach.

Daily consumption of flavonol-rich dark chocolate or cocoa lowers blood pressure, according to a 2017 meta-analysis by Ried et al. The authors point out, though, that this reduction was small and short-term, and the studies were performed on mainly healthy adults. And it came with the usual health warning that long-term chocolate consumption has other effects: "A moment on the lips, a lifetime on the hips," as the saying goes!

Feeding back to the heart

A square or two of dark chocolate at the end of a meal is most definitely recommended: Its bitter compounds stimulate gastric juices in the stomach. Further down the digestive tract, cocoa feeds the gut bacteria that produce anti-inflammatory molecules—those that promote cardiovascular health.

CAUTIONARY NOTES

Less is more, in terms of health benefits. Opt for a small amount of dark chocolate with a high cocoa percentage—a minimum of 70 percent.

THYMUS VULGARIS
Thyme

KEY USES

- Respiratory infections
- Coughs
- Expectorant
- Fungal foot and nail infections
- Wound disinfectant
- Fatigue
- Irritable bowel syndrome (IBS)
- Intestinal worms
- Joint pain

Thyme, and the thymol it contains, is one of the strongest natural antiseptics and is used in throat lozenges, mouthwashes, and toothpastes.

Classification and habitat

Thyme is a member of the mint (Lamiaceae) family, which includes other aromatic culinary and medicinal herbs, such as sage (*Salvia*, p. 170) and rosemary (*Rosmarinus officinalis*, p. 166). There are numerous varieties, but *T. vulgaris* is the well-known ordinary garden thyme. It is a native plant of arid locations in Mediterranean countries, but now grows worldwide. This slight perennial (height 12–18in, 30–45cm) has small, highly aromatic gray-green leaves and white to purple flowers in late spring and early summer. Thyme is a particular favorite of honey bees.

Low-growing thyme provides fragrant ground cover in the garden. It needs well-drained, preferably sandy soil, in a sunny positon, and can be grown in containers.

Harvesting

The flowers and leaves are harvested regularly in summer, which has the advantage of preventing the plant becoming woody. These are used fresh in cooking; distilled for oil; or dried for infusions, liquid extracts, or culinary use in the winter.

Medical use

As well as being a classic kitchen herb, thyme has a number of medical uses. Thyme's antiseptic properties were known by the ancient Sumerians, around 3000 BC, and the ancient Egyptians used it both to preserve meat and to aid the mummification process. In the 18th century, a German

A fragrant bouquet

There is no standard recipe for bouquet garni, those "tea bags" of herbal mixtures, but most French recipes include thyme, bay leaf, and parsley. The robust flavor of thyme works particularly well in slow cooking as, unlike most herbs, its flavor doesn't easily fade. And thyme tea, sweetened with the finest thyme honey, will help soothe colds, hay fever, IBS, and hangovers alike.

Thyme to die

Thyme, like other similar aromatic plants, is associated with death. Wafts of its characteristic smell were said to be detected at haunted burial grounds because the souls of the recently departed were thought to reside in the flowers.

apothecary discovered that the plant's essential oil had antifungal and antibacterial properties. Before the arrival of modern antibiotics, thyme was applied as a medication to bandages.

One medicinal application really stands out, so much so that the 17th century English herbalist Nicholas Culpeper (p. 10) described thyme as "a noble strengthener of the lung." Thyme tea suppresses coughs, clears phlegm, and disinfects the airways, helping to fight lung infections. It is often combined with echinacea (*Echinacea purpurea*, p. 100), ma huang (*Ephedra sinica*, p. 104), licorice (*Glycyrrhiza glabra*, p. 114), and Indian tobacco (*Lobelia inflata*, p. 130).

The active principles are flavonoids and a phenol called thymol—an essential and volatile oil also found in several other species of plants. Alongside its use as a respiratory aid, thyme helps digestion and has an antispasmodic action in both the gut and the lungs. It can also alleviate PMS and fatigue, and treat threadworms and hookworms. Applied to the skin, thyme relieves joint pains. Thyme essential oil can treat athlete's foot and can be dropped neat onto nails infected with fungus. A study by Gucwa et al. in 2018 showed that thymol has high activity against *Candida albicans*, a common fungal infection.

CAUTIONARY NOTES

The essential oil should only be used neat for fungal nail infections and should not be taken internally.

URTICA DIOICA
Stinging nettle

KEY USES

- Anemia
- Arthritis and Rheumatism
- Gout
- Scalp and skin problems
- Eczema
- Burns
- Nosebleeds
- Heavy menstrual bleeding
- Allergies
- Enlarged prostate

If you're unlucky enough to be stung by nettles, dock leaves (*Rumex obtusifolius*), chamomile (*Chamomilla recutita*, p. 70), or aloe vera (p. 28) will soothe the pain.

Classification and habitat

The *Urtica* genus contains about 50 species of annuals and perennials, distributed throughout temperate regions. Although it's a native European herb, *U. dioica* is really a weed and now thrives worldwide.

The name *Urtica* is the original Latin name and is derived from the word *urere*, meaning "to burn," referring to the minute stinging hairs covering the stems and underside of the jagged leaves. Nettles grow to 5ft (1.5m) and have extensive yellow roots. In summer they produce tiny green flowers in clusters 4in (10cm) long.

As a stinging weed, nettles are not exactly popular in domestic gardens. But, if grown for medicinal purposes, this fast-growing plant doesn't need much encouragement: Restrict growth in a container and plant in rich, moist soil, in the sun or partial shade.

Harvesting

The young leaves are picked (best done with thick gloves) just before flowering. Dried leaves are used in infusions, ointments, powders, and liquid extracts. Thankfully, the dried herb is sting-free. The roots may also be harvested.

Medical use

Externally, contact with unprocessed nettle leaves provokes a strong allergic reaction (see "Nettle rash"), but topically applied nettle extracts can treat arthritic pain, dandruff, eczema, burns, and hemorrhoids. Nettle's anti-inflammatory properties can be harnessed internally for a range of conditions, from treating gout to controlling nosebleeds and, as the leaves contain antihistamines, as a remedy for hay fever and asthma.

CAUTIONARY NOTES

Fresh leaves will sting!

Nettle rash

Gardeners and walkers know all too well the pain of nettle encounters. The word "nettle" comes from the Anglo-Saxon word *noedl*, meaning "needle." As the tiny hairs on the nettle leaf encounter the skin, they break off, leaving sharp needlelike tubes, which inject formic acid (the same as ant and bee stings) and other compounds such as acetylcholine, histamine, and serotonin. Really designed to ward off insects, these toxins produce a painful itching and burning rash. Nettle stings weren't always considered a bad thing. The Romans relished the way nettle stings increased the circulation, helping them to cope with the shock of cold British winters!

Historically, the plant is often associated with reducing inflammation in the stiff and painful joints of gout and arthritis, but it's now attracting interest for treating enlarged prostates too. A small clinical trial by Ghorbanibirgani et al. in 2013 showed that nettle root was a promising treatment to reduce the symptoms, such as difficulty passing urine or pain. Nettle root tincture can be taken on its own for enlarged prostate or combined with saw palmetto (*Serenoa repens*, p. 176). Nettle is combined with ma huang (*Ephedra sinica*, p. 104) for allergies.

Food for thought

Cooked like spinach, nettle leaves are rich in vitamins A and C and minerals such as iron. Those who lived through World War II will remember rationing and wild foraging: Soups made out of the young leaves were all the rage. Nettles also provide food for the caterpillars of the red admiral butterfly and, who'd have thought it, a competition too! Every summer, the annual World Nettle Eating Championships takes place in The Bottle Inn, a pub in Dorset, UK.

VACCINIUM MACROCARPON

Cranberry

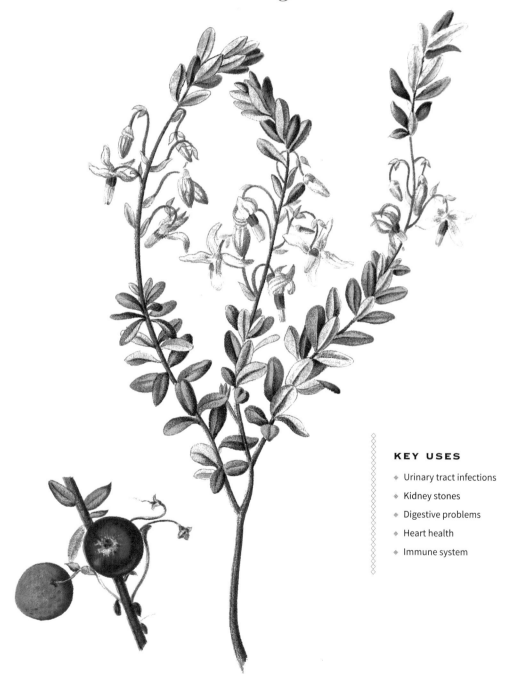

KEY USES

- ◆ Urinary tract infections
- ◆ Kidney stones
- ◆ Digestive problems
- ◆ Heart health
- ◆ Immune system

Classification and habitat

Vaccinium macrocarpon is native to North America, one of the few fruit species that are, but is now widely cultivated across North America and Europe. Belonging to the Ericaceae family, cranberry is related to the blueberry and the bilberry.

It grows as a shrub (8in, 20cm tall), which produces white or pink flowers, followed by red berries (about ½in, 1cm across). *V. macrocarpon* likes to grow in damp, peaty soil—the wetter the better—and high acidity is also key.

Harvesting

Cranberries are picked in the fall, before any frosts. The fruit can be used fresh or dried, or made into capsules.

Medical use

Cranberries, and their juice, have a long history of medicinal food use and are probably best known as a treatment for urinary tract infections (UTIs). These are one of the biggest burdens on healthcare systems, with about 150 million people worldwide developing a UTI each year. The bacterium *Escherichia coli* is the primary cause.

Numerous studies (reviewed in Luczak and Swanoski, 2018) have shown that antibacterial compounds in cranberries, such as proanthocyanidin-A, prevent *E. coli* from adhering to the walls of the bladder and urinary tract, and inhibit biofilm

Acidic survival

Scientists have come up with an intriguing explanation as to on why cranberries are so much sourer than their sweet relations. It turns out they didn't need to evolve into enticing sweet treats, at a time when there were fewer animals on Earth. Animals will eat blueberries, thus dispersing their seeds, but avoid sour cranberries. That doesn't matter for the species' survival, because cranberries have little air pockets that mean they float, dispersing them across the watery locations that the plant favors.

Cooking up a treat

The cranberry is too tart to eat raw but it's a welcome accompaniment in sauces for fatty or bland meats, such as the Thanksgiving or Christmas turkey.

formation. The bacteria are then flushed out in the urine. There is some controversy as to how effective cranberries really are but that may be because of the quantity required. For recurrent UTIs and/or increasing antibiotic resistance, cranberries have their place. For a few days, it might be necessary to drink up to 26fl oz (0.75L) of neat cranberry juice to achieve the desired effect. Otherwise, capsules are another recommended approach.

Elsewhere in the body, cranberries offer a double whammy—particularly for our long-suffering tongues. Their bitterness (detected right at the back of the tongue) stimulates the flow of saliva and other digestive juices in the stomach. And their fibrous content helps keep things moving further down as well. Cranberries are also sour (detected on either side of the tongue, toward the back), because they contain high quantities of vitamin C. This, and other antioxidants, helps to prevent free radical damage. Cranberries are a useful ally in the fight against degenerative diseases such as arthritis and heart disease, and for boosting the immune system.

If you're trying to foil a urinary infection, the more of the tart natural cranberry juice you can drink the better. Owing to its flavor, the neat juice is pretty much undrinkable, so combining it with other fruit juices is probably the way forward. Adding lots of sugar defeats the purpose somewhat but stevia (p. 184) could come into its own here, providing some much-needed sweetness.

CAUTIONARY NOTES

Very high doses can cause stomach upsets and may interfere with anticoagulant medication.

VALERIANA OFFICINALIS
Valerian

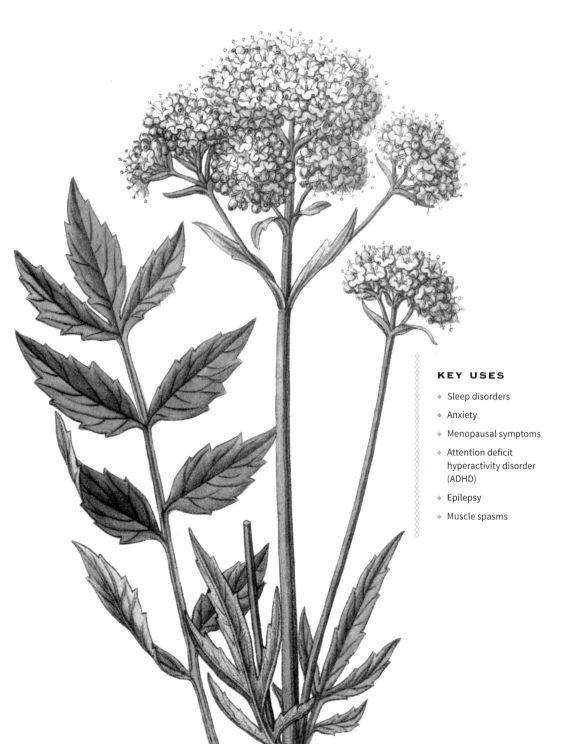

KEY USES

- Sleep disorders
- Anxiety
- Menopausal symptoms
- Attention deficit hyperactivity disorder (ADHD)
- Epilepsy
- Muscle spasms

Classification and habitat

The genus *Valerian* includes over 250 species but *V. officinalis* is the species most often used in the United States and Europe. *V. officinalis* is a tall perennial (height 5ft, 1.5m) found in the wild in woods, grassland, and scrub on damp soil. The name valerian is thought to derive from the Latin *valere*, meaning "to be well." Indigenous to Europe and West Asia, it is now at home in North America too. Its sweet-smelling flowers are light pink or white and it can be readily spotted by its even, opposing leaves with broad blades. It produces a mass of fine roots, and growing in a container makes it easier to harvest these.

Harvesting

A portion of the roots can be cut away in fall—but be ready for the reek when they're harvested! The roots are used in dried form, either using a drying rack or more quickly using a dehydrator. Dried roots can then be made into teas, tinctures, syrups, or powders.

Medical use

Valerian is mainly used as a sedative, helping people to fall asleep and improving the quality of sleep. Valerian root is frequently found in commercial sleep aid teas, often with other sleep-inducing herbs such as chamomile (p. 70) and lavender (p. 126).

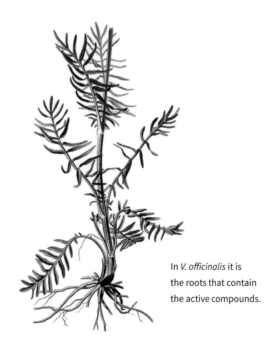

In *V. officinalis* it is the roots that contain the active compounds.

Catnap

Valerian is an elixir to cats too, just like catnip. Three drops of valerian essence added to a water bowl is the recommended treatment for an anxious cat.

Valerian appears to work by targeting chemical pathways in the brain so that nerve stimulation is reduced. Its action resembles that seen with benzodiazepine tranquilizers and researchers are investigating whether valerian can help withdrawal from such commonly prescribed medications.

Its tranquilizing action means that it can help to promote relaxation in chronic anxiety states, and it has been used to calm and promote sleep in children with autism and ADHD. Valerian's sedative abilities may also explain why it was used to treat epilepsy in medieval Iran and late 18th-century Europe.

In addition, herbalists use valerian as an anti-spasmodic to reduce muscle tension, menstrual cramps, and gut spasms. The 17th-century botanist and herbalist Nicholas Culpeper described valerian as good for expelling "wind in the belly."

CAUTIONARY NOTES

Valerian can cause drowsiness, so care should be taken when driving and operating machinery. People vary in their response to valerian so it's best to start with a low dose and build up. Thankfully, the valerian-based teas sold in stores contain small amounts of the active compounds. They're most likely to improve your sleep and not to make you groggy the next day.

VINCA MAJOR

Greater periwinkle →

KEY USES

- Dementia
- Atherosclerosis
- Hypertension
- Bleeding—nosebleeds, heavy menstrual bleeding, gingivitis
- Headaches

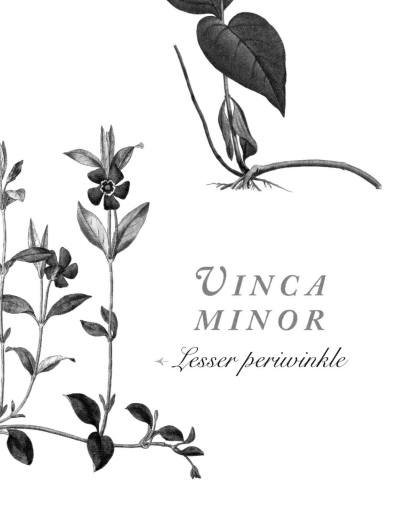

VINCA MINOR

← *Lesser periwinkle*

Classification and habitat

Vinca major and *V. minor* belong to the family Apocynaceae and are herbaceous evergreen perennials. They are commonly known as vinca and periwinkle and are related to *Catharanthus roseus*, sometimes known as *Vinca rosea* or Madagascan periwinkle (p. 66).

V. major and *V. minor* are very similar in appearance. As the name suggests, all parts of *V. major* are larger than those of *V. minor*. The leaves of the major also have a finely serrated, hairy margin, unlike the minor, which is smooth.

Periwinkles are popular ornamental plants, grown for their glossy foliage and impressive blue-purple flowers. These trailing plants are perfect for ground cover (height 12in, 30cm): rooting as they spread along the ground, rapidly forming dense mats. Unlike the Madagascan periwinkle, which is a heat-loving sun-seeker, these two thrive in the shade.

Harvesting

Medical herbalists use the leaves, which are gathered in spring, although the flowers can also be used medicinally, as a flower essence. The roots are gathered in the fall and dried. Leaves are harvested for extraction of active compounds.

Medical use

V. major and *V. minor* are not commonly used by medical herbalists, mainly because their highly toxic nature means it's difficult to achieve the correct dose. To a certain extent, when they are used, these plants are interchangeable in their medical uses. Both can be used internally for improving blood flow, heavy menstruation, and

Molecular profiling

To date, at least 50 different alkaloids have been isolated from *V. minor*, some of which are also present in *V. major*. It's not yet clear whether both species contain the same alkaloids, in what proportions, and how many have medicinal properties. In 2012, a new alkaloid was found in *V. major* (Bahadoria et al.) but not *V. minor*. It is one molecule that may allow these plants to be distinguished on more than just appearance alone and could yield yet another powerful medicine.

nosebleeds, and in a gargle for sore throat. Externally, the bruised leaves, or an ointment made from them, can be applied directly for dermatitis, eczema, and as an astringent to stem bleeding gums, hemorrhoids, and nosebleeds. The roots can be utilized to lower blood pressure.

From a pharmacologist's point of view, these are fascinating and vital plants. Like their Madagascan relative (*Catharanthus roseus*, p. 66), these periwinkles contain key therapeutic chemicals, many of which overlap with *C. roseus*, and which are responsible for their potent actions. The one that's attracted the most interest is vincamine, an alkaloid that is extracted from the leaves and used as a vasodilator (opening up blood vessels) and a cerebral stimulant, treating patients with atherosclerosis ("clogged" blood vessels) and dementia.

Cautionary Notes

Periwinkles are popular garden plants but they are extremely poisonous and most definitely not ones to be tried medicinally at home.

Spot the difference: Since the 1980s, a derivative of vincamine, called vinpocetine, has been used to treat stroke and dementia. Structurally, there is only a small difference from the parent molecule, but semisynthetic alterations like these can make all the difference to factors like a molecule's toxicity, side effects, or half-life in the body. Plants have started the process of "designing" an ideal drug and the scientists try to finish it, or at least finesse it!

Vincamine

Vinpocetine

$\mathcal{V}ITEX\ AGNUS-CASTUS$
Chasteberry

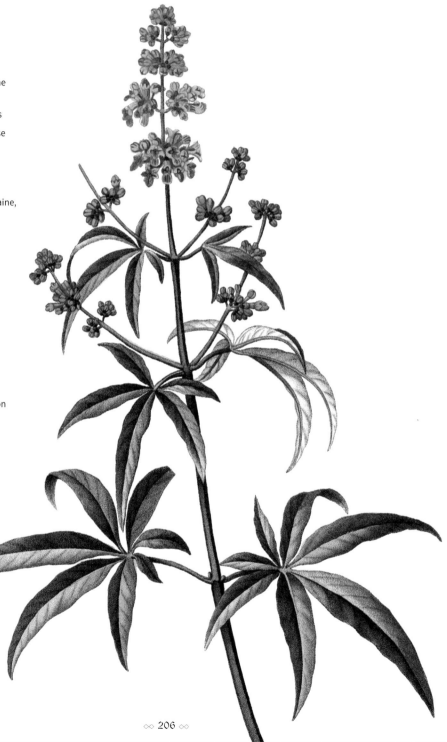

KEY USES

- Premenstrual syndrome (PMS)
- Menopausal symptoms
- Polycystic ovary disease
- Acne
- Deficient lactation
- Pain, including breast pain, headaches, migraine, and eye pain

The influence of chasteberries on the hormones extends to increasing milk production when breastfeeding and to treating acne, which is often linked to a sex hormone imbalance.

Classification and habitat

Vitex agnus-castus belongs to a genus of about 250 species of mainly evergreen and tropical trees and shrubs. A few of these are native to Europe, including the southern European *V. agnus-castus*. It is a deciduous shrub, or sometimes a small tree (15ft, 5m), with palmlike leaves, resembling those of the cannabis plant, and clusters of lilac-scented purple flowers in summer. The flowers are carried on spikes, and are followed by tiny reddish-black fruits—the chasteberries.

This ornamental shrub will grow in warm temperate areas and sometimes in sheltered areas in colder climates.

Harvesting

The berries are harvested in the fall and used fresh or dried for decoctions, tinctures, or powder extracts.

Medical use

This shrub has long been associated with chastity: its species name *castus* comes from the Latin word for "clean." In monasteries, in the Middle Ages, the ground seeds served as a condiment, allegedly to suppress any sexual urges. The science behind this is now better understood and the chasteberry does indeed influence sex, but at a hormonal level, so its use has changed somewhat! In fact, chasteberry may increase libido, not suppress it. It likely depends on what levels your sex hormones are at when you take it.

A review in 2017 by Cerqueria et al. concluded that chasteberry was a safe and effective treatment for PMS. Chasteberry acts on the pituitary

Steeped in wisdom

Chasteberry therapies date back at least 2,500 years. The Greek physician Hippocrates (c. 460–c. 370 BCE) knew about its effect on the menstrual cycle when he wrote, "If blood flows from the womb, let the women drink dark wine in which the leaves of the chaste tree have been steeped.

gland—the "master gland," or pea-sized structure at the base of the brain, which produces hormones itself, as well as controlling the production of other hormone-producing centers in the body, such as the ovaries and testes. Chaste tree berries work by stemming the pituitary gland's secretion of the hormone prolactin, acting downstream of this to normalize the levels of the sex hormones when they are out of kilter in the menstrual cycle. Chasteberry is slow-acting, so extracts or tinctures need to be taken for several months and are best taken first thing in the morning, when the pituitary gland is at its most active.

Another review of 43 clinical studies concluded that it can also help treat menopause symptoms, particularly in the perimenopause, and may have a role to play in the treatment of infertility in women and men (Rafieian-Kopaei and Movahedi, 2017). Medical herbalists recommend combining *V. agnus-castus* with *Actaea racemosa* (black cohosh, p. 18), *Hydrastis canadensis* (goldenseal, p. 122), and *Salvia officinalis* (sage, p. 170) for menopausal symptoms.

CAUTIONARY NOTES

An excess of V. agnus-castus *is thought to cause formication (a word to be read carefully here!), the sensation of ants crawling across the skin. And because of its influence on the hormones, it should be avoided by women taking the contraceptive pill, on HRT, or undergoing fertility treatment.*

WITHANIA SOMNIFERA
Ashwagandha

KEY USES

- Alzheimer's disease
- Stress and exhaustion
- Obsessive-compulsive disorder (OCD)
- Chronic illness
- Asthma
- Bronchitis
- Impotence
- Infertility
- Joint and nerve pain

Ashwagandha root contains numerous plant compounds that are responsible for its therapeutic benefits: steroids, like the withanolides, and alkaloids, such as withanine and somniferine.

Classification and habitat

Withania somnifera belongs to the nightshade family, Solanaceae, like the deadly nightshade (*Atropa belladonna*, p. 44) and edible plants, such as potatoes, tomatoes, and aubergines. The *Withania* genus contains 10 mostly evergreen shrubs, found in Asia and Africa. The *W. somnifera* shrub grows in stony places, up to approximately 5,000ft (1,524m) above sea level in Mediterranean countries, India, and Africa.

It is an upright evergreen plant (maximum height 6ft, 2m), with inconspicuous yellow-green flowers that appear all year round, followed by tiny red berries. *W. somnifera* can be grown in herb gardens, requiring dry stony soil and full sun or partial shade.

In Sanskrit, *ashwagandha* means "horse's smell," both alluding to the plant's aroma, and comparing the strength of the animal to the herb's strengthening functions.

Harvesting

The root and the fruit are harvested. Roots are dried for use in powders, capsules, pastes, or medicated oil or ghee (Indian clarified butter).

Medical use

Known as the "ginseng" of Ayurvedic medicine, ashwagandha is the equivalent to *Panax ginseng* (p. 142) in Chinese medicine. The principal difference is that ashwagandha is more of a sedative than a stimulant.

Having been used for over 3,000 years, ashwagandha is traditionally associated with rejuvenation, particularly in old age and when convalescing from illnesses. It was taken to help preserve memory and intellect, as an aphrodisiac, and to protect against disease. Respiratory conditions such as asthma and bronchitis benefit from its use.

In recent years, ashwagandha has undergone something of a resurgence in Europe and America. Recent studies show that it improves learning and memory, and may help protect nerve cells from the damage seen in spinal cord injuries and Alzheimer's disease (Kuboyama et al., 2014).

Dampening down the disorder

Obsessive-compulsive disorder (OCD) affects 1 percent of the American population. OCD causes obsessive thoughts that result in compulsive behavior, aimed at reducing anxiety. It is often treated with antidepressant drugs such as the selective serotonin reuptake inhibitors (SSRIs), but they don't always get on top of the condition. Recent research has shown that ashwagandha has a calming influence for OCD. A study in 2016 (Jahanbakhsh et al.) showed that a daily supplement of ashwagandha root extract taken for six weeks, used in conjugation with SSRIs, helps decrease the severity of OCD symptoms.

It can take a while to show effects, so it may be necessary to take ashwagandha, at sufficient concentrations, for several months.

The root is also anti-inflammatory, so other diseases of old age, like arthritis, may benefit from this herb. In chronic long-term illnesses, ashwagandha is taken to support the immune system, with data emerging that suggests it decreases markers of inflammation and increases the activity of natural killer cells—white blood cells that ward off infections.

Ashwagandha's calming actions—it is an adaptogen—make it a good tonic for relieving stress and exhaustion. Chandrasekhar et al. showed in a 2012 study that ashwagandha reduced levels of the stress hormone cortisol, with an associated decrease in stress, anxiety, and depression. And ashwagandha can be taken to improve erectile dysfunction, boosting testosterone levels (Ahmad et al., 2010) and improving fertility in both sexes.

CAUTIONARY NOTES

Ashwagandha is generally a safe herb, although it should be avoided during pregnancy.

ZINGIBER OFFICINALE
Ginger

Ginger, like cinnamon (p. 74), is a warming herb, stimulating the circulation and metabolism, and it is a versatile spice too. Fresh, young ginger can be eaten raw, preserved in syrup, or made into candy. Root ginger's pungent essential oil creates a powerful taste in savory dishes—particularly curries—and dried, ground ginger enhances sweet dishes and cakes. The flavor becomes mellower the longer it is cooked.

Classification and habitat

Native to South East Asia, *Zingiber* is a genus of about 100 species of perennials. The name *Zingiber* is derived from the Greek *zingiberis* meaning "ginger," while the Sanskrit word for ginger means "horn root." *Z. officinale* is cultivated across the world in tropical and subtropical regions, including Australia, China, India, and Florida in the USA.

This deciduous perennial (maximum height 5ft, 1.5m) has thick, branching rhizomes, upright stems, and long, pointed leaves. In the summer, yellow-green flowers are produced (but only if the rhizomes are properly exposed), followed by capsular fruits.

Ginger is grown like the potato plant, sprouting out of another potato, but in hotter climates, with high rainfall. The rhizomes sit just above the ground like the iris plant and grow in humus-rich soil. In hothouses or greenhouses, rhizomes bought from the supermarket can produce a good crop of ginger. The attractive canelike foliage dies down in the fall, making space for other plants to shine.

Harvesting

The rhizome is harvested in the growing season to be cooked fresh or dried to make a powder. The latter is available for cooking and in capsules for medicinal purposes. An oleoresin mixture, containing essential oil and resin, can be extracted from the rhizomes.

Medical use

Ginger has always been valued—so much so, that in England in the 13th and 14th centuries, a pound of ginger commanded the same price as one sheep. Cultivated since ancient times for culinary purposes, ginger also has medicinal qualities. Known for its invigorating and warming properties, it was used to alleviate digestive problems, such as colic and heartburn, simulate sweating and blood circulation, and help treat fevers. Ginger is often used with other herbs, particularly those that combat circulatory or digestive ailments (senna, p. 64) and colds and flu (garlic, p. 24).

A masterful player

Ginger contains numerous active compounds but the principal player is 6-gingerol. This is chemically related to capsaicin and piperine, the compounds that give chili peppers (p. 60) and black pepper (p. 156) their respective spiciness. Gingerol wears a number of hats: It is anti-inflammatory, antibacterial, antiviral, antioxidant, and anticancer. Its anticancer function influences several biological pathways that both kill cancer cells and prevent them from spreading.

Many recent uses have focused on ginger's ability to ease nausea, particularly in travel sickness, chemotherapy side effects, and the morning sickness of pregnancy. For example, Viljoen et al. demonstrated in 2014 that ginger reduced nausea in morning sickness although, disappointingly for pregnant women, it didn't seem to significantly decrease the incidence of vomiting.

Ginger can help painful joints too. In a 2001 study, Altman and Marcussen showed that oral ginger extracts could reduce knee pain in patients with osteoarthritis. In type 2 diabetes, ginger has been shown to lower blood sugar and, along with studies that also show reduced cholesterol levels, to improve the patients' heart risk profile (Arzati et al., 2017).

Ginger zest

Grated fresh ginger root combined with garlic, lemon, and honey in a hot drink provides a warming pick-you-up to settle an upset stomach or help combat colds and flu.

CAUTIONARY NOTES

Avoid high doses if you're on anticoagulant blood-thinning medication.

ACTIONS OF PLANTS
AND CONDITIONS THEY TREAT

As this book is a snapshot of just some of the plants available to medical herbalists, this is not a definitive list, but it does illustrate the many conditions that plants can alleviate.

ACTION OR CONDITION	PLANT
Addison's disease	*Glycyrrhiza glabra*
Altitude sickness	*Erythroxylum coca, Ginkgo biloba*
Alzheimer's disease	*Camellia sinensis, Curcuma longa, Ginkgo biloba, Lycoris squamigera, Physostigma venenosum, Withania somnifera*
Anemia	*Simarouba glauca, Urtica dioica*
Antibacterial	*Allium sativum, Aloe vera, Capsicum annuum, Cassia, Cinnamomum zeylanicum, Echinacea purpurea, Hydrastis canadensis, Plantago major, Rosmarinus officinalis, Salvia officinalis, Sanguinaria canadensis, Simarouba glauca, Stephania tetrandra, Stevia rebaudiana, Tabebuia impetiginosa, Vaccinium macrocarpon*
Anti-fever	*Andrographis paniculata, Artemisia absinthium, Artemisia annua, Cinchona ledgeriana, Cinnamomum zeylanicum, Colchicum autumnale, Eucalyptus globulus, Harpagophytum procumbens, Piper nigrum, Rosmarinus officinalis, Sambucus nigra, Simarouba glauca, Stephania rotunda*
Antifungal	*Allium sativum, Chamomilla recutita, Cinnamomum zeylanicum, Eucalyptus globulus, Lavandula officinalis, Pisonia grandis, Tabebuia impetiginosa, Thymus vulgaris*
Anti-inflammatory	*Actaea racemosa, Aesculus hippocastanum, Aloe vera, Ananas comosus, Andrographis paniculata, Arnica montana, Betula pendula, Camellia sinensis, Centella asiatica, Cinnamomum camphora, Pisonia grandis, Plantago major, Rosmarinus officinalis, Salvia hispanica, Serenoa repens, Zingiber officinale*
Antioxidant	*Allium sativum, Aloe vera, Ananas comosus, Camellia sinensis, Carica papaya, Coffea arabica, Linum usitatissimum, Rosmarinus officinalis, Theobroma cacao, Vaccinium macrocarpon*
Antiviral	*Aesculus hippocastanum, Allium sativum, Echinacea purpurea*
Anxiety	*Cannabis sativa, Chamomilla recutita, Hypericum perforatum, Lavandula officinalis, Rauvolfia serpentina, Valeriana officinalis, Withania somnifera*
Arthritis/osteoarthritis	*Actaea racemosa, Ananas comosus, Betula pendula, Brassica nigra, Cinnamomum zeylanicum, Dioscorea villosa, Gaultheria procumbens, Glycyrrhiza glabra, Harpagophytum procumbens, Pisonia grandis, Rosmarinus officinalis, Salvia officinalis, Stephania tetrandra, Urtica dioica*
Asthma	*Ammi majus, Datura stramonium, Dioscorea villosa, Ephedra sinica, Ginkgo biloba, Gossypium hirsutum, Lobelia inflata, Mentha × piperita, Oenothera biennis, Salvia officinalis, Stephania rotunda, Withania somnifera*
Astringent	*Aesculus hippocastanum, Berberis vulgaris, Citrus limon*
Bleeding/Hemorrhage	*Artemisia annua, Claviceps purpurea, Plantago major, Urtica dioica, Vinca major/minor*

Blood pressure—hypertension	*Allium sativum, Cinnamomum zeylanicum, Convallaria majalis, Elettaria cardamomum, Linum usitatissimum, Lycium barbarum, Petroselinum crispum, Rauvolfia serpentina, Salvia hispanica, Stephania tetrandra, Stevia rebaudiana, Vinca major/minor*
Blood sugar regulation	*Allium sativum, Plantago ovata, Stevia rebaudiana*
Breast pain and lactation	*Actaea racemosa, Oenothera biennis, Salvia officinalis, Silybum marianum, Vitex agnus-castus*
Cancer	*Betula pendula, Camellia sinensis, Camptotheca acuminata, Catharanthus roseus, Cinchona ledgeriana, Citrus limon, Colchicum autumnale, Convallaria majalis, Curcuma longa, Digitalis lanata, Eugenia caryophyllata, Gossypium hirsutum, Hydrastis canadensis, Linum usitatissimum, Panax ginseng, Piper nigrum, Podophyllum peltatum, Salvia hispanica, Sanguinaria canadensis, Simarouba glauca, Stephania tetrandra, Tabebuia impetiginosa, Taxus baccata*
Cholesterol—high levels	*Allium sativum, Curcuma longa, Cynara scolymus, Linum usitatissimum, Lycium barbarum, Plantago ovata, Zingiber officinale*
Circulation—poor	*Brassica nigra, Capsicum annuum, Ginkgo biloba, Vinca major/minor, Zingiber officinale*
Colic	*Chamomilla recutita, Elettaria cardamomum, Mentha × piperita, Zingiber officinale*
Common cold	*Andrographis paniculata, Camptotheca acuminata, Cinchona ledgeriana, Cinnamomum camphora, Cinnamomum zeylanicum, Echinacea purpurea, Ephedra sinica, Eucalyptus globulus, Rosmarinus officinalis*
Coughs	*Brassica nigra, Ginkgo biloba, Papaver somniferum, Silybum marianum, Thymus vulgaris*
Constipation	*Aloe vera, Areca catechu, Cassia, Linum usitatissimum, Plantago major, Plantago ovata, Salvia hispanica*
Crohn's disease	*Artemisia absinthium, Curcuma longa, Dioscorea villosa*
Decongestant	*Cinnamomum camphora, Ephedra sinica, Eucalyptus globulus, Gaultheria procumbens, Lavandula officinalis, Mentha × piperita, Piper nigrum, Plantago major, Sambucus nigra*
Deep-vein thrombosis	*Aesculus hippocastanum*
Dengue fever	*Carica papaya*
Depression	*Curcuma longa, Hypericum perforatum, Rauvolfia serpentina, Rosmarinus officinalis*
Diabetes—mainly type 2 (see also, blood sugar)	*Camellia sinensis, Carica papaya, Catharanthus roseus, Cinnamomum zeylanicum, Cynara scolymus, Linum usitatissimum, Lycium barbarum, Panax ginseng, Piper nigrum, Salvia hispanica, Stevia rebaudiana*
Digestion—stomach infections (gastroenteritis)	*Artemisia absinthium, Camellia sinensis, Capsicum annuum, Cinnamomum zeylanicum, Ginkgo biloba, Hydrastis canadensis, Piper nigrum*
Digestive aid	*Ananas comosus, Camellia sinensis, Capsicum annuum, Carica papaya, Chamomilla recutita, Curcuma longa, Elettaria cardamomum, Glycyrrhiza glabra, Lavandula officinalis, Mentha × piperita, Pilocarpus microphyllus, Piper nigrum, Plantago major, Rosmarinus officinalis, Salvia officinalis, Berberis vulgaris, Silybum marianum, Theobroma cacao*
Digestive disorders—including diarrhea, nausea, and vomiting	*Artemisia absinthium, Camptotheca acuminata, Cannabis sativa, Catharanthus roseus, Cinnamomum zeylanicum, Curcuma longa, Dioscorea villosa, Eugenia caryophyllata, Glycyrrhiza glabra, Gossypium hirsutum, Harpagophytum procumbens, Oenothera biennis, Papaver somniferum, Petroselinum crispum, Piper nigrum, Stephania rotunda, Vaccinium macrocarpon, Zingiber officinale*
Dysentery	*Andrographis paniculata, Areca catechu, Berberis vulgaris, Camellia sinensis, Gossypium hirsutum, Pisonia grandis, Simarouba glauca, Tabebuia impetiginosa*
Ear infections	*Hydrastis canadensis, Sambucus nigra*

Edema	Adonis vernalis, Aesculus hippocastanum, Areca catechu, Catharanthus roseus, Convallaria majalis, Cytisus scoparius, Petroselinum crispum, Serenoa repens, Stephania tetrandra
Epilepsy	Cannabis sativa, Cytisus scoparius, Valeriana officinalis
Expectorant	Allium sativum, Eucalyptus globulus, Glycyrrhiza glabra, Thymus vulgaris
Eyes—dilates/contracts pupils	Atropa belladonna, Physostigma venenosum
Eyes—glaucoma	Cannabis sativa, Physostigma venenosum, Pilocarpus microphyllus
Eyes—macular degeneration	Lycium barbarum
Eyes—pink eye (conjunctivitis)	Chamomilla recutita
Eyes—tired and sore eyes	Camellia sinensis, Hamamelis virginiana, Vitex agnus-castus
Fatigue—mental/physical	Camellia sinensis, Coffea arabica, Erythroxylum coca, Lycium barbarum, Panax ginseng, Rosmarinus officinalis, Thymus vulgaris, Withania somnifera
Gallstones	Berberis vulgaris
Gingivitis (gum infections/ inflammation)	Aloe vera, Citrus limon, Gaultheria procumbens, Hamamelis virginiana, Salvia officinalis, Vinca major/minor
Gout	Ananas comosus, Betula pendula, Colchicum autumnale, Cytisus scoparius, Harpagophytum procumbens, Petroselinum crispum, Rosmarinus officinalis, Urtica dioica
Hair growth	Berberis vulgaris, Serenoa repens
Hay fever	Ephedra sinica, Sambucus nigra
Headache/migraine	Actaea racemosa, Chamomilla recutita, Claviceps purpurea, Ginkgo biloba, Lavandula officinalis, Mentha × piperita, Rosmarinus officinalis, Stephania rotunda, Vinca major/minor, Vitex agnus-castus
Heart—angina	Ammi majus, Convallaria majalis
Heart—arrhythmia (irregular or rapid heartbeat)	Adonis vernalis, Cinchona ledgeriana, Convallaria majalis, Cytisus scoparius, Digitalis lanata, Digitalis purpurea
Heart—coronary atherosclerosis	Ammi majus, Arnica montana, Cynara scolymus, Vinca major/minor
Heart—failure	Cytisus scoparius, Digitalis lanata, Digitalis purpurea
Heart—palpitations	Adonis vernalis
Heart—sedative	Adonis vernalis
Hemorrhoids	Aesculus hippocastanum, Centella asiatica, Cinchona ledgeriana, Echinacea purpurea, Hamamelis virginiana, Silybum marianum
Hunger suppressant	Areca catechu
Immune system stimulant	Ananas comosus, Andrographis paniculata, Citrus limon, Vaccinium macrocarpon
Inflammatory bowel disease (IBD)	Andrographis paniculata, Harpagophytum procumbens
Influenza (flu)	Andrographis paniculata, Cinchona ledgeriana, Cinnamomum camphora, Ephedra sinica, Rosmarinus officinalis
Irritable bowel syndrome (IBS)	Aloe vera, Curcuma longa, Cynara scolymus, Dioscorea villosa, Eugenia caryophyllata, Mentha × piperita, Plantago major, Plantago ovata, Salvia hispanica, Thymus vulgaris, Zingiber officinale
Kidney disorders	Berberis vulgaris, Betula pendula
Kidney—kidney stones	Ammi majus, Citrus limon, Cynara scolymus, Vaccinium macrocarpon

Liver disorders (including hepatitis and jaundice)	*Artemisia absinthium, Berberis vulgaris, Camptotheca acuminata, Curcuma longa, Cynara scolymus, Glycyrrhiza glabra, Hydrastis canadensis, Petroselinum crispum, Salvia officinalis, Silybum marianum*
Malaria	*Artemisia annua, Cinchona ledgeriana, Simarouba glauca, Stephania rotunda*
Memory—loss (dementia)/ enhancing memory	*Artemisia absinthium, Centella asiatica, Panax ginseng, Rosmarinus officinalis, Salvia officinalis, Vinca major/minor*
Menopause symptoms	*Actaea racemosa, Dioscorea villosa, Hydrastis canadensis, Linum usitatissimum, Oenothera biennis, Salvia officinalis, Valeriana officinalis, Vitex agnus-castus*
Menstruation—pain/irregular	*Chamomilla recutita, Gossypium hirsutum, Hydrastis canadensis, Petroselinum crispum, Urtica dioica, Vinca major/minor, Zingiber officinale*
Microbiome support	*Allium sativum*
Motion sickness	*Atropa belladonna, Datura stramonium*
Mouth ulcers	*Citrus limon, Glycyrrhiza glabra*
Multiple sclerosis (MS)	*Cannabis sativa*
Myasthenia gravis	*Physostigma venenosum*
Obesity	*Brassica nigra, Camellia sinensis, Lycium barbarum, Salvia hispanica, Stevia rebaudiana*
Parkinson's disease	*Atropa belladonna, Camellia sinensis, Claviceps purpurea, Datura stramonium, Lycoris squamigera, Mucuna pruriens, Piper nigrum*
Premenstrual syndrome (PMS)	*Actaea racemosa, Chamomilla recutita, Dioscorea villosa, Oenothera biennis, Salvia officinalis, Vitex agnus-castus, Zingiber officinale*
Pain (see also, headache/ migraine)	*Cannabis sativa, Capsicum annuum, Chamomilla recutita, Cinchona ledgeriana, Cinnamomum camphora, Dioscorea villosa, Harpagophytum procumbens, Papaver somniferum, Pisonia grandis, Salix alba, Stephania rotunda, Tabebuia impetiginosa, Vitex agnus-castus*
Pain—fibromyalgia/neuralgia	*Betula pendula, Datura stramonium, Gaultheria procumbens, Harpagophytum procumbens, Hypericum perforatum, Oenothera biennis*
Pain—rheumatic and muscular	*Aesculus hippocastanum, Arnica montana, Atropa belladonna, Capsicum annuum, Cannabis sativa, Eugenia caryophyllata, Gaultheria procumbens, Lavandula officinalis, Lobelia inflata, Rosmarinus officinalis, Thymus vulgaris, Withania somnifera*
Psychoactive	*Erythroxylum coca, Cannabis sativa, Papaver somniferum, Theobroma cacao*
Respiratory/lung ailments (see also, asthma, coughs, and decongestant)	*Ananas comosus, Convallaria majalis, Elettaria cardamomum, Eucalyptus globulus, Glycyrrhiza glabra, Lavandula officinalis, Linum usitatissimum, Lobelia inflata, Mentha × piperita, Panax ginseng, Sambucus nigra, Sanguinaria canadensis, Thymus vulgaris, Withania somnifera, Zingiber officinale*
Rheumatism/rheumatoid arthritis	*Actaea racemosa, Betula pendula, Cannabis sativa, Cinnamomum zeylanicum, Curcuma longa, Gaultheria procumbens, Harpagophytum procumbens, Lobelia inflata, Oenothera biennis, Petroselinum crispum, Pisonia grandis, Simarouba glauca, Stephania tetrandra, Urtica dioica*
Sciatica	*Cytisus scoparius, Gaultheria procumbens*
Scurvy	*Citrus limon*
Sedative	*Actaea racemosa, Atropa belladonna, Papaver somniferum, Stephania rotunda, Valeriana officinalis*
Sexual/reproductive disorders	*Ephedra sinica, Gossypium hirsutum, Mucuna pruriens, Panax ginseng, Pausinystalia yohimbe, Serenoa repens, Vitex agnus-castus, Withania somnifera*

Shingles	*Eugenia caryophyllata*
Sinusitis	*Ananas comosus, Berberis vulgaris, Echinacea purpurea, Hydrastis canadensis*
Skin—acne	*Allium sativum, Echinacea purpurea, Hamamelis virginiana, Oenothera biennis, Vitex agnus-castus*
Skin—bruises	*Arnica montana, Hamamelis virginiana, Hypericum perforatum*
Skin—burns	*Aloe vera, Chamomilla recutita, Gossypium hirsutum, Hypericum perforatum, Plantago major, Urtica dioica*
Skin—chilblains	*Arnica montana, Brassica nigra, Capsicum annuum*
Skin—dermatitis	*Aloe vera, Sambucus nigra*
Skin—eczema	*Aloe vera, Betula pendula, Chamomilla recutita, Curcuma longa, Echinacea purpurea, Glycyrrhiza glabra, Oenothera biennis, Urtica dioica*
Skin—insect bites/stings and snake bites	*Lobelia inflata, Plantago major, Rauvolfia serpentina*
Skin—psoriasis	*Aloe vera, Ammi majus, Betula pendula, Camptotheca acuminata, Colchicum autumnale, Glycyrrhiza glabra*
Skin—ulcers	*Aesculus hippocastanum, Centella asiatica, Curcuma longa, Pisonia grandis, Plantago major, Simarouba glauca, Tabebuia impetiginosa*
Skin—urticaria (hives)	*Chamomilla recutita, Colchicum autumnale*
Skin—vitiligo	*Ammi visnaga*
Skin—wound healing	*Aloe vera, Ananas comosus, Arnica montana, Carica papaya, Centella asiatica, Citrus limon, Curcuma longa, Echinacea purpurea, Eucalyptus globulus, Hypericum perforatum, Lavandula officinalis, Oenothera biennis, Pisonia grandis, Plantago major, Thymus vulgaris*
Sleep disorders	*Cannabis sativa, Chamomilla recutita, Hypericum perforatum, Lavandula officinalis, Oenothera biennis, Papaver somniferum, Valeriana officinalis*
Stimulant	*Areca catechu, Camellia sinensis, Capsicum annuum, Theobroma cacao*
Thread veins	*Aesculus hippocastanum*
Throat—infections/tonsillitis	*Artemisia absinthium, Echinacea purpurea, Mentha × piperita, Salvia officinalis, Sambucus nigra*
Throat—sore throat	*Brassica nigra, Citrus limon, Elettaria cardamomum, Eucalyptus globulus, Glycyrrhiza glabra, Sambucus nigra*
Thyroid—underactive	*Capsicum annuum*
Tinnitus	*Actaea racemosa, Ginkgo biloba*
Tonic	*Andrographis paniculata, Berberis vulgaris, Betula pendula, Capsicum annuum, Centella asiatica, Citrus limon, Elettaria cardamomum, Hydrastis canadensis, Panax ginseng*
Toothache	*Ammi majus, Capsicum annuum, Eugenia caryophyllata*
Urinary infections (cystitis)/ incontinence	*Berberis vulgaris, Betula pendula, Datura stramonium, Petroselinum crispum, Piper nigrum, Serenoa repens, Vaccinium macrocarpon*
Vaginal infections	*Hydrastis canadensis*
Varicose veins	*Aesculus hippocastanum, Centella asiatica, Cinchona ledgeriana, Citrus limon, Ginkgo biloba, Hamamelis virginiana*
Worms—parasitic diseases	*Artemisia absinthium, Carica papaya, Cassia, Datura stramonium, Mucuna pruriens, Thymus vulgaris*

GLOSSARY

Active principle—the compound that is responsible for the main biological effect of a plant or herbal extract, for example, morphine from the opium poppy or quinine from *Cinchona* bark.

Adaptogen—A substance that helps the body adapt to stress and disease, supporting health and wellbeing.

Adrenal glands—These produce hormones that regulate, for example, blood pressure and response to stress.

Aerial parts—Any parts of the plant that are above ground.

Alkaloid—A type of nitrogen-containing plant compound that often has significant physiological actions on humans (see p. 13).

Analgesic—A substance that reduces or relieves pain.

Analog—A chemical, or structural, analog is a compound with a similar chemical structure to another one but not necessarily the same function. In drug development, a series of structural analogs of a primary lead compound are synthesized and tested to find the safest and most effective compound.

Androgen—A steroid sex hormone that primarily, but not exclusively, acts on the male reproductive system, for example, testosterone.

Annual—A plant that completes its life cycle, from germination and flowering to seed and dying back, in one year.

Antibiotic—A substance that kills bacteria.

Anticoagulant—A substance that prevents blood coagulation.

Antioxidant—A substance that helps to prevent cell damage caused by **free radicals**.

Antiseptic—A substance that inhibits the growth of microorganisms, such as bacteria.

Astringent—A substance that tightens and contracts the skin and mucous membranes, reducing minor bleeding and secretions.

Atherosclerosis—A build-up of plaque (fatty deposits) in the arteries, restricting blood flow as these gradually narrow.

Autoimmune disease—An acute or chronic illness in which the immune system attacks the body's own cells, instead of a foreign invader such as a virus or bacterium.

Ayurveda—A traditional Indian and Sri Lankan system of medicine.

Biennial—A plant that usually completes its life cycle in two growing years, producing foliage only in the first year, then flowers and fruits in the second, before dying.

Bioavailability—The amount of a substance, such as a drug, that enters the circulation and is available for action in its active form.

Biofilm—A thin layer of bacteria, adhering to a surface and enclosed in a protective coating, often making the bacteria antibiotic-resistant.

Blood–brain barrier—This layer of tightly packed cells that lines the blood vessels in the brain and the spinal cord acts to prevent large molecules and pathogens entering the brain.

Cardiotonic—A substance that has a favorable effect upon the heart's action.

Chemotherapy—The use of chemical compounds to treat disease, particularly cancer.

Chilblains—Painful, itchy swellings on the skin that usually effect the body's extremities (toes, fingers, ears, and so on) after exposure to the cold.

Cholesterol—A type of **sterol (steroid)** found in every cell in the body: high levels are associated with heart disease.

Compress—Material soaked in hot or cold herbal extract (usually a tea or infusion) for application to the skin.

Cultivar—A cultivated variety of plant—for example, a strain produced by plant breeding—that is not normally found in the wild.

Deciduous—A plant that loses its leaves annually, at the end of the growing season.

Decoction—A water-based preparation of tougher plant parts, such as roots, bark, berries, or seeds, simmered to extract water-soluble compounds such as tannins.

Decongestant—A substance that clears congestion in the nose and upper respiratory tract.

Dermatitis—Skin inflammation.

Diuretic—A substance that stimulates urine production, helping to reduce water retention.

Edema—swelling caused by excess fluid collecting in the body's tissues.

Enzyme—A biological catalyst that speeds up chemical reactions but remains unchanged itself.

Essential oil—Aromatic oil distilled from plants containing volatile oils.

Evergreen—A plant that keeps its leaves throughout the year.

Expectorant—A substance that stimulates clearing (through coughing) of phlegm from the throat and chest.

Family—In biological **Linnaean classification**, this is a principal taxonomic category that ranks above **genus** and below order.

Fibromyalgia—Affecting both the muscles and the bones, this chronic condition causes widespread pain and debilitating fatigue.

Flavonoid—A type of polyphenol found in plants and fungi, with a common structure of a 15-carbon ring, abbreviated to C_6-C_3-C_6 (see p. 12). They are often highly colored and beneficial to humans.

Free radicals—These are unstable and highly reactive molecules produced naturally as a byproduct of metabolism, which can damage cells, causing disease and aging.

Genus—In biological **Linnaean classification**, this is a principal taxonomic category that ranks above **species** and below family. Genus is denoted by the first word of the Latin binomial name: for example, *Salix* as in *Salix alba*, the willow tree (p. 168).

Gingivitis—Inflammation of the gingiva (gums) surrounding the teeth.

Glycoside—A compound in which a sugar is bound to another functional group via a glycosidic bond (see p. 13). Cardiac glycosides affect the heart.

Gut flora—The resident bacteria in the gut.

Half-hardy—A plant that tolerates temperatures above 32° F (0°C).

Half-life—The amount of time for the quantity of something (for example, a drug in the body) to fall to half its initial value.

Hardy—A plant that tolerates year-round temperate conditions, including frost, without protection.

Herbaceous—A **perennial** that dies down at the end of the growing season.

Hybrids—The offspring of genetically different parents—produced accidentally in wild or cultivated plants or artificially by scientists.

Hypertension—High blood pressure.

Infusion—A water-based preparation, similar to tea, in which flowers, leaves, or stems are steeped in boiling water—good for extracting water-soluble compounds such as the **flavonoids**.

In vitro—From the Latin for "in glass," and describing biological processes taking place outside an organism, in laboratory conditions.

In vivo—From the Latin for "in life," and describing biological processes taking place inside a living organism.

Laxative—A substance that stimulates a bowel movement.

Legume—A plant that is a member of the Fabaceae or Leguminosae family, commonly known as the pea family, and characterized by the pod-like growth of the crop.

Lignan—A type of plant polyphenol that is often found in seeds but also in whole grains, legumes, fruits, and vegetables.

Linnaean classification—Carl Linnaeus, the 18th-century Swedish naturalist, devised a classification system that groups organisms with similar characteristics. This allows organisms to be divided into increasingly smaller and more specialized divisions, from the five kingdoms (including plants, animals, and fungi) branching out into phylum, class, order, **family**, **genus**, and finally **species**. Like other organisms, plants are given a Latin binomial name denoting the genus, followed by the species.

Meta-analysis—Statistical analysis that combines the results of multiple scientific studies addressing the same question, enabling a more robust statistically significant conclusion.

Metabolism—The chemical processes that occur within a living organism to maintain life.

Metabolite—A substance formed by, or necessary for, metabolism.

Metastasis—The spread of cancer from the part of the body where it originated to another part of the body.

Microbiome—The microorganisms (bacteria, viruses, fungi, and parasites) in a particular environment (including the body or a part of the body). In the gut, this is principally bacteria.

Neuralgia—Nerve pain, caused by a damaged or irritated nerve.

Perennial—A plant that lives for two years or longer and, once mature, flowers annually. Usually denotes a herbaceous perennial that dies back completely, unlike woody ones, which leave a tough stem at the base.

Pharmacokinetics—This branch of pharmacology describes what happens to a drug in the body—its bioavailability, and the time scale of its absorption, metabolism, and excretion.

Phenols—Phenolic compounds are groups of **metabolites** available in all plant **species**. They range from simple compounds with just one phenol group to more complex ones like the **flavonoids**, which are often polyphenols.

Phytoestrogen—A type of estrogen found in plants. This xeno, or foreign, estrogen can bind to estrogen receptors on human body cells and is generally thought to be beneficial.

Pinnate (leaves)—A compound leaf, in which the leaflets grow in two rows either side of the stem.

Poultice—This is a plant paste (ground or mashed herbs with water added) either applied directly to the skin or wrapped in an absorbent material or substance.

Prebiotic—a non-digestible food ingredient, usually plant fiber, that promotes the growth of beneficial gut bacteria, already present in the human gut. (Probiotics introduce beneficial bacteria.)

Psoriasis—A chronic inflammatory skin condition, characterized by red, scaly patches as the skin overgrows.

Psychoactive—A substance, usually a drug, that acts on the brain and affects mood or behavior.

Rhizome—An underground stem, which usually grows horizontally just below the soil's surface and has a swollen appearance.

Rubefacient—A substance that increases blood flow and reddens the skin, acting as a painkiller in various musculoskeletal conditions.

Saponin—A type of **glycoside**, abundant in some plant **species**, and characterized by the soap-like foam (detergent) it makes when shaken with water.

Sedative—A substance that has a direct effect on the nervous system, suppressing brain activity, reducing nervous excitement or irritability, and inducing a more relaxed state.

Smooth muscle—This is found in the walls of hollow organs (for example, the digestive tract, blood vessels, and urinary bladder) and other areas (for example, the iris of the eye).

Species—The basic unit of **Linnaean classification**—taxonomy—is a species. A species is a population or groups of populations that can potentially interbreed freely within and among themselves to produce fertile offspring. Species is denoted by the second word of the Latin binomial name: for example, *alba*, as in *Salix alba*, the willow tree (p. 168).

Standardized extract—A herbal extract with a defined level of active principles or key compounds.

Steroid—An active compound, often a hormone, which may be found in plants, animals, and fungi, but can also be manufactured synthetically.

Sterol—A type of steroid found in both plants and animals.

Stimulant—A substance that has a direct effect on the nervous system, enhancing brain activity, and increasing alertness, energy levels, and physiological activity.

Subspecies—Subgroups within a **species** that have different traits, or appearances. Subspecies can interbreed with other subspecies within that species but often don't due to, for example, geographical isolation.

Synergism—The interaction between two substances (or organisms) that produces a combined effect greater than the sum of their individual effects.

Tannin—A type of plant **polyphenol**—often yellow or brown—with **astringent** and binding (or tanning) action.

Terpene—An aromatic compound found in many plants, whose strong odor may deter plant eaters.

Tincture—A concentrated liquid herbal extract. It is typically made by soaking herbs and other plant parts in an alcohol solution to extract the active compounds. The proportion of alcohol to water determines the composition of water-insoluble versus water-soluble compounds extracted.

Tinnitus—A condition that causes someone to hear ringing sounds or other noises in the ears.

Tonic—A substance that exerts a restorative or stimulant action on the body.

Topical—Applied directly to the skin.

Urticaria (hives)—An allergic reaction to substances such as pollen, insect bites, chemicals, food, or the cold, which causes a raised, itchy rash.

Vitiligo—An autoimmune disease wherein the pigment (melanin) producing cells in the skin are destroyed, resulting in the appearance of non-pigmented patches.

Volatile oil—A plant compound, with an antiseptic and aromatic nature, distilled to produce essential oil.

INDEX

CREDITS

ABOUT THE AUTHOR

Dr. Catherine Whitlock is a science writer with a BSc in Biological Sciences, a PhD in Immunology, and a Diploma in Science Communication. Catherine writes on science, medicine, and nature, and is based in Kent, England. Her previous books include Meet Your Bacteria *(2018) and* Ten Women Who Changed Science and the World *(2019).*

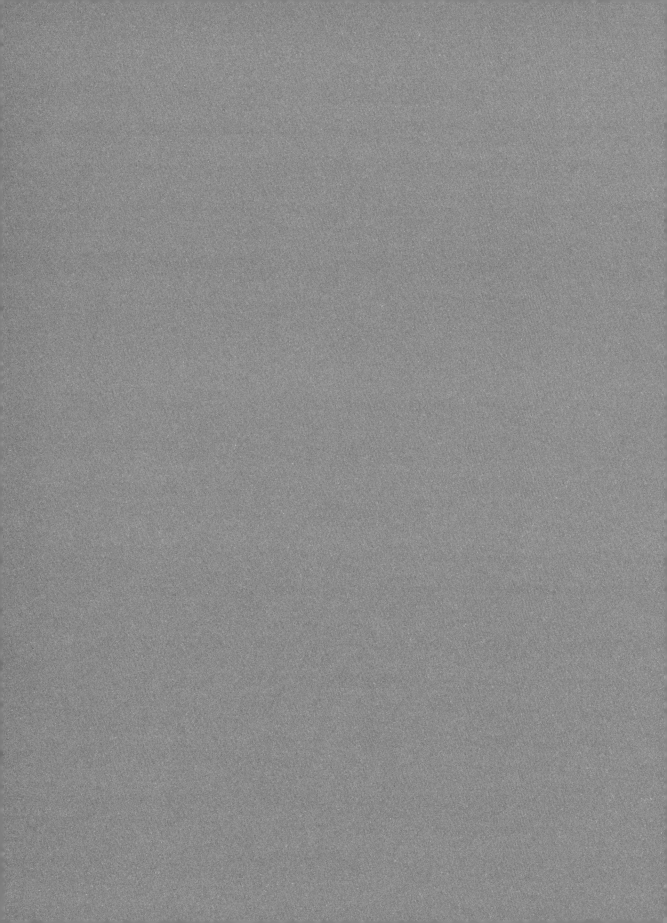